For Yolie, Jenny and Bill Paxton

Introduction

Let me first just say thank you for reading this book. I don't know what possessed you to, but thank you all the same. I really do appreciate it. I was struggling with a way to introduce this book, and I figured a sincere thank you ought to do it.

Now, allow me to talk a little bit about both myself *and* the book: My name is Billy Russell and I wrote *VideoBilly's 101 Must-See Movies: A Bathroom Book* as a means of expressing to the world how much the movies mean to me. I love everything about the movies… I love watching them at home on a lazy Sunday afternoon, I love staying up late to watch something on TCM Underground (I know I can record it, but half the fun is gathering the endurance and the reward is violence and exploitation), and I love the smell of movie theaters. I love collecting my ticket stubs. I love the coming attractions. I love getting there early to get a good seat. And I love that my girlfriend Yolie always gets a couple containers of jalapenos to go with our popcorn.

My love affair with the movies began at a very young age and I tried to chronicle some of that through many of my reviews. The first movie I ever remember watching was *Beetlejuice*. I know it wasn't the first I ever *did* watch, but it's the earliest memory I have, and it happens to be a really good movie (one of Tim Burton's earliest and best), so it earns a place, rightfully, in the book.

The 101 movies that I chose for the book is the result of a bizarre, personal ranking system that makes sense only to me. These aren't the greatest films of all time; they're just some of my favorites. If there's one thing I want to you glean from these reviews and essays, it's maybe to learn a little something about me, since I've included some personal stories about myself… sort of like, a story of my life, as told through the movies.

Why the subtitle "A Bathroom Book", you might ask? I, like most people, have to poop—sometimes several times a day—and I enjoy having something to read when I'm using the facilities. Phones are… they're fine. We all have the World Wide Web at our fingertips now, but there's something about reading a *book* when you're sitting on the

toilet. A book chooses the content for you. If I'm at someone's house and they don't have a book or a magazine to read, I'll read the back of a shampoo bottle or whatever else might be lying around. To me, if a book winds up in the bathroom, it's a form of a high complement. Whatever is available to me in the bathroom, I will read the holy hell out of.

VideoBilly's 101 Must-See Movies has gone through many iterations. At one point, it was a much more ambitious book, and I wanted it to consist of thousands of smaller reviews. This proved to be way too daunting, so I scaled the project back and increased the overall word count and personality of the reviews of the movies I eventually tabulated. I always wanted to have a movie guide of my own, ever since being gifted Leonard Maltin's movie guide by my parents on one of my birthdays decades ago. I disagreed with Maltin *vehemently* on certain movies, but it was still a damn good guide. I dog-eared pages of the book to remember movies for later, ones that I'd never heard of that he'd written glowing reviews of. It's because of his guide that I saw films like *Martin* and *Suspiria*.

Another inspiration to my book was a book my sister had, *Videohound's Cult Flicks and Trash Pics*, a copy of which had graced my own bathroom for years. A new volume desperately needs to come out. The last update was fifteen years ago! I must have read through every review of that thing a hundred times over. The book also gets an honorable mention for introducing me to the movie *Miracle Mile*, for which I got a chance to interview the film's director, Steve De Jarnatt, for this book's entry on that movie.

I opened with thanking you, Dear Reader, for reading this book, and now I'd like to close by thanking some of the people who helped me through this book, and my inspirations.

I'd like to thank my girlfriend Yolie for riding my ass on days when I've said I didn't feel like writing, and for letting me bounce ideas off of her endlessly. And for putting up with my shit sometimes, when I'd get disheartened by my writing. Thank you for believing in me when starting this book looked like a dream that would never be realized. I love you.

I'd like to thank my family. My mom and my dad, for teaching me that movies were special and that it was okay to enjoy them with fervor. My brother Chris and my sister Jenny, who were always down to watch something weird with me when I was growing up, and together we'd eat up those free screener tapes from the video store my mom managed. So many hours were spent watching movies from Full Moon Features.

I'd like to thank my friend Bret who expressed enthusiasm for the book and wanted me to do the one thing I was most hesitant about: To make it more personal.

I'd like to thank Robert Osborne and Roger Ebert, people who taught me about the deeper appreciation of film. Roger Ebert, whose show with Siskel I watched one day, taught me that a crime film with theological discussions and conversations revolving around hamburgers wasn't just odd, but brilliant, and one of the best movies ever made. Robert Osborne, whose excitement with the art form always came across with each film he introduced, wanting to share his love with us. May they both rest in peace.

I'd like to thank Stephen King, whose book *On Writing* is the most helpful guide on the craft of writing I've ever read in my life.

I'd like to thank John Waters, whose book *Role Models* was an endless source of inspiration.

I'd also like to thank Leonard Maltin. He and I clearly have differing opinions on what makes a movie great, but his guide was a big influence on me growing up.

Please, enjoy the book. And flush once for me.

28 Days Later
(2003)

When I first saw *28 Days Later*, it was a bit of a gamble at the time. In 2003, zombie movies (I know, I know, they're not technically zombies, but they're the same damn thing, okay?) weren't a thing again yet. They hadn't made their comeback. And *28 Days Later*, in many ways, was responsible for that massive comeback that the genre had. I mean, prior to *28 Days Later* what was the last big-deal zombie movie to have even come out? What was the last zombie movie even of note to have come out before *28 Days Later*? (*Dead Alive* in 1992?) Because in its wake you had this gigantic resurgence, including *Shaun of the Dead*, George Romero finally making a new zombie movie for the first time in twenty years, *Land of the Dead*, his classic *Dawn of the Dead* getting a pretty okay remake, and now one of the most popular shows on TV right now is "The Walking Dead," which gave homage to *28 Days Later* in its "guy wakes up from coma" framing of the apocalypse.

But in 2003, none of that had happened yet. I was at the theater with my friends and we wanted to see a movie… any movie. I think our only other option for new releases that weekend was the second *Charlie's Angels* movie which was an easy pass. When I was a teenager, getting to the movies from my hometown to the closest city was a good 45-minute drive. We were there, dammit, and we were gonna see *something*.

I had seen some TV spots for *28 Days Later* that were cryptic. I knew that the guy who did *Trainspotting* had done it, but I think the ads touted him as the guy who did *The Beach*, which… fine, I guess? I looked at the poster: Rated R for strong violence, gore, language and nudity.

"Well, hey," I reasoned to my friends. "At least we know it'll be violent and have nudity."

I am now reminded of an exchange from the show *King of the Hill* where Connie asks Joseph, "You've been to an "R" movie?" and he replies with, "Yeah but the only person naked was Harvey Keitel." In my case, the only person naked was Cillian Murphy… and it was a limp, side-dangling penis.

It's funny when I look back at the trepidation I somehow had. I was about to go see one of my new favorites, an absolute and instant classic of both the zombie genre and apocalyptic horror genre (and horror as a whole), and I was kind of wavering back and forth, unsure. First of all, what the hell did I have to lose? Even if I didn't have a job, being out the $6 or however much it cost to see a movie in 2003 wasn't a devastating blow. Secondly, where does a 16-year old get off thinking he's above anything?

Pretty much right away, I was absolutely floored. I loved everything about *28 Days Later*. I loved the *look* of the movie; the MiniDV-filmed, low-budget cinematography looks dreadful anywhere else, but in *28 Days Later*, those splotches of pixels and video noise really add to it. It looks like a quasi-documentary filmed by inexperienced survivors of an apocalypse who used whatever equipment happened to be laying around.

A prologue explains that a group of well-meaning activists released caged animals which had been infected with pure rage. Whoever is bitten or accidentally ingests the blood of someone infected will, in turn, be infected. The infected are reduced to rabies-like madness, like if rabies and roid-rage had a baby. And it spreads very, very quickly. Just one drop is all it takes.

Cut to the titular "28 Days Later" where Jim (the aforementioned sometimes-naked Cillian Murphy) awakens in a hospital. He's alone. He's alone not only in the hospital, but seemingly the whole of London—maybe even the world. He wanders the streets, piecing together clues of what had happened, unaware of the state of the world that had crumbled around him while in a coma.

The scenes of Jim wandering a deserted London are an amazing feat pulled off with its low budget ($8 million). Danny Boyle, working with a very small crew, would shoot literal minutes at a time, over the course of many days, to piece together the entire, exhilarating segment.

After Jim encounters, and is attacked by some of the infected survivors of the plague, the movie kicks off in both expected and unexpected ways, the journey for survival somehow being both derivative, lulling you into a false sense of security, and then subverting your

expectations at pivotal points. The vision of an apocalyptic world, as presented in *28 Days Later*, is pure movie magic. Everything about it works. The third act might be the weakest thing about the movie, but goddamned if it isn't shot and acted brilliantly. Those shots in the rain are absolutely gorgeous. The shot of the chained infected soldier standing in the window, illuminated by a flash of lightning, is pure poetry.

Runtime: 108 minutes.

Adaptation.
(2002)

Adaptation. is usually the first movie I bring up as a counter-argument whenever someone says Nicolas Cage is a shitty actor. Yes, he's been shitty in shitty movies, but he's also been great in great movies. He's an actor that requires a good director and a good script, because even when he's at his worst, he never lacks the manic energy that's required of him.

When you have a script as good as this (care of Charlie Kaufman) and a director as good as Spike Jonze, Nicolas Cage is going to belt out one hell of a performance. That he also plays twins, a dual-role, each performance as each twin, is just… it's fantastic stuff.

Nicolas Cage plays Charlie Kaufman, the writer of the real-life screenplay in a movie about how *Adaptation.* came to life.

If this all sounds a bit too hard to follow, don't worry. It's not. That's one of the great things about this movie: It presents abstract ideas like real people playing themselves, while famous people play real people that they are not that end up getting fictionalized resolutions in scenarios that actually did happen in real-life—and it does this with ease. It's such an assured piece, juggling so many ideas of varying complexity, it's like watching a brilliant musician play several instruments at once, all with surgical precision.

Nicolas Cage also plays *Donald* Kaufman, Charlie's stupid, eager-to-please twin brother whose success with screenplays as ridiculous as

The Three, a movie about a cop, a serial killer, and a woman kidnapped by the killer who all happen to be the same person ("Trick photography" is Donald's reason to explain this twist logically), inspires jealousy in Charlie. Charlie may indeed be the smarter, more talented brother, but Donald is everything he wants to be—well-liked, confident, funny. Charlie is none of those things. He's twisted up in his own neuroses, masturbating to the mere idea of someone approving of his work with warmth and appreciation.

While the movie has Charlie and Donald both representing the yin and the yang of personalities, it also delves into the nonfictional book that Charlie has been tasked with adapting into a screenplay, *The Orchid Thief*. *The Orchid Thief* technically gets two adaptations in *Adaptation*. You get a very faithful re-telling of a woman (Susan Orlean, played by Meryl Streep) who is following the obsession that her subject John Laroche (played by Chris Cooper) has for orchids. The movie dives head-in, explaining the beauty, the fragility, the absolutely crystal-clear reasons *why* John would become obsessed with them and all that he does, and all the laws he breaks to cultivate them. And then you get the Hollywood version of their story, where Susan and John are drug-addled lovers—with car chases, shoot-outs and overwrought drama aplenty.

And then, as if that weren't enough, the film ponders the idea of adaptation itself. The film begins with a montage at the age of the dinosaurs. The dinosaurs are wiped out. Life begins again. Life learns to adapt. To simply say that it's a metaphor for artistic process of starting over and beginning again is technically true on its surface, but it's so much more than that. *Adaptation.* is a movie that's as obsessed with humanity as John Laroche is with orchids, or Susan is with John, or Charlie is with finishing his "un-writable" screenplay. Adaptation and evolution are the processes that brought humanity into this world, and if the movie is to be obsessed with humanity and how it ticks, in all its ugly quirks and eccentricities, then it needs to start at the beginning, at the very beginning and the dawn of man.

Movies like *Adaptation.* are a revelation. They remind us why we go to the movies in the first place. We go for lots of reasons—to be thrilled, to laugh, to cry. Another reason we go is to learn something about its

creators. Some films are deeply, deeply personal and tell us how they see the world, which is totally different from the way you and I might see things. The way Charlie Kaufman sees the world, and the way Spike Jonze renders that vision, is so painfully melancholic sometimes, but tinged with nostalgia and wonder and joy. It's so fucking *human*, it's ridiculous.

Runtime: 114 minutes.

Alien/Aliens

(1979/1986)

There are some pop culture arguments that are going to be raging for eternity: The Beatles or the Stones? Ginger or Mary Ann? *Breaking Bad* or *The Sopranos*? On the *Alien* or *Aliens* debate, I refuse to take a position, because I don't have to. I'm not gonna, and you can't make me.

The way I view *Alien* and *Aliens* are as two parts to one whole narrative. One picks up right after the other ended (well, give or take 50-something years), and can be viewed continuously. Each half of the story is told so differently, but each with such unique vision and skill, I don't think one has to be better than the other. They're both nearly-perfect movies. Their narrative perfections are matched only by their technical skill.

Alien begins in the cold of space, in a realistic depiction of what it might be like to be working-class in an age of unprecedented scientific marvels. In an era when space travel is possible and even regular, someone has to do the shit job of loading up large cargo crafts and shipping them back to Earth, a process that takes such a long time the members of the crew must be kept in stasis for the majority of their trip.

The crew responds to a mysterious transmission that may be a distress signal coming from a nearby planet. Following company orders and standard protocol, they land on the planet's surface and venture into a derelict spacecraft to investigate. This whole segment, the journey into the belly of the beast, is my favorite part of the movie. It's this hypnotic, hallucinogenic journey into almost absolute madness. It evokes the best of H.P. Lovecraft, and the way Ridley Scott (director of *Alien*) utilizes H.R. Giger's artwork and brings it alive... it's just pure imagination. It's pure dread, too, because you know something absolutely terrible is going to happen, but who could resist going further and further into that cavernous spaceship? Strange aliens from long ago are found dead, their chests bursts from the inside out. A deadly premonition of things to come.

Shortly after discovering a very large open area filled with thousands of eggs, Kane (played by John Hurt) has an alien attach itself to his face. Later, back on the ship and en route home, he suffers a seizure and a small alien lifeform bursts out of his chest.
Thinking that the unexpected passenger on board that burst from Kane's chest is still as small as it was when it emerged, they discover it is now actually a large, very angry predator that is just about indestructible. It has acid for blood. It has a tail with a stinger. It has a second set of jaws that can penetrate someone's skull. It has claws. And it's always lurking somewhere in the shadows. It doesn't need to eat. It's a perfect organism. It can hide, it can stalk, it can and it will find you.

Alien is like existential dread. You know it's going to attack, the question is just a matter of when.

Aliens cranks everything to 11. It begins where the last one left off, with Ripley (Sigourney Weaver) floating through outer space after her encounter with the chest-bursting monster. Ripley wasn't exactly passive in the first movie, in fact she was a badass, but in *Aliens* she's basically Rambo (perhaps it's not coincidental that James Cameron, writer/director of *Aliens* also wrote the second *Rambo* movie?).

The first film asks the basic question of what would you do if there was a basically-invincible monster trying to kill you and there was nowhere you could go, nowhere that was safe? The sequel asks what you would do if you thought you thought you were prepared, but found yourself way in over your head, and surrounded by monsters and, once again, there's absolutely nowhere you can go that's safe?

The tension in *Aliens* ramps up and ramps up and when it reaches a boiling point, it doesn't stop, it just allows everything to boil over. It's like a sickening roller coaster ride through hell.

In the basic premise of *Aliens*, Ripley must return to the planet from the first film, which is now colonized by terreformers, sort of like the gentrifiers of the future. She is aiding as an eye-witness expert for a team of marines that are sent to investigate what happened to the colony, why their transmission suddenly went dead. And it wouldn't be an *Alien* movie if there wasn't some sort of slimy corporate interest pulling the strings.

Both movies are such brilliant exercises in horror, tension and just balls-out terror that at the end of each one, I usually need to watch an episode of *I Love Lucy* or something to cleanse my palate. Once the screaming begins, it doesn't let up. But it's always refreshing to see a movie where people aren't getting killed because they made a stupid choice as part of some plot contrivance. Rather, characters get killed because the monsters that want them dead are very, very smart and use critical thinking to outwit their prey. Sigourney Weaver as Ripley helps add a lot of credibility to both films because she's fantastic.

I saw *Aliens* first (I didn't see *Alien* until much later), on TV when I was about 9-years old or so. At the time I thought it was just the coolest thing. I don't think my excitement over the 21 years since I first saw it has ever dulled. I still think it's as cool now as I did then. And *Alien* is one of those movies you watch and just absorb and within the first twenty minutes you know you're watching something very, very special, unlike anything you've ever seen before.

Alien Runtime: 117 minutes.

Aliens Runtime: 137 minutes.

Amélie
(2001)

Jean-Pierre Jeunet's *Amélie* is like taking a two-hour-long vacation from all of your problems. It's a movie so pure in its fantastical vision of the world that it never has time to get caught up in cynicism or irony. Even when it touches upon real-life tragedy like the death of Princess Diana, it doesn't linger on the death or revel in the worldwide depression that the event caused, it simply fast forwards to the moment of collective healing and moving on.

Amélie, played by Audrey Tautou, is a girl who views life differently than most other people. She stands atop a high peak in Paris and ponders how many couples, at that very moment, are experiencing an orgasm. It's these silly little moments that earned the movie an R-rating in America, despite there being absolutely no violence to speak of—it's the idea of sex that kept it from being considered "family friendly." The rest of the movie, in how it views the world with such optimism, is so very childlike in its innocence. And the scene itself, with a montage of orgasms, is played for a laugh.

On the night of the death of Princess Diana, Amélie finds a box in a wall in her apartment, hidden for decades, that had belonged to a young child and filled with his favorite items. Arduously, and after many dead-ends, she finally discovers the original owner of the box, now a middle-aged man. Seeing the absolute joy she brings to his life in this moment, she decides to dedicate her life to making others happy.

She does find some time for revenge, though. The revenge she gets on people who have wronged her, or she has seen wrong others, is never mean-spirited. It would be out-of-place in a movie like this to have her seeking justice in malicious ways. Instead, it's always funny. Unplug the TV at the moment when a soccer game is at its most exciting; replace someone's slippers with a smaller pair.

A movie like *Amélie* can make you fall in love. In love with the character, in love with the setting (the always photogenic and lovely

Paris), with the very specific way it was shot in lush golds and vibrant greens and saturated, almost too-black blacks. And the score. *Amélie* has one of the very best musical scores that has ever been recorded for any movie. It's among the ranks of John Williams or Bernard Hermann, so it's surprising that Yann Tiersen hasn't done more.

At its core, *Amélie* is a love story. It's a story about a girl who falls in love with a boy. Romantic films are usually so... bland. Love is a wonderful thing, but the movies reduce the emotion of love to basic story beats: The couple meets, they dislike each other, they begin to understand each other, they fall in love, they fall out of love, and then the story ends with them back in love again. *Amélie* never does that. There is difficulty in getting the two together at the end, but what good would a story be if there wasn't a struggle? There's never any contrived moment where everything hinges on one disagreement between the two. Instead, their difficulty in getting together is in Amélie's own insecurity in herself. She can help a blind man see a street, but she can't tell someone she's attracted to who she is, because she's deathly afraid of rejection. She's as afraid of being rejected as she is with being alone. Aren't we all?

Amélie is filled with brilliant little touches that are too many to count. There will be a moment where the film pauses to inform us that a cat enjoys overhearing children's stories. The moment is nearly subliminal, lasting only a few seconds, but these moments are important enough to the director that he shot it (which includes tedious-enough work that it would be understandable to dismiss it) and included it in the final version of the film. Every little moment like that matters, like it's a smaller piece of a larger picture, and without that little touch, the film would have felt incomplete. It's a cliché to refer to anything as being a "rich tapestry" but that's exactly what *Amélie* is, and without moments like the cat overhearing a story, a man popping bubble wrap as a sweet release or a child pointing and laughing at a dog that's watching a chicken roast, it wouldn't give us the insight into the world that we're experiencing along with the main character.

Runtime: 115 minutes.

American Beauty
(1999)

Back in the day—and even up to today, now that I think about it—I used to have what I would call "sleepy-time movies." These movies had to be on tape; there was something about the hum of the VCR that worked as a sedative on sleepless nights. And the movie I chose had to be familiar. It didn't need to be a "comforting" movie in the traditional sense. It just needed to be good, familiar and something personal to me.

American Beauty was one of my first sleepy-time movies. If I couldn't get to sleep, I'd pop it into the VCR and I'd eventually find my eyelids getting heavy.

In recent years, *American Beauty* gets dismissed because it hasn't aged well, whatever that means, lumped in with movies that have undeservedly won Best Picture at the Oscars. I'm not sure if it was the best film of 1999, because how do you quantify such a thing, but it's definitely a product of its time. It's very much a late-90s movie, where it seemed to be trying to say something profound, but that profound statement (that the yuppie, suburban lifestyle and pursuit of the American Dream in the name of greed is hollow and empty; that just underneath that happy exterior is a very, very dysfunctional *interior* if your life is based around superficiality and not genuine emotion) isn't particularly deep. I mean, we all know this. For some reason people keep making this mistake as time goes on, but fundamentally, we all know this and *American Beauty* wasn't particularly breaking new ground in its social commentary. But, so what?

It tells a simple story (thankfully leaving a framing device set in a courtroom on the cutting room floor) with confidence, and its pros far more than outweigh the cons. For every con, you've got one of Kevin Spacey's best performances, Annette Bening killing it as the unhappy wife, a great score by Thomas Newman, Conrad Hall's unbelievable cinematography and Elliott Smith covering the Beatles.

Echoing William Holden's narration in *Sunset Boulevard*, Lester Burnham (Kevin Spacey) is narrating *American Beauty* from beyond the grave. He is dead, and the story begins with the events leading up to

his death. He introduces us to his life, where his only real moments of satisfaction are when he jerks off in the shower in the morning. He has a wife named Carolyn (Annette Bening) who hasn't loved him in years. Their daughter Jane (Thora Birch), is sick to death of their fighting, and she's sick of herself and the way she looks, placing so much angst upon herself that she wants to save up enough money to augment herself.

A family maybe even more fucked up than the Burnhams moves in next door. Paterfamilias Colonel Fitts (Chris Cooper) is a homophobic, closeted military man with violent tendencies. Wife Barbara (Allison Janney) looks too scared to ever speak her mind. Son Ricky (Wes Bentley) is in love with Jane and attempts to woo her heart with grand romantic gestures that would be welcome in a romantic comedy, but here look like the makings of a serial killer.

After getting high with Ricky, Lester sees Ricky quit his job rather than suffer the indignity of being someone's whipping boy. Lester then has some profound realizations about himself. Namely, that he's miserable and that he believes his lusting after a teenage girl might be the cure to all of his problems. This realization, coupled with general unhappiness in his own skin and a midlife crisis, gives him the courage (or insanity; both are acceptable words here) to quit his job, blackmail his former employer into a settlement, and to work out to become attractive enough to have sex with a minor.

American Beauty is a dark movie with enough humor to elevate itself from simply wallowing in misery. It's a movie that follows in the tradition of movies like *Happiness* that show us fucked-up slices of life but don't cast harsh judgment on the characters. Lester is a pervert, but he's not an irredeemable sicko. He's a guy next door that just desperately needs real human contact to ground him in reality to tell him that he's behaving inappropriately, but he's isolated in his suburban lifestyle from anything even coming close to a real friendship. The closest friend he probably has is Ricky, his teenaged, pot-dealing, next-door neighbor.

At the end of the day, *American Beauty* has a very simple message: Happiness is more important than money. That might seem like a no-brainer, but that message, in all its simplicity, seems to get lost on a lot of people, even today. You need to work hard and save your money for

a house, you need to have your dream house, you need a new car, you need the best of everything, and you should go into debt for it because that's how the economy works. Get married, have children, and tell your children that *they* need to buy a house, a dream house, and buy the best of everything. It's this continual cycle of bullshit that values *things* over anything else. And very little has changed since 1999 when *American Beauty* was first released. So, did *American Beauty* really age so poorly, or has America just decided to reject its message and continue living in isolated bubbles?

Runtime: 120 minutes.

American Movie
(1999)

I loved *American Movie* from the very first time I saw it—it was one of those real instant attraction kind of things. But I once saw this movie under the influence of hallucinogenic drugs, and now I feel like I have a spiritual connection with it.

American Movie tells the story of Mark Borchardt, an eternal dreamer who one day wants to make a movie. He wants to tell a personal story set in the Midwest that explores America. No one takes his dream seriously. By looking at him, with his thick glasses, thin, tall frame and mullet haircut, you'd think he was pulling your leg. But if you listen to him, if you listen to the way that he talks about film, it's clear that he actually does know what he's talking about. He's technically proficient in filmmaking, he knows how to light a shot, record sound, slate for editing—it's just that making movies is really, really expensive and he just doesn't have the money that it takes in order to get a production off the ground. And it's seemingly impossible for him to get outside funding because no one who controls the purse strings is particularly interested in financing a film which sounds like a sure flop (a personal almost-biopic about alcoholism and the American Dream).

Mark's longtime passion has been to make the film *Northwestern*, which is what the documentary *American Movie* was intended to cover

the production of. Partway through the pre-production, Mark realizes that it's not possible for him to ever finish *Northwestern* with the budget that he has, so he decides to finish filming a short horror film he began years ago called *Coven* (pronounced COE-ven because coven sounds like oven, man) as a means of gathering a budget in order to finally make *Northwestern*.

Nothing is ever easy for Mark. The production of *Coven* is troubled every step of the way by budgetary problems, Mark's own financial issues and just general bad luck sometimes. This is one of those situations where if this were a fictional movie, I'd write in "but he never lost hope." But he *does* lose hope. It's impossible not to lose hope in his situation. He spirals into depression several times, he drinks severely and he snaps at his family and his friends at big holiday gatherings.

American Movie is such a perfect and apt title of its subject. *American Movie* is probably the most perfect representation of the American Dream I've ever seen committed to film. Mark's quest for success is analyzed—he even wonders aloud why he should be successful while others are not, but even he admits that he can't answer that. One of his brothers, in sheer cynicism, says that perhaps he's just best suited to be working in a factory or something. But success, whether it ever comes or not, isn't the most important part of the story. It's where Mark has carved out his existence, with his friends and family and all of the people who care about him. The American Dream isn't measured solely by financial success, it's about your success as a person in this country, in the life you've forged for yourself.

If life were perfect, everyone would have a sidekick as loyal as Mark's friend Mike Schank. Mike is a scene-stealer. He's long since been burnt out by drug use, he speaks in a slow, thick Midwesterner's accent, and he's a brilliant musician who can effortlessly play Beethoven on a guitar while blindfolded. He even provides the acoustic score for the final product of *American Movie*.

A perfect movie, I feel, touches on every feeling in the human spectrum of emotion. *American Movie* does that. It's hilarious—one of the funniest movies you'll probably ever see. It's sad, in those final moments with Uncle Bill reciting one of his poems for Mark. It's

thrilling when Mark is racing against time to finish editing *Coven*. *American Movie* truly does have everything, something for everyone. It even has time for a little romance.

In the end, when we see *Coven* premiere in front of a crowd of people in an actual movie theater, projected onto a large silver screen, there's such a feeling of pride I have for Mark. I loved seeing him succeed. And after that moment of success, he's ready to push on to the next thing—possibly *Northwestern*, though it's been over 20 years since *American Movie* was filmed and *Northwestern* is yet to have been filmed, sadly. Mark did triumph at the end of the movie. Making a movie, especially one shot on film, is incredibly hard work, and by god he did it, and he can wear that success as a badge of honor.

Runtime: 104 minutes.

An American Werewolf in London
(1981)

Comedy-horror is a tricky genre to get right. There's a delicate balancing act that's required in order to give love to both the comedy elements and the twisted, macabre elements of horror. If you fail, you have a movie that's neither funny, nor shocking. You just have this mess of a movie that has no real audience in mind. Probably the easiest way to succeed at a comedy-horror movie is to focus on the humor and leave the horrific elements in the background, almost as window-dressing. The real risk is in the horror—you don't want to have some unfunny, tasteless, bloody flick that wants recognition just by being edgy.

An American Werewolf in London strikes possibly *the* best balance between horror and comedy of any movie out there. When it's scary, oh god is it scary. When it's funny, its humor on the level of some of the best comedies ever made.

John Landis is an uneven director, but when he's on, he… is… *on*. *An American Werewolf in London* is certainly his masterpiece and reflects all of his strengths and best assets that he has as a filmmaker. On a

technical level, it's amazing—that transformation sequence, in the days before CGI, is literally breathtaking.

The film begins in the English countryside where American college students David (David Naughton) and Jack (Griffin Dunne) are just getting out of a truck after being given a lift to the country, where they plan to backpack their way through the scenery. They stop for a drink, get the usual warnings that people always get in horror movies, ignore the warnings as characters in horror movies are wont to do and are viciously attacked in the moonlight by an animal that is shot down and killed, but when the corpse is revealed, it's in the shape of a man.

David recovers from his injuries of the attack in a hospital, but soon he begins to see visions of his dead friend Jack, who tells him that they were attacked by a werewolf, and they only way to end the curse is for David to kill himself. If he continues to live, on the full moon he will kill, and the people that he kills will be stuck in limbo, walking the earth in spirit form, unable to pass into the afterlife.

"Have you ever tried talking to a corpse?" Jack pleads to David. "It's boring! I'm lonely!"

Sure enough, on the full moon, David becomes a werewolf and terrorizes the city, stalking and claiming victims in violent attacks, cloaked by the shadows of the night. And his victims plead with him to end his own life, for his sake, for their sake, and for the sake of everyone in London who's at risk for being killed by him when in a lycanthropic state.

One of the best scenes in the film encapsulates everything that's perfect about it: A man, underground in the subway station, is stalked and eventually killed by David in his werewolf form. As the man runs away from the monster, we only ever see shots from the monster's perspective or as the man looks over his shoulder we catch the quickest glimpses of a beast, covered in hair, just edging visibility. The movie shows a tremendous amount of restraint by cutting before we ever actually see anything. In the deleted scenes on the DVD, though, you can see that they actually had filmed and intended for the monster to be very visible during this scene. But, what was scarier was what *wasn't* seen, so those shots of the werewolf in full view were left

out. In all the rigging, lighting and tedious work that goes into filming, they still felt it didn't tonally mesh with the rest of the movie and cut it out of the final product. That right there explains the difference in how movies were made then and how they're made now. I still think the Hollywood system puts out plenty of great movies every year, but I feel like there's been an ideological shift in the blockbuster. There's no way there would be a big budget movie destined to be a hit that would leave such an expensive bit of film on the floor. Instead, that werewolf would be front and center in a dozen more shots.

An American Werewolf in London is a bonafide classic. It's a movie that ages like fine wine. Its jokes get funnier. Its scares get scarier. Its callouts to other classics and film-buff references just become richer. It's a movie to watch with the lights dimmed and the volume up to fully experience every second of it.

Runtime: 97 minutes.

Batman Returns
(1992)

Batman Returns might not be very good as a Batman movie, because it violates many of the central rules that makes Batman who he is at his very core, but it's one hell of a Tim Burton movie.

I also like 1989's *Batman*, but its sequel, *Batman Returns*, is something that speaks to me on a very personal level, and I feel like it subliminally implanted in me the essentials of German Expressionism and Filmmaking 101. Tim Burton seemed to have taken every complaint he had about the first movie and doubled down on it. What we're left with is this dark, depressing Christmas movie about alienation, freaks and shadows crawling up walls in dimly-lit gothic buildings and sewers. In fact, I think it gives *Die Hard* a run for its money in terms of all-time best nontraditional Christmas movies. Does *Die Hard* have Danny DeVito biting someone on the nose, causing a jet a blood to spray everywhere? No, it doesn't.

The movie begins in the past, giving us a prologue on the birth and tragic infancy of the villain the Penguin (Danny DeVito). He's a mutated baby with flippers for hands, prone to violence and his parents can't handle it, so they throw his carriage off a bridge into the icy water below. Their attempted infanticide fails and he grows up in the sewer amongst penguins from an abandoned zoo, where he plots his revenge for decades.

At the time, his plot seemed ludicrous: He stages a very, very obvious rescue of the mayor's child from his own bandits and uses that goodwill to run for mayor, where he'll control the city under the puppetry of evil businessman Max Shreck (Christopher Walken), whose name is an obvious homage to the actor who played the vampire in *Nosferatu*—the homage here makes sense more than in any other Batman movie, because this isn't a superhero flick, it's a straight-up monster movie.

In hindsight, the only thing ludicrous about the Penguin's plot is that when audio of him saying he's going to play the city like a harp from hell, the people of the city are disgusted and he's once again ostracized to the sewer. Turns out, that wouldn't make much of a difference in real life. You can brag about sexual assault and become the fucking *president*.

Also joining the band of misfits and villainy is Catwoman, aka Selina Kyle (played by Michelle Pfeiffer). She's pushed out of a window, falls through about thirty canopies that slow her fall just enough that she doesn't quite die when she hits the pillowy snow below. She's seemingly brought back to life when feral cats begin to gnaw on her fingers.

And then there's Batman, who's just as fucked up as any of them, isolated from the rest of Gotham City in a mansion that overlooks them, like Dracula's castle overlooking *Transylvania*. True to the mythos of Batman, he's technically the good guy, even though everyone—law enforcement included—is terrified of the guy. He barely speaks a word, even to those he saves, and vanishes in the night.

Batman Returns isn't entirely faithful to the character. This is more like if Batman wound up somehow in a fairy tale on LSD. The plot of the Penguin's that he must foil involves kidnapping and killing the children of Gotham and then... something about trained penguins with missile launcher helmets on their heads in order to wreak havoc and bring about massive destruction and untold death. Let's be honest, it's all a bit silly, but seriously who has time to care in a movie like this? Danny Elfman's music has never been better; I'd go so far as to say this, along with *Edward Scissorhands*, are tied for his very best scores. The set design is completely unparalleled; very few movies look this damn good. And the performances... I was born in 1986, so my Batman of choice is Michael Keaton. To me, he *is* Batman. I think Christian Bale did a very good job, but Keaton is just where my loyalty lies, partially because that's who I grew up with, and partially because he made that role his own. Michelle Pfeiffer is a good actress, but she's never, ever been better than she is as Catwoman. She steals every scene she's in; she also stole my heart. Michelle Pfeiffer as Catwoman was the first crush I can recall having on a woman. And Danny DeVito as the Penguin was the stuff nightmares are made of. Who would have thought he would have taken the disgusting character even further as Frank Reynolds in *It's Always Sunny*?

Setting the film around Christmastime doesn't feel like gimmickry here. Christmas enhances the ugliness of the movie. It helps us feel how lonesome the central players are. Everyone is alone, struggling with some major psychosis, and they all externalize it through fearsome costumes and violence. Blood spills and meanwhile the snow falls and the neon holiday lights keep twinkling.

Runtime: 130 minutes.

Beetlejuice (1988)

This is it. This is *the* first movie I have any memory of watching. I must have been, what, three years old at the time? My mom used to manage a video store when I was a kid and she would take me along to

work sometimes, set up a movie for me and hit play while she was ringing up customers. To make sure I was actually learning something, she would give me little pop quizzes. The only exchange I really remember was my mom asking me, "Who directed *Beetlejuice*?"

I said, "Tim Burton."

She then asked me, "Who was the star of *Beetlejuice*?"

"Michael Keaton."

"And what other movie did they make together?"

"*Batman*."

And thus began a lifelong obsession. *Beetlejuice* is the first movie I can remember watching and *Batman Returns* is the first movie I can remember really anticipating and literally counting down the days until I could see it (days was too vague a term, so I referred to the amount of time I had to wait as "wake ups"; as in I only have to wake up three more times).

When I look back and re-watch *Beetlejuice*, it's weird that the movie was so heavily marketed toward kids… I mean there was even a short-lived animated series that followed in the 90s. There was a slew of toys based on the character you could buy. Costumes. You name it, there was a product. The movie itself, though, isn't really kid-friendly material: There's the F-word in there somewhere, whorehouses, references to suicide and dead people galore. It's a macabre film through and through. And that's why I love it. Every kid should develop an early obsession with death, and *Beetlejuice* is a great way to kick-start that obsession. It makes being dead look simultaneously awful and the greatest thing in the whole world. You can fly, you can rip off your own head, you can possess people and make them dance like idiots. This and *Ghost Dad* made me wish I was dead, that I could be a superhero whose power was that I was a ghost.

The movie begins with young, married couple Adam (Alec Baldwin) and Barbara (Geena Davis) very much in love with each other. They tragically die in a car accident and find that they are confined back to the house, unable to leave—except to visit the bureaucratic purgatory

to meet with a caseworker to discuss their afterlife. Unfortunately for Adam and Barbara, an annoying yuppie family (mother and father played by Jeffrey Jones and Catherine O'Hara; daughter Lydia is played by Winona Ryder) is moving into and destroying their country dream house, making it their own tacky little dwelling. They figure if they have to literally haunt their old house, they might as well take the whole being ghosts thing to the next logical evolution and actively try to scare the new inhabitants out.

The problem is, they're bad at being ghosts. They're bad at being scary. After all, they're just a nice, dorky couple that died too young. So, they enlist the help of "bio-exorcist" Beetlejuice (Michael Keaton) to scare the new family out of their house. Making a deal with a character as shady as Beetlejuice is never a good idea, as he starts to unravel his own fiendish plans for the family.

Beetlejuice is one of the Tim Burton-iest Tim Burton films, from the time when he was young and hungry and eager to prove himself as a unique visionary and storyteller. It's just amazing to look at. The color palette of the whole movie is an awesome experience, in all the blacks and whites and reds and greens. And the character of Lydia is up there as one of his best characters, just someone everyone can relate to in a weird way. She calls herself, "strange and unusual" and everyone, especially a teenager, feels more awkward and isolated from society than they ever really are. She has this outward appearance of being above it all, of being way too cool to give a shit, but all she really wants is a friend, and she finds a special friendship that she actually cherishes with the ghostly previous inhabitants of the house.

Movies like *Beetlejuice* are sort of painful, in a way… reminding us of a time when Tim Burton was one of the best, most unique filmmakers out there. Where when it was announced that he had a new movie coming out, the reaction was to get excited. Tim Burton isn't the literal *worst* director today, but his early body of work is fantastic stuff, and *Beetlejuice* is something that couldn't have been made by anyone else. It needs that gothic look only he can pull off. It needs his eye for casting. It needs his twisted sense of humor. And, frankly, I think modern movies as a whole are missing out on that.

Runtime: 92 minutes.

Being John Malkovich
(1999)

1999 was a hell of a year for movies. Sometimes you get these kinds of years where every month you're getting some new classic. What a fantastic year for movie-going audiences that you get to decide between so much good shit like *American Beauty*, *Three Kings*, *The Matrix*, *Fight Club*, *Office Space* and the mind-fuck movie that is *Being John Malkovich*.

Being John Malkovich is one of those plots that sounds absurd just for the sake of being absurd, but when you see it, it's the real deal. It's like the difference between someone who fabricates this persona of quirkiness versus a genuine weirdo. *Being John Malkovich* is something that only the awesome and twisted mind of Charlie Kaufman could come up with and execute in a way that's easy to understand and is just as funny as it is creative.

Craig Schwartz (John Cusack) is an out-of-work puppeteer. He's depressed. He feels worthless. He gets a job at an office after being urged to get out of the house by his wife Lotte (Cameron Diaz) who assures him he'll feel better if he just gets to work and feels productive. The office he works at is in a building on Floor 7 ½, which is exactly what it sounds like... office space with incredibly low ceilings and everyone must navigate the hallways hunched over.

Filing papers one day—which Craig happens to be inhumanly good at due to his skills as a puppeteer—he drops a folder behind a cabinet and finds a strange crawlspace. Entering the crawlspace, he finds it to actually be a portal into the mind of the actor John Malkovich. For a few minutes at a time, whoever enters the portal will experience the world through John Malkovich's eyes... see what he sees, hear what he hears, smell what he smells. When the time is up, the person who entered the portal is spit out into a ditch near the New Jersey turnpike. When Craig explains this to his coworker Maxine (Catherine Keener), whom he desperately wants to have sex with, the wheels in her head start spinning and they begin charging admission to the portal. $200 a pop and you, too, could experience life as John Malkovich.

Complications ensue, as complications tend to do in movies, when Craig's attraction to Maxine is completely rebuffed. Maxine also falls for Lotte, Craig's wife, but *only* when she's in the head of John Malkovich—there's something about the eyes of a woman looking out from behind the eyes of Malkovich. And then Craig learns how to control Malkovich, through his skills as a puppeteer, a natural manipulator.

Just about everything about *Being John Malkovich* works. It's such a bizarre idea for a movie, but the film explains the plot and portal so earnestly that we never really have an opportunity to register just how bizarre it really is. And so much of the movie plays like a sitcom, like Craig's boss (played by Orson Bean), who knows a lot more about the tunnel into John Malkovich's head than he lets on, but is convinced that he has a terrible speech impediment because his assistant with an apparent hearing problem won't admit she's the one who has a problem with understanding, convincing him it's a problem of being misunderstood. And in the reality of this movie, for some reason, John Malkovich is best friends with Charlie Sheen, of all people.

I love movies that create their own reality and convince the audience, effectively, that what they're seeing is, in fact, real. A movie's job, essentially, is to earn your suspension of disbelief. One movie can have a werewolf devouring human flesh and be more realistic than a badly-written movie with tangible human emotions if those moments aren't earned by the filmmakers.

Spike Jonze and Charlie Kaufman only ever made two movies together: This and *Adaptation.* They're an amazing pairing. I've liked Kaufman's work elsewhere (particularly *Eternal Sunshine of the Spotless Mind*), and Spike Jonze is a good director in his own right, but their pairing together is something magical, something on a par with Paul Schrader penning scripts for Martin Scorsese. Maybe it's good to leave the relationship at two and done, with both films being absolutely perfect, joyous celebrations of creativity, and risk having that legacy tarnished by a third, lesser entry and creating an imperfect trilogy. I still cross my fingers and toes hoping that they'll make something totally unexpected together again, something as inventive and fantastic as *Being John Malkovich*.

Runtime: 112 minutes.

The Big Lebowski
(1998)

There's nothing sweeter than making a movie that's ahead of its time. To see it go from curious, confused shrugs as a collective reaction, to a massive cult following, and then as a regarded, modern-day classic. That's the trajectory of *The Big Lebowski*. When it first came out, those who loved it *loved* it, while many critics didn't know precisely what to make of it. It never really found an audience at the time, either. With a budget of $15 million, it made about $17 million at the box office, which still isn't quite a profit given the additional costs for release and marketing, but not a massive flop, either. Just… a sort of ho-hum reaction.

In the years that followed, *The Big Lebowski* spread through great word of mouth on tape and on DVD. Years later is when people began quoting it ("Shut the fuck up, Donny!"). It started attracting loyal viewers who had seen it multiple times. Then there were festivals, gatherings, where people could amass together and share their love of this picture.

Today, *The Big Lebowski* is just one of those top-tier comedies. If you look at any given list of commonly-regarded "best comedies" you can expect *The Big Lebowski* to be on that list.

The appeal of *The Big Lebowski* isn't exactly a mystery, either. In some way, "The Dude" (Jeff Bridges), represents all of us, as who we are as people. He represents the Zen-like attitude we all wish we could attain—the Zen-like attitude he himself thinks he has, but he doesn't—and the absolute panic-stricken inability to deal with something as severe as the situation that he finds himself in.

Basically the plot, as described by the Coen brothers, is if you had a very typical film noir or some Raymond Chandler-esque plot, and placed a slacker stoner in the midst of it just to see what would happen. One night, after a night of bowling, as the Dude does in his

free time (although he is never once shown throwing a ball down a lane in the movie), he is attacked in his home by some thugs who have mistaken him for another man bearing the same name, a millionaire who owes money all over town. Before they leave, they piss on his beloved rug that really tied the room together.

Following some bad advice from his friend and partner in bowling, Walter (John Goodman, in one of his best roles ever), a damaged Vietnam vet with a penchant for explosions of rage, the Dude confronts the other man named Jeffrey Lebowski (the titular *big Lebowski*), looking for damages to cover the cost of the rug. This request is denied, so he steals another rug out of the house on his way out.

This ill-advised meeting sets forth a chain reaction and a series of events that involves kidnapping, nihilism, possible castration, pornographers looking to collect on debts owed and a couple acid flashbacks for good measure.

The Big Lebowski is also quintessentially a Los Angeles film. A plot like this wouldn't work anywhere else. It needs to have the city surrounding this sort of lunacy, because a story like this just makes sense in a city like LA. LA is the kind of city where someone like the Dude could actually be friends with a guy like Walter, or a guy like Donny (played by a perpetually-interrupted Steve Buscemi) and where they could all get into a sticky situation with millions of dollars being scammed and lost in some complex kidnapping-ransom plot that, in the end, doesn't amount to anything at all. When all is said and done, not a whole lot ever really happened. But, that's appropriate for this movie. It's part of its charm, that what seemed like a matter of life and death was, in actuality, a series of miscommunications and lies blown out of proportion.

If I'm going to be honest, I didn't really like *The Big Lebowski* a whole lot when I first saw it. I loved the Coen brothers, and pretty much the entire cast of the film, so I saw it and expected to fall in love immediately. Maybe my expectations were too high, but at the end of it, I wasn't impressed. But I kept thinking about it and thinking about it. Lines of dialogue from the film kept nagging at me. So, I watched it again. And then I adored it. And then I watched it *again* and the

brilliance of the narrative became more and more apparent. After watching it probably literally 50 times or so throughout the years, I'm truly in love with *The Big Lebowski*. It's an incredible movie on so many levels. It's one of the all-time great comedies and the Dude is one of the most unique characters in film (even if he is kinda-sorta playing a real-life guy). I probably watch it once a year and howl with laughter as though it were the first time I'd watched something so funny. It's one of those movies that only gets better with repeat viewings.

Runtime: 117 minutes.

The Blair Witch Project
(1999)

The Blair Witch Project is the first movie I can recall in my life that was immensely popular and, as a result, became very popular to hate. It was the first movie where I could feel the palpable pushback and backlash against its success and overhype. The reasons were usually sort of samey: The camera shakes too much, it made the viewer feel nauseous, nothing happens, it's boring, it's this, it's that, it's whatever. Most of all, the people who hated it just didn't think it was scary.

What people find scary is going to vary from person to person, so if *The Blair Witch Project* doesn't do it for you, it's not going to do it for you. But for those who enjoy the movie as much as I do, there's a lot there for the viewer, and to this day it blows my mind that the movie was as successful as it was without ever having to say anything definitively about the mystery of the witch.

The Blair Witch Project was a *sensation* when it was released. It's hard to convey just how big of a deal this movie was when it came out. It was the movie that sort of started viral internet marketing. Artisan, the studio who released *The Blair Witch Project*, just treated the found-footage style that we take for granted today as if it really was footage that police had recovered in the woods. They had the three actors at the center of the film lay low and pretend they were missing. They had

a special on the sci-fi channel that created an entire mythos for the Blair Witch.

No one really *believed* that the movie was real, but it was fun to imagine. And *The Blair Witch Project* wasn't the first movie to pretend that its pseudo-documentary stylings were based in fact (*Cannibal Holocaust* did that two decades prior, but obviously wasn't a huge box-office smash given its controversial-as-hell content including rape, torture and real animal killings), but it was just the right time and the right place. Everything worked together to form the perfect storm.

Unlike the slew of imitators and homages that have followed in *The Blair Witch Project*'s wake, the found-footage format for the movie is actually integral to the story itself. It's not found-footage just for the sake of breaking the fourth wall with immunity, it's a specific narrative design to put us directly in the perspective of the main characters. We're with them every step of the way, seeing exactly what they see. And what they see lays somewhere deep within the shadows of the woods. The unfinished documentary format that devolves into madness works much better than the usual found-footage style where someone seems to just pick up a camera for no real reason and never puts it down, no matter what.

The plot, by now, is familiar: Heather, Josh and Michael (named after the real-life actors who played the roles), are making a documentary about the Blair Witch, a legendary evil that haunts the woods of Maryland. They interview locals who fill in some exposition about the witch's history, some of whom may be mentally ill, others who may be pulling the kids' legs. Some might be sincere.

Once they venture into the woods, they find that they have become lost. Trying to keep up their spirits up at first, they soon get on each other's nerves and jump down each other's throats. Whether supernatural or not, something is clearly out there in the forest with them and it doesn't like them.

Ambiguity is *The Blair Witch Project*'s best asset. Venturing into the domain of a witch and seeing it, in all its evil glory, just isn't scary. It might be for about ten seconds. It might be good for a jump or a jolt, or momentary chills, but it isn't something to linger on in our hearts.

What *is* scary, on a basic and very profound level, is the unknown. Being so horribly lost that you accept the fact that the land surrounding you is going to be the place where you die. The shadows. The thing that goes bump in the night. Giving a face to thing removes the absolute mystery that its existence is shrouded in. And when Heather says directly to the camera, "I'm scared to close my eyes, I'm scared to open them," it's absolutely chilling.

Whether or not there even was a witch in *The Blair Witch Project* is irrelevant. The final answer to that question is up to the viewer and the script and direction by Daniel Myrick and Eduardo Sánchez makes that the entire point of the film. You can either believe that Heather, Josh and Michael were never really *lost* in the woods, but were being psychologically and emotionally manipulated by dark magic until they were so beaten down and weak with fear that they finally succumbed to it. Or, you can believe that these kids from the city who didn't know a whole lot about wilderness survival got lost in the woods and locals from town, with malicious intent, fucked with them and slowly drove them crazy before killing them. If they even died at all. Whatever happens that isn't explicitly stated is up to the viewer to decide.

No one is inherently afraid of witches, ghouls, goblins or monsters. What we're all afraid of is much more primal or instinctual and *The Blair Witch Project* taps into that fear. When Heather says that nowadays it's impossible to get lost in the woods, and they do just that, it's such a great criticism of bravado, of being young and dumb and too confident.

After some more time, after the buzz and the perhaps even over-hype of this movie is forgotten and becomes legend, I think it will be regarded as a classic in the same vain as *Halloween*, *The Texas Chainsaw Massacre* and even, yes... *Psycho*; I do think that the way it builds and builds into such hysterical fear is something to be considered, without exaggeration, Hitchcockian. I think it's that good, the way it layers character development with completely unexplained terror. It's a perfect movie to watch in October, when the wind has a chilling bite to the air and the falling leaves are scuttling in the streets.

Runtime: 88 minutes.

Blood Simple ***(1984)***

Let me give you some backstory on how I first came to watch *Blood Simple*, the Coen brothers' first movie. I had already seen *Fargo* at this point, as well as *The Hudsucker Proxy*, so I knew that the Coen brothers were a big deal. I was 13 years old at the time I had first heard of *Blood Simple*. I was watching the PBS show *American Masters*, and this episode had a focus on the independent film boom that occurred in the 80s and 90s. It chronicled the whole movement, but what I was drawn to were the images I saw for one of the highlighted films of the era, *Blood Simple*: A man, critically wounded, crawling down the road while another man follows, dragging a shovel. Something inside me clicked and I said, "I have *got* to see this movie."

At the time, living in a very small town, the closest place to rent a movie that might be harder to find was either at Blockbuster or Hollywood Video about 45 minutes away, down a winding country road to the nearest "big city." Neither Blockbuster, nor Hollywood Video had it.

You know who did have it, though? The Internet! My parents weren't thrilled with the idea of letting me use their credit card to buy the movie online—the internet was still scary at the time, with pirates lurking around every corner to steal your credit information. So, I kind of forgot about the movie for a while and how much I wanted to see it.

And then, one day, while eating lunch with my friends I saw one of my buddies look at a bottle cap and wonder aloud, "Huh, I wonder how much this cap is worth?"

I asked him what he meant and he explained to me that if you plugged in these codes found on the bottom of Sprite bottle caps, each code was worth a certain amount of money. You could create a login and type in these codes and save up an amount of money for things you could redeem online. I was curious, so I created an account and

browsed their partnership with Amazon.com and—egads!—I found out you could fucking buy *Blood Simple*!

So, I got to work, using the school library computer for code redemption. I was an industrious little fella during all this shit. Every soda I bought, it was Sprite. If I saw my friends drinking Sprite, I'd ask for their caps. If I saw an empty Sprite bottle sitting alone on a table, I'd swipe the cap. I wasn't above digging in the trash a couple times. On one occasion I remember some guys came up to me and asked if I was "the Sprite dude" and I said yes, so they handed me a couple fistfuls of Sprite caps.

Most caps were worth about ten cents. Sometimes you'd get lucky and they'd be worth *fifty* cents. I got really lucky once and found one that was worth something like $1.25.

This whole thing was bullshit. It fucking sucked. I'd go to redeem the points and then I'd need another three or four bucks or whatever for shipping, and I'd have to go out and drink more goddamned Sprite or collect more bottle caps. When I finally, finally had enough money to cover the cost of shipping *and* the price of the movie I moved it into my shopping cart, hit redeem points and saw an error message pop up. I refreshed. *No, no no!* The movie was "temporarily" out of stock. The movie was unavailable, and my points were gone.

I went to Sprite. I told them what had happened. They said they were sorry, but the error was on Amazon's side. I went to Amazon, and they told me it was Sprite's codes. I went back to Sprite. I went back to Amazon. They both promised to touch base with each other and get back to me. 17 years later, they never, ever have.

I saved up enough money and just told my parents, "Look, I tried to do it on my own without a debit or credit card, and I couldn't. Here's money. Can you please just buy it for me?" They agreed, but when went to purchase, all copies were sold out. Even used copies.

"Turns out they're putting out a special edition that'll be out next year," My mom told me.

When that special edition came out, you better fucking *believe* my parents bought it for me. It came in the mail on a Saturday I had a

football game and I went to throw it on before the game. "I dunno," my dad said. "You might be too distracted by the game to fully enjoy the movie."

I think I said something like, "Oh, fuck football. I suck at it anyway. You don't know what I've gone through to watch this movie. I'm watching it! And if you're gonna stop me from watching it, you're gonna have to kill me!" And my dad backed out of the room, probably thinking I was an insane person.

Literally one month later, I found a copy of *Blood Simple* at a Goodwill for about $0.99.

Now, as for the movie... you might be wondering, with all this hype, could a movie such as *Blood Simple* possibly live up to those expectations? Indeed, it has. *Blood Simple* is the kind of film debut that every director wishes they had. When you have a film debut, the movies floating in the back of your mind are always *Reservoir Dogs*, *Eraserhead* and yes, *Blood Simple*.

The plot is classic noir: Abby (Frances McDormand) is cheating on her husband Marty (Dan Hedaya) with bartender Ray (John Getz). Marty can't get the image of them out of his head... the idea of being a cuckold. In an act of revenge, he hires Private Detective Loren Visser (M. Emmet Walsh) to kill the both of them. Visser, seeing an opportunity for eas*ier* money—nothing is completely easy—doctors photos of Abby and Ray to make it look like he killed them, collects the money and then kills Marty, pinning the crime on Abby and Ray, the still-alive couple.

What plays out is like *Diabolique* set in Texas. Abby still thinks Marty is alive, and Ray thinks Abby is the one who killed him. No one knows what really happened, except of course for Visser.

The finale of *Blood Simple* is one of the most perfect things I've ever seen. Setting the pieces and putting them into play in those final fifteen minutes or so is watching absolute perfection unfold on film. The image of light streaming out through bullet holes in the wall is a haunting, beautiful image. Carter Burwell's music transforming from piano tinkling in the beginning to the insane chants at the end. Everything about it is amazing.

Blood Simple isn't necessarily my favorite Coen brothers movie, or their very best, but in some ways, there are some aspects of greatness in this film that they've never topped. Hell, I would say that the roadside scene in *Fargo* involving the state trooper owes much to the roadside scene involving Ray and Marty here in *Blood Simple*. Sometimes when I see the Coens having fun on some bizarre, over-the-top semi-musical like *Hail, Caesar!* I wish they would get back to the basics and do something like this, with simple images being burned into our mind's eyes: The shovel dragging, the bullet holes, the flock of birds flying from a field...

Runtime: 99 minutes.

Boogie Nights
(1997)

1997 was an excellent year for movies set in Los Angeles. You had *L.A. Confidential*, *Jackie Brown* and *Boogie Nights*. Each one tells its own tale that's unique to the city. *L.A. Confidential* is about a Los Angeles that will never exist again. *Jackie Brown* is this sort of surprisingly sweet love story surrounded by double-and-triple-crosses and murder. And *Boogie Nights* is one of the very best movies about family there is, being at turns both laugh-out-loud, uproariously funny and just beyond depressing when it turns those dark corners.

Eddie Adams (Mark Wahlberg) becomes legendary porn star Dirk Diggler after being rejected by his real family and finds a surrogate one, under the fatherly guidance of adult film producer Jack Horner (Burt Reynolds). In the tradition of those "star shoots to the top" stories, Eddie lets his ego, and too many drugs, destroy his stardom, where he once again finds himself at the bottom.

Boogie Nights is one of those movies that could only be made in the 90s. I feel like everyone saw it on HBO thinking it was going to be a nudity-laden, corny romp like *Showgirls*, but was blown away by how deeply personal and overall really goddamn *good* it actually was. I think I was 11 or 12 when I first saw it and wasn't prepared for the emotional wallop it packs. I just knew Heather Graham got naked in it

and I wanted to see that. After that infamous New Year's Eve party, where the band of pornographers say goodbye to the 70s and hello to the 80s, everything changes. The movie seems to be divided in halves... the 70s representing the fun of stardom, the 80s representing the emptiness of fucking for money, fueled by cocaine and witnessing the shift in the industry from film and narrative to video and pure sex. When I saw it the first time, it fucked me up for a long time.

Everyone has a story to tell and no one is exactly happy with where they are in life. Jack has a dream of making real, actual movies. The ones people go to so they can jerk off, but after they clean themselves off they want to stay and see where the movie goes. Rollergirl (Heather Graham) wants to be seen as a human being, not just a sexual object. Amber Waves (Julianne Moore) wants to see her children again and she seduces her surrogate son, Dirk Diggler himself, by showing him affection by letting him ejaculate inside of her. Buck Swope (Don Cheadle) wants to own his own business, but has trouble being taken seriously by anyone to get a loan because of his history in the porn industry. Reed Rothchild (John C. Reilly, who steals every scene he's in) wants to be a magician.

Paul Thomas Anderson, who wrote and directed *Boogie Nights*, had seen his previous film *Hard 8* taken away from him by an overzealous studio and re-edited into something he barely recognized. So when he pitched *Boogie Nights* to New Line cinema, he was adamant that it was going to be three hours long and rated NC-17. New Line said that they loved the script, they loved his vision, but there were a few reasonable demands: That it *definitely* be rated R and that it only run at about two-and-a-half hours. Anderson agreed, the studio kept their word about limited involvement—leaving the ultimate vision to the director—and a masterpiece was created.

Boogie Nights has a great cast and Paul Thomas Anderson is a director who knows how to utilize a robust cast full of colorful characters. It's not one of those movies where you see star after star and the whole thing is just this giant spectacle to jam-pack as many names into one movie as possible. Everyone is cast perfectly into their roles. Mark Wahlberg has been in good movies since but he's never been better than he is as Dirk Diggler, the naïve boy from Torrance who basically

becomes a household name for having a huge dick. The scene where he's screaming at his mother, telling her that he's not stupid, that he's destined for greatness, is genuinely masterful acting.

Despite its subject matter, *Boogie Nights* seems to be the most mainstream movie Paul Thomas Anderson has ever made. It remains an accessible, mainstream work despite its lurid subject—the world of pornography. Later works in his filmography seem to do away with traditional narrative, but *Boogie Nights* is grounded in traditional plotting. And today, I think it remains his best film. As much as I enjoyed *The Master* and *There Will Be Blood*, *Boogie Nights* is something that speaks to me, something I want to casually revisit again and again. Underneath all the ugliness that occurs, there's a legitimate sentimentality to it. It's clear that Paul Thomas Anderson cares about his characters and cares about what happens to them, even when he's putting them through complete hell.

Runtime: 152 minutes.

Bram Stoker's Dracula (1992)

Bram Stoker's Dracula is a bizarre movie. Some of it is so well-made that it ranks legendarily high in terms of overall aesthetic appeal. The movie is goddamned gorgeous to look at. The effects, all achieved practically, are so complex and beautiful that you truly do believe that you're looking at something filmed in another world entirely when you're in the presence of the Count, as his shadow dances behind him with a life all its own. Some of the movie, though, is among the corniest stuff you're ever going to see. Anywhere. Anthony Hopkins and Gary Oldman appear to be the only actors who actually enjoy the scenery that they're chewing. Everyone else seems kind of confused about what kind of movie, exactly, Francis Ford Coppola seems to be directing. In the end... it all works out. The puzzled performances, the gorgeous sets, the over-the-top melodramatic tears of Dracula, they're all essential ingredients to the film. And it's amazing.

Francis Ford Coppola's film adaptation of *Dracula* remains overall pretty faithful to its original source material. He adds embellishments here and there, inserting scenes of violence and nudity in order to spice things up, but the basic story, and some of the framing device from the original novel, remain intact. Count Dracula (Gary Oldman, in such a great performance) renounces God when he is told that his wife who had committed suicide, thinking he was dead, will not go to Heaven, but will burn in the fires of Hell. She is reincarnated hundreds of years later as Mina Murray (Winona Ryder), engaged to be married to Jonathan Harker (Keanu Reeves). Dracula makes sure her fiancé is out of the way and sets about a plan to seduce her and win her heart.

Meanwhile, people of London begin vanishing. Mina's friend Lucy (Sadie Frost) becomes ill and looks weaker every day. She has mysterious punctures on her neck. Dr. Van Helsing (Anthony Hopkins) believes this to be the work of a vampire, and launches into one of those great gothic monologues about the monster that details their powers, their abilities, and their weaknesses.

As Dracula stalks through the shadows, evading his hunters or looking for prey, he takes on many forms. In one of the film's best scenes, he takes on the form of a beast that looks like a werewolf. There's never any real logic, it seems, to when Dracula may shapeshift to become something else, or look completely different, but the movie seems to employ a dreamlike logic. The whole thing is like witnessing a beautiful nightmare caught on film.

Bram Stoker's Dracula was Francis Ford Coppola's gamble to help save his studio, American Zoetrope. After misfire after misfire, he needed a hit. What I love, though, is that he didn't set about having a hit by making something digestible and mainstream that he knew was going to pack butts into seats and fill theaters nationwide. He decided to make something artsy, violent and weird as hell. It worked! Pretty good critical reception and word-of-mouth spread and it more than doubled its budget at the box office.

The movie has a great cast, but the real star of the movie is the very *look* of the film. The cinematography from Michael Ballhaus (who's always great) perfectly complements the story. The lights and the

shadows and the blue hues and the dark, deep reds are all essential palates necessary to do this story justice.

I love the lengths the filmmakers went to in order to craft the world that *Dracula* exists in. It would have been easy enough for a shot in which Jonathan writes in a novel while aboard a train: Get a shot of the book and overlay that shot over a train. But, no. *Bram Stoker's Dracula* built a huge book built into a tabletop set with a little, miniature train to go by behind it. It's nearly subliminal, but those little touches make all the difference. You're no longer trying to make ordinary objects exist in an extraordinary world, you're building that world from the ground up.

Every year I have a stack of movies I want to watch come October to get into the Halloween spirit. *Bram Stoker's Dracula*, every single year, makes the cut. I love everything about it. I even love Keanu Reeve's bizarre performance, who's just so miscast in the role and clearly in there because at the time he was a big name. But there's something kind of charming about it. Everything in Francis Ford Coppola's vision for *Dracula* has some strange charm to it. In a career filled with such hits and classics, this is one of his most audacious, and one of my absolute favorites.

Runtime: 130 minutes.

Branded to Kill
(1967)

There are some movies that you've seen even if you've never actually sat down and watched it. Like, say you've never seen *Pulp Fiction*, in that you've never watched it from beginning to end... but you've pretty much seen it by way of other movies and shows that have parodied whole scenes, or through the slew of rip-offs that have imitated it in the years that followed. Or maybe you know passages of the movie through memorable quotes. Without ever seeing the movie, you pretty much get the gist of it.

Branded to Kill is one of those movies. Even if you've never even *heard* of it, you've seen it. The movie is so influential that it's pretty much been remade (even if not officially) again and again. It sort of invented a style that's been copied to death. For a mostly-obscure 1960s Japanese film, its footprint is all over cinema in the years that have followed its release. And it's oh, so appropriate that such an influential movie was, at the time, just savaged by critics and was a commercial flop.

Seijun Suzuki, the director of *Branded to Kill*, was criticized by his studio for making an absurdist film that would eventually go on to make virtually no money for them, but his style has been embraced by contemporary filmmakers like Quentin Tarantino, Jim Jarmusch and Chan-wook Park who have all had their fair share of hits and critically-beloved works. Suzuki's straight-faced, ridiculous satire was perhaps something that audiences at the time just weren't ready for.

Goro Hanada (Joe Shishido) is the third-most ranked hitman in the world for the Yakuza, with an obsession with the smell of boiling rice. He himself is marked for death after a butterfly lands on the barrel of his rifle and he botches an assassination. Misako Nakajo (Annu Mari) is a mysterious woman who gives Hanada a ride home after his car breaks down, and has an obsession with death—in the form of a collection of dead butterflies and dead birds. Hanada and Misako have a strange love affair that involves Hanada's eventual seduction of her when he promises to kill her.

For Hanada's failure to perform the assassination, he is to be killed by the Number One Killer, a hitman whose existence is almost legendary. Hanada finds himself holed up in Misako's apartment, under siege from Number One. The movie explodes into bouts of violence, including a scene where someone is shot from underneath a sink, right through the pipe, which was imitated in Jim Jarmusch's *Ghost Dog*.

In some movies, a plot is merely an excuse for set-pieces. You have this flimsy skeleton of a plot that goes from one place, where violence will ensue, to another place, where violence will ensue. *Branded to Kill* seems to be the antithesis of that kind of filmmaking. For the purpose of review, I made the plot seem much more straightforward and easy to follow than it actually plays out, but the story being told is of the

utmost importance to the filmmakers. Even if the plot doesn't make a whole lot of sense (which is often), Seijun Suzuki realizes that the point of making a movie is to tell a story, and he gets to it. It's not a movie where a lot of fun, dumb action happens. The plot twists and turns through strange places and character motivations that have a sort of internal logic that makes sense in the realm of absurdity, but has absolutely no place in any sort of "realistic" scenario.

Branded to Kill is like if you took a John Woo movie, where there's this sort of murderous anti-hero at the forefront of the picture, and then you took a fistful of LSD. It's appropriate that the movie that would go on to inspire so many mainstream successes would, itself, be in this whole other league. If you go into it, you might almost expect something similar to its influences—and the moments it inspires in other films are all very apparent—but it's much, much stranger than a lot of people would have expected it to be. For me, I was really happy that it wasn't just this 1960s, black-and-white version of a 1980s action flick. It was like this strange marriage of James Bond, film noir and completely deadpan satire, where sometimes you're wondering if what's being said is actually a joke, or if the movie actually believes some of the more ridiculous things that are being said.

Runtime: 91 minutes.

Burden of Dreams

(1982)

I was going back and forth on which entry to include, because I really, really like *Fitzcarraldo*. It's an impressive film about the tremendous lengths someone will go to in order to achieve their dreams—nature, civilization and everything else be damned. It's a film about obsession in its purest form, telling the story about a man who dreamed of nothing more than to open an opera house in Peru. He finds a lucrative enterprise in rubber trees, used for the mass production of latex at the time, and he finds a huge swath of them. In order to maximize his profits, he finds the easiest way to do this is to load a gigantic ship up

with the trees and move the gigantic ship up over a mountain using indigenous people as a source of slave labor. It's a massive undertaking, but fueled with insanity and a will to see his dream come to fruition, by god he does it.

Werner Herzog, director of *Fitzcarraldo*, similarly mad and with a singular vision that he wanted to see come to life, decided that the easiest way to film this was by... well, doing exactly what Klaus Kinski did in the movie, but in real life. He just moved a goddamned ship over a mountain and filmed it without the use of special effects. As incredible as *Fitzcarraldo* is, the documentary about this arduous production in the film *Burden of Dreams* is even better, getting the real-life story inside the making of it. Plagued at every turn with production problems, that *Fitzcarraldo* even saw the light of day is a miracle. That it was a *great* film is... it almost defies logic as we know it. The nightmarish production of *Apocalypse Now* as detailed in *Hearts of Darkness: A Filmmaker's Apocalypse* is another must-see movie for anyone interested in making-of stories on troubled film sets, but *Burden of Dreams* takes it even further. *Apocalypse Now* had Martin Sheen suffering a heart attack and Marlon Brando acting like a prima donna; *Fitzcarraldo* had Jason Robards and Mick Jagger being replaced by an actually-insane Klaus Kinski, and trying to keep Kinski's bouts of psychopathy under control whilst the crew set about accomplishing the impossible task of moving a huge aquatic structure over a mountain in the jungles of South America.

Burden of Dreams' director, Les Blank, was so stressed out during the shooting of the documentary that he wrote in his journal, "I'm tired of it all and I couldn't care less if they move the stupid ship – or finish the fucking film." More of the clashing between Klaus Kinski and Werner Herzog is detailed in the documentary *My Best Fiend*, where at one point Klaus Kinski threatened to leave the film midway through the production and Werner Herzog told him that he had a rifle with seven bullets... six to plug into Kinski's back, and one for Herzog to commit suicide with. Sure enough, Kinski stayed on.

Herzog had to struggle not only with Kinski and the goddamned boat, but with tropical weather and a terrain that he was constantly at war with. At one point in the documentary, speaking frankly and like

someone who would never be sane again, Herzog explains that one of the people helping with the film had been cutting a tree with a chainsaw and was bit by a poisonous snake. The worker, without thinking twice, used the chainsaw to cut off his leg so that the poison wouldn't spread to his heart and kill him.

Burden of Dreams is an incredible film and one of the very best documentaries ever made. Werner Herzog is one of the best directors who ever lived. To get to see this glimpse into his creative process is the mad journey you would expect it to be. No one else makes movies the way he does. There's no one comparable. He's a man who makes films that explore the bounds of man by going out and actually testing those bounds. If the goings-on in the film seem all too real, it's because what's happening is, in all actuality, very, very real.

In some ways, I view Werner Herzog as the daring adventurer I want to be in my heart, but am too lazy and afraid of failure to ever actually become. The way he sets about things is so romantic and he's so in love with life. I love the idea of making a costume drama in the jungle by just getting a bunch of people willing to wear costumes and just film the thing in the jungle. But he isn't just a person who takes risks and lucks into them paying off—he's a gifted storyteller with a unique insight into the human condition. He's the only person I can think of that tells stories the way that he does. For anyone else, it would be a cheap imitation.

Runtime: 94 minutes.

Children of Men
(2006)

"The end of civilization" is a scenario that's irresistible to storytellers. Everyone has their own unique vision for how it's going to go down. Will it be a blood-drenched horror like George A. Romero's vision in *Dawn of the Dead*, or will it be a battle of Good versus Evil like in Stephen King's novel *The Stand*? Alfonso Cuarón's *Children of Men* is probably the most realistic interpretation of the end of days that I've

seen committed to film—not so much in the actual *cause* of the world's decay into madness (that women can no longer conceive or give birth to children), but how the world reacts to it. When civilization sees that there is no future, they give in to the proliferation of violence, racism and government corruption. Factions of rebels fight against a tyrannical government, but when they employ terroristic tactics and view everyone as expendable, is anyone even on the right side? *Is* there even a "right side"? The only people to admire are the ones who simply want to live out the last years of their lives in peace.

The film begins when baby Diego, the youngest person alive at eighteen years of age, is murdered by an angry autograph-seeker. A huddled group of people watch the news in horror, some of them crying, others just panic-stricken. Theo (Clive Owen) steps outside with his cup of coffee to pour booze into it and an explosion destroys the building he was just inside only moments ago. The opening sequence is one of many single, unbroken shots that don't call attention to themselves, but exist to stick us, the viewer, smack-dab in the middle of the action.

Theo is later kidnapped by a militant group called the Fishes, led by Theo's ex-wife Julian (Julianne Moore). She needs Theo to ask his cousin to help them get some papers so that one of their own can get to a safe place outside of the warzone of a city. Theo agrees, for a large sum of money. When it's revealed that Kee, the young woman that they need to get somewhere safe (Clare-Hope Ashitey), is *pregnant*, everything changes. No one is safe. The miracle of childbirth, the possible solution to the doomsday scenario, is treated with paranoia, distrust and murder—the glimmer of hope is buried so far beneath everyone's cynicism that instead of reacting with joy, everyone reacts with horror.

Theo, along with Kee and her midwife Miriam (Pam Ferris), start a journey through the wreckage of society, exposing the ugliness humanity is capable of. Everything we see is reminiscent of something that's already happened in reality. Mankind is capable of so much compassion, but mankind is also responsible for so many atrocities that have happened, that have left untold millions dead. Immigrants

are rounded up with hoods thrown over their heads. Some executed, some thrown into a prison that's the size of a small city.

In one of the movie's most amazing sequences (again in one long, seemingly unbroken shot), Theo must traverse the prison during a climactic battle between soldiers, prisoners and the Fishes. Buildings explode, people are shot, all hell breaks loose, and the camera never, ever stops rolling.

Whenever I want to sing the praises of *Children of Men*, I almost always just end up gushing. "And then I like this one thing, and then I like this other thing—oh! Oh! And the best part was when this one thing happened!" There's just so much to admire. Every time I watch it, I pick up something new, something else that adds to it. It's a rich film full of insane details. Every small detail is an important piece to the overall narrative. You may never notice it, but Theo never once picks up a gun. *Children of Men* is almost like the anti-action movie. It's absolutely brimming with thrilling set pieces of action, but it eschews many of the genre's sometimes-annoying trademarks. There are no sequences of rapid cutting; most of the scenes in the film that another director would shoot in extreme close-up with the shutter speed cranked and no less than ten edits per second are instead done with a wide lens and all in one shot.

A scene or an extended sequence all filmed in one shot is an amazing tool when utilized by the right people. Just like anything else, when it falls into the wrong hands, it ends up looking like a clumsy gimmick. The long-take, when utilized by Alfonso Cuarón and cinematographer Emmanuel Lubezki, is a thing of beauty. When you look at the scene in the car, where the camera goes from inside the vehicle, to outside, to a handheld shot, capturing the mayhem without missing a beat, you want to reach to the English language's top shelf and use a word like *awesome* and mean it without exaggeration.

In fact "awesome" is the perfect word for *Children of Men*. The whole movie is such a breathtaking experience, you simply watch it in awe with a slack jaw and absorb the images as they come to you. There's so much to write (or gush) about that I haven't even gotten to mention Michael Caine's performance as Jasper, where he gets an opportunity

to play against type and be the comic relief stoner character. And the weird part is that Michael Caine is really good at it!

Runtime: 109 minutes.

The Crow
(1994)

They don't make 'em like they used to. I mean, I don't mean that as a cynical remark on the quality of movies or whatever, but if you take a quick look at a movie like *The Crow*, you'll see what I mean. They just don't make 'em like they used to. *Deadpool* was indeed a very hard R-rated movie dripping with gore and it made a lot of money. But when do you think we'll ever see a studio-produced comic book movie like *this* again? One completely soaked with rain, wallowing in absolute misery, with rape and murder and the cleansing spirit of revenge right at the forefront?

The Crow is based on the graphic novel of the same name by James O'Barr. It's not religiously faithful to its source material, but the basic plot is the same with some tweaks to the actual incidents and players involved. A man (named Eric Draven in the film, played by Brandon Lee) and his beautiful fiancé, Shelly, are murdered by a gang of thugs. She is beaten and raped in front of him and later dies of her injuries. He is thrown out of a window and dies pretty much instantly.

One year later, a crow pecks at Eric's grave and carries his soul back to his body, where he returns from the dead, literally rising from the grave as a zombie, and comes looking for revenge, to find those who wronged him. He comes equipped with magical abilities, is basically invincible, and checks off his assassins, one by one.

The Crow is, unfortunately, probably best known for the real-life tragedy of Brandon Lee, the star of the film and the son of the legendary Bruce Lee, who died on set when a mishap involving a blank charge in a gun sent a very real projectile through his body. Brandon Lee was just beginning a very promising career of his own and it was cut too short by the accident. He really does give a fantastic

performance in the film. He's great in the action sequences, having a natural physical, almost balletic ability. And he's very, very good in the more tender, emotional moments, such as in the flashback sequences with Shelly or when he's comforting his young friend Sarah (Rochelle Davis, who only has two on-screen credits before or since being in T*he Crow*).

Looking past the tragedy that occurred, *The Crow* is also just a fantastic film in its own right—the overall look, the killer soundtrack, the great casting choices, the appropriately-sleazy dialogue for the baddies. It's a very attractively-filmed movie. Alex Proyas, the director of *The Crow*, has a real talent for mixing and matching shots with miniatures, sets and physical locations so that everything seamlessly blends together. What you end up having is this vision of Detroit as the center of hell. It has this grittiness that Detroit has in real life cranked up and exaggerated to the umpteenth degree, and then it has these flourishes that make it look like an even more rundown version of Batman's Gotham City, with skyscrapers that have gargoyles glowering on the city from way up above.

Long before the days of digital color correction, choosing such a concentrated color palette for a movie was a lot of work. It took a lot of communication between departments. *The Crow* is almost monochromatic, dripping with blacks and grainy lens noise. Only glimmers of color pop up on screen in flashes of red when bullets tear through someone or when the sun pops out from behind the clouds for a brief moment while Eric plays guitar on the rooftop.

When I was a kid, I thought that *The Crow* was the bee's freaking knees. I still do, but I'm glad I got to experience it at such a young age. This and something like *Batman Returns* wear their influences on their sleeves. You learn a lot about German Expressionism or gothic films watching movies like this. You delve deeper down the rabbit hole and you find similar movies. It's a movie to get you excited about other art created by other people in other times. It's a gateway movie. It exposes you to great music. It gets you excited about the Cure, Nine Inch Nails (from Nine Inch Nails to Joy Division) and the Jesus and Mary Chain. It gets you excited about graphic novels—I learned that there are *lots* of standalone stories that are beautifully drawn and personal

to the creator, like James O'Barr trying to exorcise his demons in dealing with the death of his girlfriend in the form of an artistic expression.

Runtime: 102 minutes.

Cry-Baby
(1990)

John Waters is a national treasure. As a personality, he's something of a gift to the world. He's so funny and his insight into the human condition is so distinctive that the works he makes can only be made by him. No one can hold a candle to John Waters are being a genuine, real-deal weirdo. And his writing? A lot of people don't know it, but he's one of the greatest living essayists we've got today. His nonfiction books, about his passions and his role models, are fantastic reads. By nature, I'm not a very good reader. I never have been and I probably never will be. But I can breeze through a John Waters book in a couple days, absolutely hooked during every free moment of my day. When I listened to his audiobook recording of *Role Models*, it was touching for me because he's definitely a hero of mine and it was so amazing to hear a hero of mine gush about their own heroes.

But, here's where I have a dark confession to make: I'm just not a big fan of his movies. I don't, for one second, doubt that the world is somehow a better place for having his movies out there, existing in all their weirdness—all that they've done for the United States' struggle toward the progressiveness of the Freedom of Speech is truly powerful stuff. But, goddamn, they are just not for me.

Pink Flamingos makes me feel physically ill, which I suppose is the point, but it's not a journey I ever feel like taking again. *Multiple Maniacs* is almost good to me. It would have been a great 30-minute short. *Female Trouble* has a great theme song and a pitch-perfect first fifteen minutes... after that, I just lose all interest. *Desperate Living* was... I have no words.

Whenever I explain I'm a huge John Waters fan and that he's a hero of mine, but I just don't really like his movies very much, I feel like fucking Hansel in *Zoolander* talking about Sting.

I don't dislike *all* John Waters' movies, though. *Polyester*. I do like *Polyester*. I've watched it twice, the second time for the glorious audio commentary. *Hairspray* is a good, solid movie. But *Cry-Baby* is my favorite.

Johnny Depp plays Wade "Cry-Baby" Walker, a 1950s thug. In this world, the world of *Cry-Baby*, people are divided into two categories: You've got Cry-Baby, his friends and his family, who call themselves "drapes." And then there's everyone else, who are called "squares." Not all squares are bad, you see. Allison Vernon-Williams (Amy Locane) is pretty much a square, but she and Cry-Baby fall in love anyway... sort of like a modern-day retelling of *Romeo and Juliet*, an affair between two people who are from different worlds.

The drapes accept Allison, except for Cry-Baby's jealous ex-girlfriend Lenora (Kim Webb), who lies and claims to be pregnant with Cry-Baby's unborn child in order to drive the two apart. The squares are less willing to accept the romance between Allison and Cry-Baby and they do everything within their power to break the couple up.

Cry-Baby is sent to prison after being falsely accused of starting a riot that was *really* started by Allison's square ex-boyfriend Baldwin (Stephen Mailer). In the tradition of great early Hollywood epics, there's time for a few musical numbers, some fights, a breakup and reconciliation, a prison break, and one hell of a finale.

The cast of *Cry-Baby* is fantastic. It's an ensemble cast that could only be assembled by John Waters. In addition to Johnny Depp's great leading performance, you've got Traci Lords, Patty Hearst, Iggy Pop, Willem Dafoe and Darren Burrows right before the premiere of the hit show *Northern Exposure*.

Cry-Baby is a camp movie. By design, it's campy as all hell. I have a general rule when it comes to camp: It's not any good unless it's *accidentally* funny. Something like *Valley of the Dolls* works because it thinks it's a good, serious movie and the exaggerated performances give it this bizarre, corny, almost otherworldly quality, as if aliens are

observing human behavior by trying to replicate it. *Cry-Baby* is certainly camp, but is incredibly self-aware. It's a knowing comedy. So, it breaks my rule for what makes camp absolutely essential, but it substitutes accidental humor with absolute earnestness. John Waters loves camp and musicals and movies about teenaged rebels and he's making *Cry-Baby* as a means of honoring those kinds of movies. And it totally works, brilliantly. It plays like if *Rebel Without a Cause* had dropped acid, had an insightful trip, went to college and then reflected on its past and previous angst with a thoughtful chuckle, as if to say, "What a crazy kid I was back then…"

Runtime: 85 minutes.

Dark City
(1998)

An entire city falls asleep at once. They collapse where they are: Some are in the street. Some are eating. Some are walking. Everyone falls asleep at once, except for one man. John Murdoch (Rufus Sewell), awakens in a bathtub with a wound on his forehead and a trickle of blood running down. When he walks into his living room, there is a dead woman—presumably killed by him.

John has no memories. He doesn't know who the dead woman is, how she got there—or even who *he* is, or how *he* got there, for that matter. He escapes his apartment, being pursued both by the police and a group of strange men dressed all in black (called the Strangers) and begins to piece together the clues that present a view of his life, to find out who he is. Wherever he goes, John is in the shadows. The city of *Dark City* is just as it sounds, a city that's always cloaked by the darkness of night. No one has seen the sun for as long as anyone can remember.

The Strangers catch up to John and try to inject him with something. He fights back and accidentally discovers he has telekinesis and uses this ability to keep them back, killing one of them. A creature crawls out of the head of one of the Strangers and dies.

Meanwhile, Inspector Frank Bumstead (William Hurt) and John's wife Emma (Jennifer Connelly) work together to find him. The detective wants to catch a killer, and Emma just wants to make sure her husband is found safe.

So much of *Dark City* is built on the foundation of its surprises it has in store. I'm afraid of going on too much and giving away too many of its secrets. To this day, even though it has a pretty decent cult following, *Dark City* is a criminally-underseen movie. It's not exactly a surprise why it didn't do well at the box office in its initial release... many great films don't. But I'm surprised it's not more well-known. The people who love it sing its praises.

Roger Ebert, one of the movie's original champions, named it his favorite movie of 1998 and even provided an amazing audio commentary track for its DVD release that's like a mini film school class. If you ever want to learn a thing or two, just put that bad boy on. Sit back and listen. Ebert packs a lot of information into that commentary and it's all really great, valuable and practical information for anyone who's serious about film theory or filmmaking.

There's something about the way that *Dark City* sets something up and then subverts your expectations. For example, it sets up a manhunt for its main character, pitting the detective Bumstead up against John. You expect Inspector Bumstead and Murdoch to be constantly outwitting each other, not unlike something from *The Fugitive*, but it never quite reaches that, and wisely not. The strange goings-on of the city are so apparent, it would be strange if no one noticed them. And so, Inspector Bumstead *does* take notice. He comes to understand John and why he's running. It reminds me of the scene in *The Sixth Sense* when Haley Joel Osment's character tells his mom the truth about his abilities and she believes him. In a less-assured movie, it would feel more appropriate to have the reveal of the truth be met with disbelief, even though that's not what would happen at all in real life.

Like Alex Proyas's other great film, *The Crow*, *Dark City* is the kind of movie they just don't make anymore. Look at something like *Dark City* or even the Tim Burton-directed *Batman* movies, and in all of those movies, the city is a character unto itself. They look like Fritz Lang's nightmares. The cities look like something not of the past, not of the

present and never of the future. It's like they contain elements of every time that existed, but don't belong in any era. Smokestacks loom on the horizon. Ugly skyscrapers grow like twisted fingers. Movies with big, elaborate city sets like this just don't happen anymore, not with green screen being so prevalent and easy to film these days. I don't have a problem with CGI—and *Dark City* uses a fair amount of it—but it's sad to see movies like this go the way of the dodo. It's nice to see something that was built and exists in a physical reality.

Little things in movies like this make all the difference. The little hints about the true nature of the city and its inhabitants are hinted at, but in such subtle and subconscious ways that it takes repeat viewings to pick up on all the acting and directorial nuances. If you watch anyone's performance at the beginning of the movie compared to a later performance near the end, you'll see a major dramatic shift, like they're becoming more comfortable saying their lines. These are all professional, seasoned actors (William Hurt and Keifer Sutherland had been acting for decades at this point), so that's a conscious decision to allow those performances to grow like that, to reflect the story and its emerging reveals of the central mystery at the center of the story.

When I was younger—fourteen, I think, at the time—I wrote to Alex Proyas through his website and he actually responded to me and it's worth noting that he's a very, very nice guy.

Runtime: 103 minutes.

The Devil's Backbone (2001)

"What is a ghost?" ponders Dr. Casares (Federico Luppi), who runs an orphanage for children whose parents have abandoned them or died in the Spanish Civil War. "A tragedy condemned to repeat itself time and again? An instant of pain, perhaps. Something dead which still seems to be alive. An emotion suspended in time. Like a blurred photograph. Like an insect trapped in amber."

Carlos (Fernando Tielve), an orphan, is taken to the orphanage owned by Dr. Casares at the film's beginning by his tutor and left there. Carlos chases after the car, only to see it grow smaller and smaller and finally gone, only a trail of dust on the dirt road as a reminder of it. Dr. Casares takes Carlos into his care—a kind and gentle old man. He assures him he will be safe there, and he is... from the war, at least. Jaime (Íñigo Garcés), the local bully, takes an instant dislike to him.

At the center of the orphanage, in their courtyard, is a reminder of the frailty of mortality: A bomb that had fallen from the sky and landed in the mud but never detonated. It stands tall and ominously, like the monolith from *2001: A Space Odyssey.*

There's another dark secret that the grounds hold: The mystery of what happened to Santi, a young boy who died there. His ghostly apparition, with blood floating about the air around his head, is seen stalking around the dormitory's hallways at night.

Santi whispers one night that he wants Jacinto, the caretaker and groundskeeper.

The Devil's Backbone is pure melodrama, and I mean that in the highest form of compliment. A ghost story such as this is less a horror movie, and more of a gothic drama with love triangles, betrayal and murder, all set against the backdrop of a terrible war with no end in sight. The ghost of Santi is a terrifying sight to see, if only because it's something that doesn't make sense within our natural world. The way Guillermo del Toro handles the story, blending the childlike wonder he shares with the orphans at the center, the fear and terror of man's inhumanity to man, and with the supernatural specter who roams the corridors at night is absolutely masterful.

Seeing del Toro spin a yarn is an incredible sight. A fatal mistake a movie like this might make would be to focus on the horror aspects of the story, to turn a basic ghost story into a haunted house story. Audiences can be impatient, so it might feel irresistible to add spice by having the ghostly figure bang pots and pans and try to strike fear into Carlos or the other boys. But Santi never does. He's not a creature of malevolence. He's a creature of sadness. Santi is a ghost that exudes

fear itself, fear of what happened in the past and unable to let go, but not one that tries to spread fear about.

Jacinto (Eduardo Noriega) and his ongoing affair with Dr. Casares' wife Carmen (Marisa Paredes) in order to get closer to a stash of gold they're keeping leads to an explosive betrayal, with many left dead in its aftermath. Both *The Devil's Backbone* and *Pan's Labyrinth* have this interesting composition between the supernatural, scary-looking world and with the *actual* real world which might not necessarily be scary-*looking*, but is much, much deadlier... possibly because it's real, and reality is much harsher than we give it credit for, sometimes. On the audio commentary of *The Devil's Backbone*, Guillermo del Toro references the way he shot the violence in the movie, which is important. He's done "fun" violence before, like with *Blade II* or the *Hellboy* movies, but here it's shown as-is. It's ugly, and it's difficult to watch. There is no enjoyment in the scenes where someone is in pain.

The way the film re-emphasizes its beginning question of what is a ghost at the end and the way it ambiguously answers its own question and leaves on a striking image, is just amazing. Some people might be turned off if they're expecting a ghoulish story dripping with chills and carnage; it's not that kind of movie. Instead it's a reflection on the filmmakers' thoughts on life and death, and on the history of violence in our world. It's a movie to invigorate our imaginations and to think about the reality of horror—not as some ghost from the netherworld, but as a fascist government takeover, as it is in our real world every single day.

Runtime: 106 minutes.

Die Hard
(1988)

The most surprising thing about *Die Hard* was that a good movie was the end result of such a cobbled mélange of bad ideas. The production history of the movie is such a mess. That it became one of the greatest action films of all time is a testament to the amount of talent that

went into making it. It was intended to be a sequel to the Arnold Schwarzenegger movie *Commando*, with Arnie battling terrorists in a high-rise. When Arnold passed on the idea, Joel Silver moved forward on the production anyway and took a gamble on casting Bruce Willis, who at the time was known primarily as a comedic actor, for his time on the sitcom *Moonlighting*. The rest is, as you say, is history.

The casting of Bruce Willis as detective John McClane is essential to *Die Hard*'s success. Before he became known as the action movie guy, he brought a quality to his role as being just an ordinary schlub. He's not the super cop he would become in some of the more ridiculous sequels this movie got. In the first one, he was just a dude who wanted to make things work with his wife and flew out from New York to LA to give it his best shot.

On the night of Christmas Eve, the Nakatomi Corporation is having a party for its employees, including McClane's estranged wife, Holly (Bonnie Bedelia). Villainous Hans Gruber (Alan Rickman, who's never been better) and his team of terrorists hijack the entire building and hold the partygoers hostage. Meanwhile, outside, it's complete pandemonium as police, the FBI and countless helicopters circle the building. And now it's up to a shoeless John McClane to take them down and save the day with the help of Sgt. Al Powell (Reginald VelJohnson), his link to what's going on outside.

Many movies have followed in the tradition of *Die Hard* and the thing that they never seem to get right is the tone. The entire point of *Die Hard* is that John McClane is an average guy stuck in an extraordinary situation he wants no part of. He's a realistic character in an action movie that's not necessarily grounded in *total* realism. His relationship to the mayhem sort of reminds me of Frank Grimes in *The Simpsons* where he's sort of someone from the outside looking in, and through him we get to experience the situation vicariously.

Alan Rickman, as the villain, gets to have a blast in the role. He plays the part with a perfect balance of camp and outright terror. He's damn near Shakespearean. The reveal that his terroristic plot is actually just an ordinary heist in order to get lots and lots of money says a lot about who he is as a person. He's a prideful idiot who's just as greedy as anyone else and comes up with an elaborate plot in order to make it

seem like it's politically motivated. He says it was the most effective way to get what he wanted, but there are much easier ways to steal money. To me, he's ashamed to admit that he's as greedy as a regular person. He wants to hide his humanity under a guise of violent activism.

John McTiernan is a director whose work I miss very much. Only the year before, he directed *Predator*. He had a knack for making action movies that were the perfect balance of smarts and brawn. He could set up a scene with such cleverness and wit and then sit back and let the mayhem play out satisfyingly.

Jan de Bont, who would go on to have a successful career in his own right as a director, providing the cinematography. A cinematographer on a movie like this has an almost thankless role, but his work here really is top-notch. *Die Hard* looks fantastic. It's one of the best-looking action movies you're probably ever going to see. The scenes in the metallic corridors have such a claustrophobic feel but everything is lit in this gorgeous, illuminated hue.

It's been almost thirty years since its release and *Die Hard* has a tremendous legacy. It shifted the action film. It redefined the boundaries of the genre. Suddenly, big-budget action movies could be totally subversive. You could play around with tropes and you could have a normal dude as your lead, it didn't necessarily have to be some muscled-up bodybuilder who conveniently loses his shirt right at the film's finish. You could have the action all set to one location and audiences wouldn't get bored. It broke all the rules and then redefined them.

Runtime: 132 minutes.

Dog Day Afternoon
(1975)

Dog Day Afternoon begins with a montage showing the hot "dog days" of summer. It's a day just like any other day in the sweltering heat in New York City, at first, until Sonny (Al Pacino), Sal (John Cazale) and

their temporary partner, Stevie—who bails just minutes in—walk into a bank and attempt to rob it. We can tell that they're not professionals. Sonny has a gun hidden in a box of flowers that has been done in countless movies before and since (see also: *The Killing* and *Terminator 2*) and struggles to get the weapon out. Sal points a submachine gun at the bank's manager, who reacts with indifference. And Stevie stumbles through every action of this robbery. He finally admits he can't go through with it, tries to leave with the getaway car, and is bummed when he realizes he's going to have to take the bus home.

Before their funds can be secured, Police Detective Sergeant Eugene Moretti (Charles Durning) has the bank surrounded by a team of police officers and the FBI. What begins as a simple robbery blows up to an absolute media frenzy. Every second of the siege and hostage situation is broadcast live and millions of people across the city are glued to their televisions. In addition to the police, a crowd of fans show up. A delivery boy drops off pizza for the hostages and robbers, looks to the news cameras and jumps up in the air and cheerfully exclaims, "I'm a fuckin' star!"

Sgt. Moretti and Sonny's interactions with each other are pure gold. Their interactions are fueled by pure adrenaline. They don't know each other and they just yell at each other with absolute, pure honesty. Sonny tells Moretti he doesn't believe him when he says he's only looking at five years in prison tops, ending with him chanting "Attica! Attica! Attica!" and getting the crowd riled up and completely on his side.

Before *Natural Born Killers*, there was *Dog Day Afternoon*, which has a similar approach to showing how the media blows up stories and glorifies criminals. Sonny's story about robbing the bank so that he can afford a sex change operation for his lover is irresistible to the talking heads of the news. They make a complete character out of him, consequences of the situation be damned. One of the bank tellers has the chance to go home but declines, wanting to be at the center of the story that everyone's going to be talking about for a long time. What happens at the end of the standoff is only inevitable, and Sonny only ever deluded himself into thinking there was another way out, deluded

by the grandeur and the attention from everyone watching the events unfold.

Al Pacino is, of course, excellent in the lead role as Sonny. Just about any performance from Pacino in the 70s is him at his best. He's everything all at once—in just a single sentence spoken by the character, he can be pathetic, menacing and humorous. He's menacing *because* he's pathetic and likely to do anything because he doesn't know what the hell he's doing, and watching him try to figure it out in his head has this underlying dark humor to it.

John Cazale, though, is amazing in the role of Sal. He plays Sal as a strange, menacing man who's possibly a sociopath or maybe even psychopathic... just someone who doesn't have the same moral fiber as regular people. Yet, he's strangely religious and seems to have the intelligence of a child. And he's very upset that people think *he's* gay, too, when the only homosexual is Sonny. When Sal talks about where he wants to go after this whole thing blows over and he thinks that Wyoming is a country, there's something sort of sweet about it. Like, he only acts the way that he does just because he doesn't know any better. John Cazale's life was cut tragically short and he was only in a handful of movies, but he chose wisely. Just about any movie he's in is worth seeing.

In director Sidney Lumet's audio commentary on the film's DVD, he says he did very little research on what actually happened inside the bank that day, that he was more interested in telling a story *based* on the event, not in faithfully retelling the events of that day as they had actually occurred. Some events are purely fictionalized and others are condensed details of several events for the benefit of telling a concise story. Sidney Lumet is generally a great director, but with *Dog Day Afternoon* in particular he seems to pull out all the stops and just does his best to bring the story to life. For a director with as many greats under his belt as he does, it's something when it's one of *his* very best works. To me, Sidney Lumet's dedication to his work is summed up with obsession for small details. In one scene, Al Pacino as Sonny picks up the phone and pours his heart and soul into this monologue. When he was done with it, off camera Lumet yelled, "Don't think! Do it

again!" and Pacino gives this defeated look and slumps over. All Lumet wanted was that one look. And it makes all the difference to the scene.

Runtime: 120 minutes.

Drive
(2011)

Nicolas Winding Refn is a director who seems to be unconcerned with ever dabbling too much into the mainstream. When he makes movies, he makes them from the darker parts of his soul. His id is on full display. His movies are often beautifully-rendered images of grotesqueries, like the whole of *The Neon Demon*. He did dabble with the mainstream once, and the closest he ever got to making a popcorn flick was 2011's *Drive*, and the results were something that had never happened before, and likely will never happen again. He made his mark on the film industry, and now he's content with making only the movies he wants to make.

Drive is totally self-aware and knows how clever it is, but never devolves into a parody of movies that it lovingly homages. If anything, its self-awareness is part of its overall earnestness. *Drive* is a movie with heart. The reason the movie is thrilling isn't because of car chases, action or mayhem. It's thrilling because we care about what happens to the characters. When the nameless Driver (played by Ryan Gosling) stomps a man's head in, it's not a "Whoa, cool!" moment. It's layered with tragedy, knowing that he will never see Irene (Carey Mulligan), the woman he loves, ever again.

Driver is a stunt driver for the movies by day, and at night he's a getaway driver for robberies. His rules are simple: "You give me a time and a place, I give you a five minute window. Anything happens in that five minutes and I'm yours. No matter what. Anything happens a minute either side of that and you're on your own." In the opening chase sequence (in a movie called *Drive*, I think it's awesome that there are only two car chases), Driver, instead of punching the car like Bullitt and swerving through crowded streets, plays a game of cat and

mouse with the police. He accelerates to punch out his car to an advantage, waits in the shadows, listens to the police scanner, and keeps ahead of his pursuers by a couple steps psychologically. And in a moment of too-coolness, he pulls the car into a crowded area, puts on a hat, takes off his jacket and blends in with the crowd. Job done.

Irene is his neighbor in an apartment complex you don't normally see in the movies. In the movies, if a character doesn't have a lot of money, they still always live somewhere with a nice view and modern appliances. The apartment complex in *Drive* is something realistically and quintessentially LA. It looks lived in. It looks real. When Driver meets Irene, they have an instant attraction. He falls for her, but she has one problem: A husband named Standard (Oscar Isaac, who continues to be one of the best living actors today) who is due out of prison.

Driver agrees to help Standard with some problems he's having, with gangsters who say he owes them money. Driver arranges a means of pulling off a heist, one last heist, to get the gangsters the money that they say is owed to them, and then after that, the agreement is that they leave Standard, and his family, alone for good. There's internal strife within organized crime between Bernie (Ron Perlman) and Nino (Albert Brooks) and the "family" back home. Driver unwittingly gets in the middle of it and becomes a complication that would be better off erased.

Drive remains Winding Refn's most accessible movie, while still rife with his directorial trademarks and flourishes he's known for. There are long, hallucinatory stretches of silence. Apparently, huge swaths of dialogue were done away with when he signed on as director, taking a red pen to the script. He's someone who loves to tell a story visually. There's an expression sometimes in writing that he seems to have taken to heart: Why tell it when you can show it? *Drive* also remains the only movie he's made that really has fun with performances. Not that his movies don't feature strong performances from good actors, but *Drive* actually seems to be having fun with watching someone like Bryan Cranston as Driver's good friend and mentor Shannon limp around, chain smoke and espouse life lessons in a gravelly voice. The

ensemble cast of *Drive* is amazing. Christina Hendricks shows up in a bit role to help with the heist to get Standard out of trouble.

Drive is one of those "love it or hate it" movies. If you're expecting it to be a movie in the tradition of the *Fast and the Furious* series, only more serious, and with Ryan Gosling as the lead, you're probably going to be incredibly disappointed. If you go into the movie knowing that it's going to be an offbeat, show-offy work from a European director and who is less concerned with cars and more of a contemplation on violence, you'll have a better idea of what to expect.

Runtime: 100 minutes.

Duel
(1971)

It's hard to believe that there was a time when Steven Spielberg was making made-for-TV movies. *Duel*, his first feature-length directorial effort, was part of years-long effort of Spielberg's to establish himself. Working with a script by Richard Matheson and with a meager budget of only $450,000, he set out to make a movie that is essentially a feature-length car chase sequence, but somehow also a monster movie, a paranoid thriller, a nightmarish, stygian journey into madness. When you look back at a movie like *Duel,* you see a director who can take a small budget, a handful of characters, and can stretch and make so much out of it, it's a shame that Spielberg rarely works with such limitations anymore. He's still a gifted storyteller, and he still makes great movies, but he really does know how to get the most from a small budget.

Duel begins as David Mann (Dennis Weaver) heads out on the road on a business trip. David encounters a semi-truck going uphill, moving very slowly, spitting out plumes of exhaust behind it. So, David passes it. And then the truck, only moments later, passes *him*, now capable of traveling uphill at very fast speeds it couldn't handle before. Then, it begins to move slowly again, forcing David to pass it. And thus begins

the game of cat and mouse between David and the never-seen, possibly-demonic entity behind the wheel of the truck.

David stops at a gas station and calls his wife, who is incredibly annoyed with him after an argument they'd had the night before. You can see David squirm with the confrontation. This scene is so obviously set up as a piece of character development, to tell the audience that he's a cowardly guy who has to learn how to grow, but it's so well done. Dennis Weaver is a fantastic actor, and you can just see him ooze with pathetic nervousness.

Back on the road, between stretches of nothingness, the truck and its unseen driver begin their game of torment against David again, upping the ante and taking mild gags too far, finally running him off the road. He goes inside a truck stop diner to gather himself and sees that the truck has stopped, too. One of the men inside is the man who's been messing with him, and he aims to make it stop, here and now. In an incredibly tense scene, he has to psyche himself out to gather the courage to confront the man, while trying to guess who his pursuer actually is. And, of course, the man he finally does confront, losing his cool almost immediately, is the wrong man, some innocent trucker who has no idea what the hell he's talking about. We can see David begin to unravel, afraid of where to go next, knowing that the malevolent force of the truck may soon follow.

We all know that the truck will follow again, and so it does, following in its tradition of escalating in terror. Now it's clear that the truck wants David dead. The different license plates on the front of it, which once looked like a kitschy decoration, now look much more sinister... like maybe the trophies of other motorists that the truck has killed, claiming their plates as a memento.

Duel was great practice for Spielberg to learn from and grow as a director. Horror is often a great place to finesse the trademarks that will define your career—horror is a pretty loose genre, and allows you to play with everything. Spielberg went back to horror on his next outing, *Something Evil*, and then defined his entire career with *Jaws*, the first real summer blockbuster. But here in *Duel*, the horror is something kind of scarier than, say, demonic possession, or even a shark. It's basic human cruelty.

There's no reason for the truck driver to treat David this way, other than he's a psychopath. His motivation is based entirely on sadism, and that's always been terrifying to me, the idea that evil isn't something that dwells in the shadows, it's right in broad daylight and it looks just like us (even if the driver himself in this movie is never seen).

The script is written by Richard Matheson, based on his own short story. Matheson is one of the giants of the horror genre and puts some of his best work into this story—right up there with *I Am Legend*. What makes *Duel* work is that, even in its quieter moments, there's always the threat of the truck coming back and it doesn't matter where we are. It could be pulled off the road, somewhere barely hidden, or barreling down on David from miles away, hellbent for cruelty.

Runtime: 90 minutes.

Dumb & Dumber (1994)

Movies like *Dumb & Dumber* are those kinds of movies that make you laugh at yourself with embarrassment for finding a movie too sophomoric to be funny. You know you know better than to laugh at an actor as talented as Jeff Daniels suffer the indignation of explosive diarrhea... but if it's funny, it's funny.

What a lot of movies don't understand is that the explosive diarrhea isn't funny by itself. You film a guy shitting his brains out, and what's there? Poop and farts *can* be funny, but they're not *inherently* funny. Jeff Daniels poops. Big deal. What makes it funny are the events surrounding it: You have the spiking of a drink for revenge, the delicious way the poisoner looks at the cup and insists the poisonee drink more; you have the gurgling, growling bubble guts; you have the mad dash for the bathroom, the race against time; you have what you *think* is the payoff, the defecatory explosion into a porcelain bowl; but then you get the real payoff, which is that the owner of the house sure hopes he didn't just use the toilet, because it's broken. The camera pushes in on a horror-struck face. Now *that's* comedy.

Dumb & Dumber doesn't require any sort of academic overthinking to justify itself as being an uproariously funny movie. It's successfully dumb, and being both dumb and funny takes a lot of thought and intelligence (which sounds counterintuitive, but it's true). You have to be smart to make being an idiot something worthy of laughing at. We've all seen movies made by dumb people and their shots at "stupid humor" just comes off as mean-spirited. The difference is that a movie like *Dumb & Dumber* has heart. And even though the two heroes of the story, Harry and Lloyd (Jeff Daniels and Jim Carrey), are the butt of a lot of jokes, the movie is always on their side. And, even against our better judgment, we begin to care about them, as absurd as that might sound.

Lloyd is a limousine driver. One day, he falls in love at first sight with a passenger, Mary (Lauren Holly). She leaves a suitcase behind and he chases after her to deliver it. In the process, he wrecks the limo and abandons it. Apparently his employer frowns upon this and fires him.

Harry drives a van made up to look like a dog. He picks up dogs and grooms them. He feeds the animals hot dogs slathered with mustard and chili. He, too, is fired.

With nothing left to lose, Harry and Lloyd hit the road, Mary's suitcase in tow, in order to deliver it to her personally. They set out to create a new life for themselves, one away from the city where they fail time after time after time. Not this time, they decide, and begin a road trip across the country.

Unbeknownst to them, the suitcase Lloyd grabbed was a ransom for her kidnapped husband. Two hitmen follow Harry and Lloyd on their way to deliver the suitcase to Mary in Aspen, Colorado. It's a tricky gamble to have a plot like this, with main characters like these. If you're going to have such lunacy going on, you need to strike a delicate balance between certain elements. If it gets too ridiculous, you lose the audience. If it's too realistic, it gets boring or, hell, even depressing. *Dumb & Dumber* is committed to its story, from beginning to end. No matter how ridiculous the plot gets, which is plenty ridiculous as I'm sure anyone can imagine, what happens next and how the characters react to it is of the utmost importance. It's surprising that a movie called *Dumb & Dumber* would forgo the pratfalls of lesser

comedies and instead invest a decent portion of its dialogue to building and establishing genuine pathos.

Most importantly, *Dumb & Dumber* is very, very funny. It's probably my pick for Jim Carrey's all-time funniest performance. Taking the statement, "It's probably my pick for Jim Carrey's all-time funniest performance," do with that whatever you may; if you're not a fan, you may not like *Dumb & Dumber*, and none of what I've said is going to change your mind. For me, though, and for people who can put up with his shtick for more than five minutes, there's a lot to laugh at in *Dumb & Dumber*. It's a movie full of great little one-liners sprinkled throughout and big, genuine belly laughs that are carefully planned, paid off and much deserved.

Runtime: 106 minutes.

El Mariachi/Desperado/Once Upon a Time in Mexico (1992/1995/2003)

El Mariachi is the extraordinarily low-budget $7,000 movie that put Robert Rodriguez on the map as a director. His story of financing it himself through medical experiments is Hollywood legend. Armed with a borrowed camera, a supportive crew and $7,000, he went to Mexico and filmed a simple action movie about a case of mistaken identity. His intention was to sell it to the direct-to-video market in Mexico, but ended up selling it to Colombia Pictures for distribution. Having such an amazingly low budget was the movie's claim to fame, a sort of, "Look at what was accomplished for less than a percent of a percent of a typical movie budget," but it also happened to be very, very good.

When a nameless mariachi looking for work in a small Mexican village accidentally picks up a gangster's guitar case that contains not a guitar, but an assortment of weapons, he is mistaken as that vicious gangster and is pursued by a drug dealer and his henchmen. Along the way there is time for a little romance, which of course ends in tragedy, and a bloody revenge at the film's climax. *El Mariachi* is amazingly tight, told crisply through quick, staccato edits, and no time for superfluous

details like character development. It's an exercise in pure visual style, with exciting action sequences that are impossible to believe had been filmed for such little money.

The movie's sequel *Desperado* was filmed for exactly 1,000 times the budget, $7,000,000, which is still considered paltry to an average movie's budget. Rodriguez wasn't thrilled with the idea of doing a sequel, what he wanted to do was use that money to film a remake of *El Mariachi*. Colombia convinced him, however, that *El Mariachi* was something special that shouldn't be touched, and that he should simply continue the story with more money—a decision which is weird for a studio, they usually never consider things sacred. *Desperado* wasn't free of studio intervention, though, with certain elements having to be excised, such as the climactic, bloody shootout that had to be left on the cutting room floor in order to secure an R-rating.

Desperado continues the story of the nameless mariachi, now depressed and mourning the death of his love. His quest for revenge continues against those who are responsible for killing her, and he now has his sights on another drug kingpin, higher up on the chain of command. The gunfights are bigger and better, the jokes are goofier and louder, and everything about *Desperado* is more polished and clean and, well... Hollywood. In this case, it works. It works because Robert Rodriguez is thrilled about having the opportunity to be making the movie. It's completely absurd, drenched in blood, and almost like a Mexican James Bond movie, in that he has time for yet another romance... this time with Salma Hayek, so who can really blame him?

The last part of the trilogy, *Once Upon a Time in Mexico*, was suggested by Quentin Tarantino (a good friend of Robert Rodriguez, and who has a cameo in *Desperado*) in order to create and close a trilogy. Why just leave it at two parts, especially when each predecessor was a financial hit? *Once Upon a Time in Mexico* was also a product of some lucky timing. Sony had developed digital cameras made specifically to emulate the look of film, and they wanted to test them out. Knowing Robert Rodriguez's reputation for working cheaply, they gave him a modest budget, and let him go wild on the production. It was sort of hastily thrown together, with subplots borrowed from other unproduced scripts by Rodriguez. Antonio Banderas returned for

the role of "El Mariachi" and Johnny Depp and Willem Dafoe also signed on.

Once Upon a Time in Mexico feels like a more serious movie. It deals with violence in Mexico on a more clinical level. The assassins that lurk aren't just nameless drug dealers, they're part of a problem with overall countrywide corruption that Mexico is dealing with every day in reality. That's not to say it's any less fun—it's not, it's still a blast—but it actually has something to say. It wants to bring attention to American interference with Mexican politics, which is a brutal reality that results in untold death. Every scene Johnny Depp is in, he steals the show. He's a great actor, obviously, but allowing him to chew scenery can often have mixed results. Here, it works beautifully.

Robert Rodriguez's *Mexico Trilogy* is a must-own DVD pack for anyone interested in the process of filmmaking. Each movie has its own "Ten-Minute Film School" featurette, in which Robert Rodriguez highlights how someone can shoot a movie and make it look professional for very little money. His advice is incredibly, incredibly practical. With one single zoom lens, you can get a lot of shots that look like separate set-ups. But as helpful and as cool as the "Ten-Minute Film School" featurettes are, I'm a slightly bigger fan of his "Ten-Minute Cooking School" that's found on the *Once Upon a Time in Mexico* DVD, and something he's done on every movie he's made since.

If you ever have the opportunity, I want to also recommend a little movie Robert Rodriguez made for Showtime called *Roadracers* in 1994. Showtime had a movie series called *Rebel Highway* in the style of 1950s B-movies, but updated with a '90s attitude. The results were often mixed. The movies would be directed by a known director and gave them a chance to play around with a ludicrous plot and a small budget and give opportunities to up-and-coming talent at the time. Robert Rodriguez was the only director of the lot who had something to prove, so he made his movie as good as it possibly could be and it's fucking excellent. One of his best.

El Mariachi Runtime: 81 minutes.

Desperado Runtime: 104 minutes.

Once Upon a Time in Mexico: 102 minutes.

E.T. the Extra-Terrestrial
(1982)

I know it's a strange comparison, but in some ways, *E.T. the Extra-Terrestrial* reminds me of *The Catcher in the Rye*... not so much in plot (obviously, the two couldn't be more different in that department), but in how your perception of it changes as you get older. The text remains the same, but how you react to it, as you get older, is what shifts, and each interpretation you have to it is just as powerful as the one before. When I was a kid, reading *The Catcher in the Rye* for the first time, I thought Holden Caulfield was a kid who exposed the world for how artificial and bullshit it was. As I got older, I saw him as a spoiled rich kid going through a crisis, someone less privileged wouldn't have the means necessary to deal with such existential angst. Regardless of how I feel about the character of Holden today, I think the book is just as fantastic now as when I first read it. As I grew and matured, so did the book.

When I was a kid watching *E.T.* for the first time, I saw it through a kid's perspective. I saw the government tracking E.T. as a threat. I saw Dee Wallace's character, as the single mother, as someone perhaps unable to understand what's going on in her son's life because, at that age, it's impossible to imagine that an adult really "gets" what it's like to be a kid anymore. Watching it now, you see a completely different movie. You see that the government agents aren't malicious, they're sent to do a very specific job, and they have the same sense of childlike wonder regarding the mere idea of intelligence extra-terrestrial life even existing. When the government agents storm the house, with their arms extended like Frankenstein's monster, it's because that's how a child would see it, in totally exaggerated detail. And Elliott's mother maybe doesn't understand her son because life hasn't been kind to her, and working the long hours she works, she doesn't have time to be as close to her children as she wants to be (and you can tell she wants nothing more in the world than that).

E.T. tells the story about an alien lifeform that accidentally gets left behind on Earth when the government agents lead by "Keys" (Peter

Coyote) try to intercept them. E.T., the extra-terrestrial, takes shelter in the wildlife surrounding a suburban home. Young Elliott (Henry Thomas) catches glimpses of E.T. in the dark of the night, hiding, and thinks it's a monster. He comes to understand it's just a hungry creature, and lures it back to his house with candy and befriends it. The more time E.T. spends with humans, the more intelligent it becomes. It begins to mimic human speech and shows that it's capable of amazing abilities, like telepathy, levitation and neurogenesis.

Enlisting the help of his big brother Michael (Robert MacNaughton) and little sister Gertie (Drew Barrymore), they come to find the truth about E.T., that he's a lost alien visitor that wants to get back home. On Halloween night, they venture out with him, along with a communication device that E.T. created, in order to establish contact. Elliott and E.T. get separated, and the alien becomes desperately, desperately ill, on the very verge of death. And that's when the government agents show up in the aforementioned scene shot brilliantly from a child's perspective. A procedure is put in place in order to ensure the safety of the public that is viewed as a terrifying siege by faceless monsters.

E.T. isn't just one of the best "family movies" out there, it's one of the best movies. It's pure magic. Spielberg's direction is top-notch here, and the way he shifts perspectives and tones is masterful stuff. In one moment, the movie is a rip-roaring kid's adventure, with off-roading bicyclists being chased by the police. Less than five minutes later, everyone's crying and the score by John Williams is swelling, and none of it feels forced or out of place. With that shot of the silhouettes against the giant moon, you're reminded that Spielberg is far and away one of the best visual filmmakers of our time.

It's also one of those movies I couldn't imagine being anywhere near as popular if it were released today. Not that I'm being critical of movie-going audiences, it's just that there was a time and a place for *E.T.* and it was released right at the right time. I couldn't imagine the movie rocketing to the top of the box-office, staying there for a record-breaking amount of time, and becoming one of the top highest grossing films of all time today. It contains little action, special effects used specifically for the purpose of telling a story and no show-

stopping spectacles to speak of. It's a movie that embraces wonder, that looks to the stars and imagines "what if?" and presents us with a remarkably human story about acceptance—we begin the film viewing E.T. as what might possibly be a monster and end up, along with Elliott and his family, waving goodbye to the alien as he bids his farewell.

Runtime: 120 minutes.

The Evil Dead
(1981)

The same episode of PBS's *American Masters* that sparked my obsession with *Blood Simple* also introduced me to Sam Raimi's *The Evil Dead* (I had no idea, until years and years later, that Joel Coen actually worked in the editing department for *The Evil Dead*, using some camera tricks he learned there and brought them to *Blood Simple*). This episode, I remember, showed so many striking images from so many movies of the era—black and white movies, personal biopics, the early works of Spike Lee—and I was surprised that one of the images they showed was from a straight-up horror movie. Blood was spilling down someone's cheek, a wild camera was running through a forest and a body of water. The idea that horror could be in the same league as so-called "important" films was a new idea that hadn't occurred to me at that young age… that something scary could be just as artful as anything else.

I found *The Evil Dead* at a Hollywood Video and grabbed it to ask my mom if I could rent it. I looked at the back of the box: *Oh, shit,* I thought. *NC-17…* My mom was cool with renting all manner of movies for me, but I thought NC-17 might be pushing it. Like, it's one thing to rent *RoboCop*; it's another to rent fucking *Showgirls*. I showed it to her, like, *Eh?* and she took one look at the cover (which had a pair of skeleton arms holding a severed, screaming head), made a disgusted sound, but rented it for me anyway. I… was… *psyched!*

Later that night, I popped the movie into my VCR, but I have to admit I wasn't mentally prepared for what I was about to watch. My mind was

still in a place that was amazed that a movie called *The Evil Dead* could be considered worthy of a show called "American Masters" so it never even occurred to me that *The Evil Dead* could be scary... like really, genuinely *scary*. For that matter it never occurred to me just *how* goddamned scary *The Evil Dead* was going to be. For me, at the time, I was in this state of perpetual disgust and horror. It was as gross as it was terrifying. It was cheaply amateurish at times, but it was so highly original and never, not even once, was it ever, ever dull. Blood kept pouring, shocks kept coming and new surprises were around every corner. My young, 13-year-old mind was blown away. It was shattered. It fucked me up bad. But I fell in love with it all the same.

The Evil Dead tells its story simply enough: Five college-aged friends Ash (Bruce Campbell), his sister Cheryl (Ellen Sandweiss), his girlfriend Linda (Betsy Baker), and couple Scott (Hal Delrich) and Shelly (Sarah York) head to a cabin in the woods for a weekend away. I don't know who they rented the cabin from, or if they're squatting, because it's dilapidated and some of the rooms feature the exact same art direction as in *The Texas Chain Saw Massacre*. Even before the evil manifests or the dead become evil, the house is already a terrifying place for what's supposed to be a relaxing getaway.

They find a reel-to-reel recording that a professor had left behind of him reading translated passages from a book called the Necronomicon Ex-Mortis, or the Book of the Dead. Playing back the recorded voice unleashes a force of pure evil, which we never see directly. We only ever see from its point of view, as it runs wildly through the woods, possessing everyone and everything in its path. Those who become possessed become zombie-like creatures (called Deadites) prone to violence, and can survive all sorts of damage inflicted upon them. You can cut off a Deadite's head and its head will continue to chomp and its body will continue to claw.

As in most movies of this type, one by one the friends die, come back as Deadites and are chopped up into hamburger, until there's only one left: Ash, who must survive the rest of the night while his friends grow claws and a lust for blood.

The Evil Dead works because it's smart and inventive, even if it appears to be dumb as a bag of hammers on paper, or even on screen. There's

not much to the plot, but does there need to be? What matters in horror isn't the plot—over-plotting can kill scares—it's the mood of the film and the inventiveness of the filmmakers. Some of the special effects haven't aged well, and a lot of them weren't even good for the time (you get what you can get when making a movie with a budget as low as *The Evil Dead*'s was), but you don't have time to dwell on minor details like certain characters being played by multiple actors when the thrills and surprises keep being thrown at you constantly.

In a rarity for movies, especially horror movies, all of its sequels are good... hell, even the television show is somehow good. Some people prefer *Evil Dead 2* or even *Army of Darkness*, but my allegiance goes to the first one. I do love them all, as each one has its own unique charm, but the original *Evil Dead* is the perfect combination of genuine terror and bizarre physical humor.

I love that there always seems to be an ongoing tradition with problems for the rights to each predecessor. The first sequel, *Evil Dead 2* was unable to show clips from the first movie to recap what had happened, so they just remade *The Evil Dead* in the sequel's first ten minutes. When *Army of Darkness* came out, they decided to change some things, so the beginning of *Army of Darkness* doesn't really match with the end of *Evil Dead 2*. And *Ash VS Evil Dead*, the TV show, has to pretend that *Army of Darkness* never happened. But, even still, if you have these movies on tape, you can sync them up just right so that when *The Evil Dead* ends, you pop in *Evil Dead 2* right as Ash gets hit by a demon. When *Evil Dead 2* ends, you pop in *Army of Darkness* just as Ash is falling into the past.

Runtime: 85 minutes.

Fargo
(1996)

I think that the question, "What's your favorite movie?" is almost impossible to answer. It honestly depends on what day of the week it is, what mood I'm in, how old I am at the time I'm being asked the

question, and what other kind of movies I'm into at the time. But my go-to, sort of generic answer in one of those bizarre "gun against your head" scenarios where you just *have* to answer the question or die (why would anyone threaten to kill you over such a thing?) is almost always *Fargo*, a movie I feel is practically perfect, from beginning to end.

Fargo, to me, represents the defenestration of cop movie clichés. In just about every movie you see that involves a cop investigating a murder as brutal as the one at the center of *Fargo*, the cop needs to spend sleepless nights pouring over boxes of evidence. The cop needs to have some sort of conflict with his/her wife/husband. They'll need to become *obsessed* with the case. And there's almost always a scene in a library studying microfiche.

Police Chief Marge Gunderson (Frances McDormand) does no such thing. She simply investigates the scene of the crime, gathers evidence, interviews witnesses and makes logical conclusions until she's led to the murderers. In other words, she does police work. As often as she can, she finds time to have lunch with her husband, who she loves very, very dearly. And she does all of this while pregnant. The last shot of the film, with Marge and her husband Norm (John Carroll Lynch) lying in bed together watching television is one of the sweetest endings of any movie. The Coen brothers have been called nihilistic or overly cynical, but that's not the case here.

There's this omnipresent realism in *Fargo*, from the way the case is handled, to the idiotic ways that everyone involved on the criminal side keeps fucking everything up. Jerry Lundegaard (William H. Macy) plots what he thinks is a perfect crime—to have his own wife kidnapped by Carl Showalter (Steve Buscemi) and Gaear Grimsrud (Peter Stormare), and then collect the ransom money by his father-in-law. The trouble is, none of these people are good at crime. Jerry underestimates how stingy his father-in-law can be, even in the face of a kidnapping and the safety of his daughter. Carl and Grimsrud can barely even perform the task at hand, getting into more and more trouble along the way. Something that was supposed to occur without any bloodshed ends with seven people dead.

There are some movies where I try to think of my favorite scene, and I end up having to decide between about a dozen... is my favorite scene the one where Carl and Grimsrud get pulled over by a trooper and everything goes to hell, ending with a triple homicide? Is it the scene that seems like a non sequitur between Marge and her old classmate Mike Yanagita, which ends up being more important later on? The infamous, and so well-executed "wood chipper scene"? Hell, I even love the opening credits, with that incredible Carter Burwell score building and building into a triumphant symphony.

The Coen brothers often have incredibly stylized movies, but that usual style takes a back seat in *Fargo*, which isn't to say it isn't visually appealing—Roger Deakins' cinematography is still killer, and the way he lights the snow is great stuff—but instead of these complex visuals, they shoot their scenes in very basic ways. It's all very standard Filmmaking 101 setups: You have a master shot for coverage and a couple of reversals (either internal or external) for emphasis during certain aspects of dialogue. Some scenes are only shot in a master, with no cutting. This quasi-minimalist approach puts an emphasis on the actual plot and the performances, instead. There aren't any distractions in watching the macabre events unfold.

Fargo is about as tight and about as perfect as a movie can be. There aren't any scenes that I would want to have deleted. There's nothing that doesn't work. When the movie goes from funny to serious, from violent to light-hearted, there's never any tonal whiplash. Every element of the film is handled perfectly. Every aspect of the filmmaking that went into its production is top-notch... everything complements everything else. The cinematography is gorgeous and subtle (I love the shot of Jerry in his office with his window blinds looking like the bars on a jail cell), the score is brilliant, and each and every performance in the movie is perfectly cast. Frances McDormand earned the hell out of her Oscar, Steve Buscemi is probably going to be forever-associated with this movie, Peter Stormare is one of the scariest characters in any Coen brothers movie (that includes Anton Chigurh) and William H. Macy plays such a conniving, sniveling fuckhead so effectively.

In *Fargo*, the traditional "male" and "female" gender roles between Marge and Norm are swapped, but the movie never dwells on it or acts like it's making some profound statement. That Margie earns the bacon while her talented husband perfects his artistic abilities is never flatly stated, it's just how their relationship works. And they're a great movie couple, one of my favorites.

In some ways *Fargo* is like a film school lesson all of its own. Feasibly, it's a movie someone with a low budget could shoot all on their own, because there's no real reliance on special effects or action sequences or anything else. The movie instead relies on storytelling through great dialogue, plot twists and strong performances. This is a movie anyone *could* make. The only thing required is a whole shitload of raw talent. And if you've got that talent, you too could make something as amazing as *Fargo*.

Runtime: 98 minutes.

Faster, Pussycat! Kill! Kill!
(1965)

Russ Meyer is one of those directors whose movies work as a window into the mind and psyche. Watching something like *Faster, Pussycat! Kill! Kill!* works as a means of discovering what it is, exactly, that turns him on. And the answer is glaringly obvious after the first thirty seconds: Big tits and powerful, intimidating women.

Tura Satana stars as Varla, a bloodthirsty go-go dancer with a penchant for fast cars, with quick money on her mind. Rosie (Haji) and Billie (Lori Williams) are her partners in both dance and in crime. The three of them together form a trifecta of too-cool-for-school wickedness. They don't care who they have to hurt or what they have to do to get what they want.

The film begins with the three of them dancing, harsh lights on their bodies with no visible background, intercut with men in the crowd shouting like animals and a narrator telling the viewing audience, "Ladies and gentlemen: Welcome to violence." This ends up being an

apt warning, as the trio ventures out to the desert for a quick race that escalates into violence rather quickly, a man winding up dead and his underage girlfriend (Linda, played by Susan Bernard) kidnapped by them.

Linda spends the rest of the movie barefoot and in a bikini. Susan Bernard was apparently terrified of Tura Satana, which adds significantly to their on-screen relationship, as a prisoner of the imposing presence of Varla.

Varla, Rosie, Billie and their prisoner Linda soon find themselves caught up in a scheme to rob a crippled old man and his learning-disabled son of a vast fortune that they apparently have hidden in their ranch. The three women attempt to woo them, putting the young Linda as an object of perverse desire front and center, but find themselves neck-deep in even more violence, mayhem and car chases when the old man ends up being just as psychotic as they are.

Russ Meyer is a rare example of an auteur. There are others, of course, someone whose work is instantly recognizable. You turn on a movie and just by watching a few quick frames flash by, or the way it's cut, or the specific kind of music used, you know exactly who's responsible for making it. Martin Scorsese is one example of an auteur... someone who's been oft-imitated, whose work can be exaggerated by something as simple as the juxtaposition of doo-wop music and extreme violence. Wes Anderson, and the oh-so-precise way he frames his subjects with a perfect color palate and an obscure B-side from a lesser-known pop band from the 60s or 70s, is another example. And then there's Russ Meyer, with his low shot of undulating, mountainesque breasts and the powerful women who flaunt them, and always it's shot incredibly well.

The thing about trash cinema is that it only works if it's shot well. There's always the ironic appreciation of badly-made movies, but for something to be truly special in the world of trash films and cult flicks, it needs to be well-made. Russ Meyer was technically adept at the filmmaking process, and his works reflect that workmanship. He worked fast and for very little money, but the final result looked like something that cost significantly more than the actual budget. His black and white cinematography was always crisp, with gleaming

whites and pitch-black shadows. His color cinematography popped with a wide variety of psychedelic flourishes.

Faster, Pussycat! Kill! Kill! has a legacy of influence since its release. Everyone from Quentin Tarantino to John Waters has sung its praises. There's been talk, time and time again, of remaking it, but why bother? It was a movie unique to a specific time and place. It had to be made right at that time when censorship still ruled Hollywood, but things were beginning to let up. It was that in-between phase where you didn't have to be as staunchly restricted as *Casablanca*, but the freedoms of sex and violence by the likes of Sam Peckinpah were only three years away. You end up with this strange hybrid film that's technically family friendly, but the intent of the film is to titillate, arouse and thrill.

I feel like, also, whenever *Faster, Pussycat* is brought up, there's the inevitable debate as to whether or not the film is feminist or misogynistic. Is it in praise of women, or is it exploitative of them? Well... why can't it be both? Art should be a complicated thing, and it's a common misconception that it has to be in good taste. I see it as having it both ways. Russ Meyer clearly had issues with women, he loved them and he feared them, and that duality has been captured by him time and time again. But, most of all, the man loved tits.

Runtime: 83 minutes.

Fear & Loathing in Las Vegas (1998)

The mere fact that there exists a film version of *Fear & Loathing in Las Vegas* that remains loyal to its source material, the novel by Hunter S. Thompson, defies reality. And it's a well-made film made by a director of note (Terry Gilliam), with two A-list stars acting the fuck out of the lead roles. That it's a fantastic movie in its own right, with a deep understanding of what made the novel so funny and so insightful, boggles the mind.

Johnny Depp stars as Hunter S. Thompson's alter ego, Raoul Duke, a fan of tacky clothing, chain-smoking cigarettes through a long filter, sunglasses and drugs. Lots and lots of drugs. Johnny Depp has been good in many other movies, but he's never been better than he is here. He embodies the spirit of Thompson, taking the performance to the edge of parody, sometimes even surpassing that edge so much that it comes right back again, full circle. It's a strange performance that shouldn't work, but it does, somehow... wonderfully.

Benicio del Toro, as Dr. Gonzo, is something I have a hard time describing. It's certainly a great role, that's a given. Watch five minutes of the movie in any context, and that he's great in the role is clearly obvious. But there's something about it. There's something about how he can go through so many extremes in such a short period of time. Consider this scene: At one point, early on, Dr. Gonzo suffers from a drug-related freakout while driving a car. His hands flail wildly, he makes animalistic sounds with no sense to them, barely sufficing as words. He sniffs a cracked-open pill, stirs awake, and gravely and seriously wonders what the fuck he's doing out in the middle of the desert, man. He seethes with pure rage. When the drug wears off, he realizes how out of his mind he was, and begins to laugh at himself and at the poor hitchhiker that he scared half to death. The whole scene takes maybe 90 seconds and he goes through an entire spectrum of emotions, each transition flawless and effortless.

By now, the story itself is something of legend. Journalist Raoul Duke and his attorney Dr. Gonzo head to Las Vegas, an arsenal of drugs and booze in tow, in order to cover the dirt bike race, the Mint 500. Along the way, they decide to seek out and define the American Dream, that elusive, vague dream of happiness and greatness that America has as a promise for all those who work hard enough for it. The movie and the novel differ a bit on the expectation of discovery, but the enigmatic nature of it remains the same for both.

The way audiences have reacted to the film and its musings on the American Dream reminds me of one of those ideas, like the one at the center of *Fight Club*, that's easy to misunderstand and it attracts a lot of people who fall in love with it, who never really understand it. *Fear & Loathing* isn't about discovering yourself through drug-addled

madness. To think that's the big takeaway is to completely misunderstand the point. Never once, in all of their debauchery, is what they're doing ever represented as something "cool." It's not exactly presented as a healthy lifestyle choice when Duke is watching a casino floor full of reptilians having a blood orgy and he's seconds away from projectile vomiting. Nor is it portrayed as a sensible means of attaining any kind of truth when our two heroes are on the verge of madness, time and time again. It's seen as a low point in anyone's life, that drugs are an easy way of coping with a harsh reality—that time in the early 70s saddled with uncertainty, when the dream of the 60s had died and the future of the country was in the hands of Richard fucking Nixon.

The movie doesn't have so much of a plot as it does a series of vignettes that all tie into the overall narrative. Each scene almost works as a standalone episode. Each episode featuring them going further and further down the rabbit hole. They're unsure if they're getting closer to the truth, or further away from it with each act of self-harm they inflict upon themselves or with each act of cruelty that they inflict upon someone else.

In case you've never seen the movie before, imagine all of what I've said up above to describe a comedy. *Fear & Loathing in Las Vegas* is, somehow, uproariously funny. It's a bizarre, unique creation that shouldn't work. With its history of production starts and stops, at one point to have starred both Jack Nicholson and Marlon Brando, it's a small miracle that we ever got to see the film in any finished form. If you've never seen it before, you should. Even if you end up hating the movie, you should still see it.

Runtime: 128 minutes.

Finding Nemo (2003)

I've long been an admirer of Pixar's commitment to storytelling. They craft entire worlds populated with memorable characters and events that an audience can actually get invested in. And whatever happens in their plots is always character-driven… it's never some moment where

there's a spectacle just for the sheer spectacle of it. Everything is important. Everything matters. The emotions that arise are organically conceived and given life.

Finding Nemo, to me, represents Pixar at its best. Everything about the world the story takes place in seems real and alive. The ocean, populated with cute fish and terrifying creatures, is beautifully realized and rendered. And the story itself is seemingly so massive, in a way unlike overblown movies that need to have this recycled "epic feel" that just ends up feeling formulaic and familiar. Sincerity goes a long way, and I believe that the filmmakers and the minds at Pixar behind *Finding Nemo,* sincerely believe in their story and care about what happens.

Marlin (Albert Brooks) and his son Nemo (Alexander Gould) are clownfish, and the sole survivors of a barracuda attack that left Marlin's wife, and Nemo's mother (plus a hundred or so unborn fish eggs) dead. Marlin, after experiencing such horror, has become overprotective of his son. Nemo wants to explore. The ocean is massive and inviting. It calls to Nemo to brave the danger and seek out all the mysteries that it holds. Going against his father's specific orders to *not* venture out past a certain point, Nemo is captured by a human deep-sea diver and taken somewhere on land, as someone's pet. Marlin decides he can't let this happen, not after everything he's been through to protect Nemo.

Along the way, Marlin gets the help of Dory (Ellen DeGeneres), a forgetful blue tang fish with a heart of gold. Together they explore the depths of the ocean and encounter scary beasts like angler fish, vegetarian sharks that get a taste for blood, but also helpful comrades who wish them the best of luck, like a pack of laid back sea turtles that have had over a hundred years of life to provide them with a uniquely chill view of life.

Meanwhile, Nemo makes friends of his own in a dentist's aquarium, including Gill (Willem Dafoe), a scarred fish hell-bent on making a daring escape back to the ocean. The two sides of the story work wonderfully together, Marlin's journey of self-discovery like a version of the hero's journey formula, while Nemo's is like a POW movie in the tradition of *The Great Escape*.

While Pixar movies always boast great animation, I feel like their animation efforts have never been more innovative or ambitious than they have been here. Movies like *Toy Story* are definitely unique and see the world from a different perspective, where ordinary things like bookshelves are now these massive monoliths, but *Finding Nemo* is wholly a part of an alien world (an alien world that happens to exist on Earth). Looking at it, and all of the research that went into giving the fish life, is nothing short of breathtaking.

When the movie veers into emotional territory, like when Dory tearfully tells Marlin how much she needs him, it works. The writing and the performances are uniformly strong and help sell the world we're meant to believe in, so when we're asked to appreciate a moment of pathos, we do it because the film has earned that moment; it doesn't feel like something stuck in out of place, it feels like a natural progression of the story and the adventure we've been involved with. Sometimes, when watching *Finding Nemo*, I forget that I'm watching an animated film. Everything just feels real to me after a certain point. I feel like I'm just watching talking fish navigate the ocean.

Finding Nemo is a children's movie, but the first time I saw it I was twenty-years-old and I smoked entirely too much weed. I was in a state of depression after having failed on my first time out as being an adult, and I had to move back in with my parents. My friends wanted to cheer me up so they smoked me out and when they found out I'd never seen *Finding Nemo*, they threw it on for me. I was hesitant at first, but goddamned if it didn't win me over within the first five minutes.

Whenever I think about *Finding Nemo* I think about that article on The Onion where some nerd is proclaiming that he understands the Muppets on a much deeper level than you. It's like, yeah, I know the movie is meant for kids, and I know kids love it because of all the cute fish and everything, but move out the way, children. *Finding Nemo* is my jam and I like it more than you do.

Runtime: 101 minutes.

Forrest Gump
(1994)

Forrest Gump is the story of a mentally-challenged man's life through the years, through the decades, with a historical snapshot of America being told parallel to him. It begins in the 1980s, where Forrest Gump (Tom Hanks) sits at a bus stop and makes friendly conversation with anyone willing to lend him an ear and listen. Flash back in time, he tells them of his childhood in Alabama in the 1950s in a racially-segregated south where he was confined to leg braces to correct his crooked back. Constantly bullied emotionally and physically for his low I.Q., he made a friend named Jenny (Robin Wright) that lasted through thick and thin for decades.

Growing up, Forrest lucks into athleticism, going to college on a full football scholarship. His performance as an All-American leads him to meet the president. After college, he enlists in the Vietnam War, and meets two people who change his life forever: There's Bubba, his shrimp-loving friend that he makes a promise to, to create a shrimping company in his name, and there's Lt. Dan, the fate-obsessed commanding officer who loses his legs in battle.

Forrest's choices and his chance meetings lead to fortune, life-affirming realizations and heartbreak. Forrest and Jenny both symbolize different aspects of life through the 60s and 70s. Forrest, the rule-abiding all-American and Jenny, the free spirit of rebellion.

Almost every scene in *Forrest Gump* is not only crucial to the overall narrative, but almost every scene is iconic, riddled with memorable quotes or with a memorable set-piece. The way the movie moves through the years, with each specific era given its own identity and style, is incredible. The scenes of the early 60s are shot with a soft filter and color palate, and the scenes in Vietnam have a gritty realness to them appropriate for a war movie to show hell on earth.

Forrest Gump is corny, manipulative nostalgia porn for Baby Boomers. It uses well-worn clichés as a shortcut for dramatic revelations. The story is ludicrous. The soundtrack selections are derivative. And I absolutely adore it. What movie *isn't* manipulative? Movies use editing, music and performances in order to elicit a specific emotion

from the movie-watching audience. It's the nature of the beast. But it also has something interesting to say about all of our journeys through this crazy thing called life, and it's told through an interesting character, played to perfection by Tom Hanks. Lt. Dan's view of the world is dominated by fate. Forrest's mom (Sally Field) believes that life is like a feather we see floating in the beginning of the film... where nothing is preordained, that whatever happens happens. Forrest himself is unsure of how he feels about life until the end, where he decides that maybe life is the combination of the two philosophies, where fate exists in a world with freedom of choice.

The special effects used to plunk Forrest into real historical moments is pure movie magic. The effects used to remove Lt. Dan's legs almost defines what special effects are supposed to be used for—to create a seamless illusion that doesn't draw attention to itself, so that it becomes nearly subconscious and we don't realize we're looking at something that was the end result of thousands of man hours behind a computer. Robert Zemeckis is a master at combining state-of-the-art special effects and the classical elements that make a movie good, like performances, writing and strong direction.

Forrest Gump is one of those movies I watch once a year during the Fourth of July. It's patriotic without being mindlessly so. It's a movie in love with American history and shows America as it really is and was: A wonderfully beautiful yet flawed country, from systematic racism to drug addiction. But these flaws are part of the historical tapestry that makes up the present. The past has a powerful effect on the present, no matter how we view the future, whether as being made up by fate defining us or if we're completely in charge of our own destinies. All that matters is that we're all here, together, pressing forward and, like Forrest, history is all around us and it's writing itself even as we speak. Our journey through history is going to be bullet-marked by huge events and smaller, personal ones. Whether it's Vietnam, Reagan's assassination attempt or Forrest and Jenny holding hands and watching fireworks, it's all equally significant to the person it's happening to.

Runtime: 135 minutes.

Frailty
(2001)

If the vengeful God that wreaks havoc in the Old Testament, claiming the first-born child as a sacrifice—the God that makes hail fall from a cloudless sky and light aflame once it strikes the ground—were real, then *Frailty* would be a movie completely in line with His policies. This God cares little for things like psychological trauma... a job must be done, and if you have been chosen, you must do it.

Frailty is about a good family man, known only as Dad (played by Bill Paxton), a single father of two boys who, one night, awakes and hears a message from the Angel of Death, speaking to him the words of God. Dad has been chosen in an ongoing Holy War between Heaven and Hell, between humans and demons.

Fenton (Matt O'Leary) doesn't believe his dad. He even says, "Maybe you're sick," hoping that his dad wakes up from his madness. Fenton's brother Adam (Jeremy Sumpter), on the other hand, believes every word of it and accepts it as gospel. Their dad explains that God is guiding him to various weapons to be used in the battle against the demons that are hiding in human form. In a brilliant bit of dark humor, each weapon basically just looks like something you would find anywhere: First, there are the oversized gloves for handling wood—they're to be used when touching the demons. Then there's the weapon used to render them unconscious, which he proudly unfurls with a moment he perceived to be powerful, and it's revealed to be nothing more than a pipe that he'll whack unsuspecting people over the head with. And then the last tool to aid him in his holy war is an axe, to chop up the demons into little bits.

For a while, Dad seems to have forgotten everything, and life goes back to normal. Fenton is relieved. But then, one day, Dad tells him that God spoke to him directly and gave him a list. The list, he says, is of people who are really demons. Their first person that they track down is an old man coming out of a grocery store. In broad daylight, in a brazen act, Dad uses Fenton as bait, claiming to have lost a puppy, and then clocks the old man over the head with the "enchanted" pipe,

drags him into a van, and takes him home and chops him into bits in front of children. Fenton watches in horror, while Adam watches in confusion, still believing his dad to be working for God.

Frailty is an extremely upsetting movie. Whenever children are involved in a story like this, it takes on another level. No longer is the movie about someone who may or may not be unhinged, and the awful things that happen due to their possible madness, it's about watching something terrible happen to someone you love and being powerless to do anything about it. It's about the loss of innocence. It's about the complete and utter deterioration of a family. Seeing a scene with children having to dump body parts out of a plastic bag and bury them is a bit hard to take sometimes.

Told in two timelines, we go back and forth between the past and the present. In the present, one of Dad's children (Matthew McConaughey) is taking Agent Doyle of the FBI (Powers Boothe) to where his Dad had buried the bodies, making a full confession after his brother's suicide. The killings have become quite infamous, the killer known as the God's Hands Killer. How everything comes together at the end is a great surprise. It's fantastically well-structured.

Bill Paxton also directed the movie, with a screenplay by Brent Hanley, and he does so with a surprising amount of skill. From the many great directors he's worked with in his tenure as an actor, he obviously paid a lot of attention to the craft, because he borrows certain elements here and there from the likes of Sam Raimi and James Cameron and creates a wholly unique kind of film that's simultaneously stomach-churning in its intensity and pitch-black hilarious when it wants to be. Somehow, most surprisingly of all, it's genuinely sweet in parts. Dad clearly cares for his family, and he loves his sons very, very much... but whether he was stricken with insanity, or if he really was performing a holy mission for God, fate dealt him a shitty hand and he tries to make the best of it even after everything goes to hell in a handbasket. Bill Butler, who was also the cinematographer on *Jaws*, deserves a special shout-out for creating the look of this movie, somewhere in between *Invaders from Mars* and a Coen brothers film.

Frailty is by no means a religious movie, and it handles its imagery of religion fearfully, but I don't find it to be cynical regarding faith. It's a

movie that takes the savagery of older religious texts and plants them in a modern context. It has fun with subverting and supplanting religious parables in today's society. *Frailty* is an incredibly original work, something that is criminally underseen. I adore it. It's five great movies all in one: It's a thriller, it's a horror movie, it's a family drama, it's a religious metaphor and it's a comedy.

Author's Note: Bill Paxton passed away a couple months after writing this review, so I wanted to say a little something about the man himself. He was a hero of mine, someone I always admired tremendously. He reminded me very much of myself. We had similar outlooks on life and similar tastes in movies and filmmaking. For two years in a row, I had my birthday party be Bill Paxton themed and attendees would dress as different characters from his movies. I even had trivia questions and gave away some of his movies to the winners.

I know it sounds stupid, but I always wanted to meet Bill Paxton. I just wanted to have dinner or something with the guy, and I'm really sad it'll never get to happen. This book is dedicated, in part, to his memory and his legacy. Rest in peace.

Runtime: 100 minutes.

Friday (1995)

The best comedies are the ones that have no shortage of quotable lines. I'd say about half the lines from 1995's *Friday* have become immortal, evolving into a life of their own, like, "Bye, Felicia!" Ice Cube had already made the transition from rapper to actor with his successful turn in *Boyz n the Hood* but *Friday* is the movie that made him a bonafide movie star, a box office draw in his own right.

Friday takes place over the course of one eventful day (can you guess which day of the week?), following Craig (Ice Cube) after he gets fired from his job on his day off of all days, and his friend Smokey (Chris Tucker, in his very best role). Craig and Smokey's friendship is one of those classic comedy duos, with Craig as the straight man and Smokey

as the jokester with all the good lines. A jokester is only as good as his straight man, and Ice Cube plays it to perfection.

Smokey is the neighborhood stoner, one of those guys everyone in their life has met, where you understand that marijuana is a non-addictive drug, but *this* guy is hooked on it. Like, I get it... it's not habit-forming, but you really need to stop smoking so much goddamned weed. Smokey's harmless shenanigans gets him and Craig both into trouble when he smokes his portion of the product that he was supposed to sell for local drug dealer Big Worm (Faizon Love). Short of cash and without the weed to make up for it, Big Worm is looking to come gunning for him. It's a small amount, but Craig and Smokey live in the hood and neither of them have jobs, and coming up with $200 by 10:00 p.m. might as well be a million dollars.

Throughout the course of the day, we're introduced to a large cast of characters and eccentric personalities that populate the small LA inner-city neighborhood. There's Craig's family, with his uptight sister, well-meaning-but-disgusting father, and caring mother. Craig's family loves him, but they're all a little tired of his shit, being a slack-off with no real source of income or seemingly any desire to get his act together. First thing in the morning, his father chides him for throwing out a huge bowl of cereal just because he doesn't have any milk, "You better put some water on that damn shit!" and for eating all the food in the fridge. And then there's Deebo, played by the ironically named actor Tiny Lister, a huge behemoth of a man, and the neighborhood bully. Everyone's well into adulthood, but still terrified of this hulking mass of pure anger who simply takes whatever he wants and stomps whoever gets in his way.

As Craig and Smokey attempt, futilely, to come up with the $200, they find time to get high, hang out together outside, and talk shit about each other and the people they know. *Friday* is a fantastic movie, but some of the best moments are when there is no plot happening at all, and the characters are just talking and rattling off jokes, like when Smokey refers to Craig's father's hair as looking like a bunch of spiders having a meeting on top of his head. Sometimes plot is an unnecessary hindrance to the delivery of jokes in a comedy, which is definitely not the case here, but I feel like if they ever decided to go back and make a

fourth *Friday* (I hope they don't, but if they did), I'd definitely want to see the return of Chris Tucker and I'd want to see it as a loose, plotless series of vignettes with the emphasis on dialogue, almost like a pseudo-documentary along the lines of *A Hard Day's Night*.

What I love most about *Friday* is that, even though the plot is about drugs, money and potential murder, it's a lighthearted comedy, but its lightheartedness doesn't keep it from acknowledging the state of things in America when it comes to being Black in this country. Segregation was abolished decades ago, but lives on spiritually... just look at the angry frothing of the mouths that occurs whenever an initiative is brought up to integrate low income housing in richer neighborhoods or schools. Even your most vocal and proud liberals will suddenly talk about how unfair it all is to see such integrations being "forced" upon them, unaware that they're echoing the exact same sentiments of white supremacists, only phrased slightly differently. *Friday*, care of director F. Gary Gray, is a movie well aware of this, and talks about it openly, and talks about the violence in these areas, but doesn't steep itself into misery or despair. That's not *Friday*'s style. *Friday* is a good time with enough self-awareness to broach serious subjects, keep them at the forefront, and then focus on the hilarious back and forth between its characters.

Runtime: 91 minutes.

From Dusk till Dawn
(1996)

Years before Robert Rodriguez and Quentin Tarantino teamed up for the 2007 double-feature *Grindhouse*, there was *From Dusk till Dawn*, which was a sneaky way to get two movies for the price of one. What begins as a crime movie ends as a blood-drenched vampire movie. The tonal shift midway through when it goes from action to horror is jarring as hell, by design, and incredibly brilliant. At the time, when it happened, people didn't know how to react. Some of them were pissed, they thought that the twist was stupid. Some of them thought that it was totally awesome, and bought it hook, line and sinker.

From Dusk till Dawn tells the story of Seth and Richie Gecko (George Clooney and Quentin Tarantino), fugitives on the run from the law after a string of robberies. Seth and Richie aren't the criminals you see in other movies, or even the kind of criminal that George Clooney would play later on in his career. Seth is no Danny Ocean, nor is he a Jack Foley. Seth is a no-nonsense criminal. He's a bad guy. If someone gets in his way, he will kill them if no easier way out presents itself. Richie, Seth's brother, is a violent and sadistic psychopath, desperately seeking the approval of Seth and from any pretty young girl around him.

After a run-in with the law (and a gas station attendant) that turns both bloody and literally explosive, Seth and Richie—along with a hostage—find themselves holed up in a sleazy motel. In the same motel is a family led by paterfamilias Jacob Fuller (Harvey Keitel), with his two children Katherine and Scott (Juliette Lewis and Ernest Liu). Jacob is a pastor who has lost his faith and has set about rediscovering himself without being a man of God. After Richie rapes and murders his hostage, he and Seth hold the Fuller family hostage and use them and their RV to cross the border into Mexico, to hide from the law.

The Geckos and the Fullers find themselves in a notorious hideout for criminals, sort of like the Mos Eisley of Mexico, called the Titty Twister. It's also a front for a den of ravenous vampires. Once the vampires reveal themselves and begin feeding on the bar patrons, the rest of the movie becomes a fight for survival, to live long enough until the sun comes up.

There are two distinct halves of the movie: You've got the fugitive film about the criminals on the run, and then you've got the vampire movie in the second half. Both segments are complementary to each other and have the same sort of commitment to ugliness and incredibly dark humor. The movie is, from beginning to end (or from dusk till dawn?) laced with a tongue-in-cheek sarcastic humor, as well as trademarks from both Rodriguez (the phallic gun) and Tarantino (Red Apple cigarettes).

Tarantino's script is also a perfect match for Rodriguez's style. Tarantino definitely takes his own directorial efforts much more seriously, but when writing for someone else, he can craft something

incredibly unique and tailored to the strengths of others as storytellers. Rodriguez's strengths as a storyteller rely on his love of B-movies. He loves sleaziness. He loves pulpy dialogue that actors snarl. He loves fitting in as much as he can into one single movie—there's even time for a sexy, memorable dance from Salma Hayek in a bikini.

George Clooney made his transition from television star to movie star with *From Dusk till Dawn*. It was a gamble that paid off for him big time. Robert Rodriguez was hot off the success of *El Mariachi* and its sequel *Desperado*, and Quentin Tarantino was still riding the phenomenal success of *Pulp Fiction*, so while starring in one of their vehicles may sound like a no-brainer, I could just imagine an agent looking at the script and advising him to think again. The film is about as uncommercial as a mainstream feature can get. The screen is littered with graphic violence, nasty characters, and no real redemption to speak of. *From Dusk till Dawn* is the wet dream of filmmakers who idolize people like Sam Peckinpah. That *From Dusk till Dawn* was even given a wide release blows my mind, but I can't even fathom that there was a time in existence that it came out to relatively good reviews and modest box-office success. A movie like that today would surely flop. Hell, look at what happened with *Grindhouse* and that was literally a bargain: You got two movies for the price of one, people! An opportunity like that will never happen again, and you blew it!

From Dusk till Dawn was the perfect movie for kids to accidentally see on cable back in the 90s. That's how I first saw it, and I loved it then as much as I do now.

Runtime: 108 minutes.

George Washington
(2000)

David Gordon Green's early work, what I call his, "pre-*Pineapple Express*" period is impeccable. And as much as I like *Pineapple Express* (which is lots), as well as many of the films he's made in that post

period (which is, also, lots), his early films are something special, to be cherished and treasured and studied for anyone who takes filmmaking seriously as a form of art. And his best film, in my humblest of opinions, is his first: *George Washington*.

George Washington is like if you took Larry Clark's exploitative bullshit, *Kids*, and actually told it from the perspective of kids who act and behave like rational human beings. It's stripped entirely of cheap thrills. Everything that happens is gut-wrenching, emotional, and completely raw. The child actors in the movie are *phenomenal*. Watching them act, and watching the way in which David Gordon Green directs them... the way I want to explain watching the craft come alive is like when you're watching something—anything—and you're seeing the very best example of it. It's like watching an exciting football game that goes into overtime. It's like watching a dancer effortlessly perform feats of human athleticism. It's like watching the best of the best of acting. It's just pitch-perfect to watch these kids spill their guts and let emotion just pour out of them, to hear them talk about their insecurities and fears.

George, the title-character, wears a helmet because his skull never hardened after birth. He can't swim because of it. He comes from a dysfunctional home with a stepdad who has an irrational fear and hatred of dogs. Life doesn't get an easier for him when he accidentally kills his friend Buddy. He and his group of friends hide the body and attempt to live with the guilt, each of them dealing with it in different ways. George thinks he's a superhero. Vernon, one of the other kids involved in the accident, tries to steal a car to run away.

Vernon's monologue is one of the most powerful moments in the whole movie, and you can see the young actor's face just subtly twist and writhe in agony as he says it, "I just wish I had my own tropical island, I wish... I wish I was... I could go to China, I wish I could go out of the States... I wish I had my own planet, I wish I... I wish there were 200 of me, man... I wish I could just sit around with computers and just brainstorm all day, man. I wish I was born again... I wish I could get saved and get my life through Christ... then maybe he can forgive me for what I did... I wish there was just one belief... my belief."

George Washington plays like it's based on the best young adult novel that's never been written. It reminds me of *On My Honor*, which is sort of like a *Crime and Punishment* for pre-teens. Guilt is something, for some reason, that children of a certain age just feel deep in their bones. I don't know what it is. Something about the powerlessness of youth. You're old enough to finally want to become your own person, or to change your life, or to change the lives of the people you love, but you're too young to do anything about it. Kids like George and Vernon are stuck in their situations, and even something as simple as an accident can have swift, damning repercussions for them.

It's never flatly said in the movie, but race has a lot to do with how they reacted to the situation. It's a fact that the justice system isn't as forgiving to blacks, or people of color, as it is to whites. If George had been white, he could have possibly told the police he accidentally killed his friend Buddy. But, George being black, Vernon thinks they might have a better chance by simply trying to hide the body and hoping they just get away with it. Life, of course, doesn't work out that way for them.

David Gordon Green has a way of shooting the south that makes it feel alive. The landscapes in *George Washington* are gorgeous and lushly shot, full of vibrant colors. I've heard David Gordon Green compared to Terrence Malick before, but I think Tim Orr (director of photography on *George Washington*), at his best, gives Malick a run for his money. And Gordon Green has a way with actors unlike anyone else making films today. Nearly everyone in the cast was totally non-professional, but you'd assume they'd been working in film for years.

George Washington is a movie that hurts to watch. It's about real agony, real suffering of the soul. But it's so beautiful to watch. It's so expertly and personally rendered that the pain and agony... it just hurts so good.

Runtime: 89 minutes.

Ghostbusters
(1984)

What a lot of people don't fully appreciate about *Ghostbusters* is that, in addition to being generally iconic (those costumes, the sound effects, the special effects, hundreds of one-liners), it's a fantastically well-constructed film. It's a great film disguised as a special-effects-driven comedy. The pacing of the film, how it slowly builds and builds, beginning with such scares as eggs cracking themselves and frying on a counter and then ending with a 300-foot-tall monster made out of marshmallows stomping through Manhattan, is deliberately conceived so that by the time you see Stay-Puft the Marshmallow Man, your reaction isn't, "Oh, god," it's "Huh, that makes sense."

By now, the story is familiar: Dr. Venkman (Bill Murray) is a scientist in a field that he frankly couldn't give a shit about. He doesn't believe in any of it. Psychic energy, ghosts, things that go bump in the night—those are things he leaves in the capable hands of his colleagues Ray Stantz (Dan Aykroyd) and Egon (Harold Ramis). Upon the actual discovery and proof of existence of paranormal entities, fate intervenes by having all three of them fired, in one fell swoop, from the university that they work out of. "You are a poor scientist," the dean scolds Venkman.

With nothing left to lose, the three of them go into business together and put their knowledge of the paranormal to use and become a team of what are essentially ghost exterminators. If you're being bothered by a ghost, spook or specter, who ya gonna call? The Ghostbusters, of course, according to their low-budget TV commercials. It takes some time for the operation to get off the ground. At first, they only have one customer, Dana Barrett (Sigourney Weaver), and find their investment money dwindling with no source of income coming in. After renting a space in New York, putting out advertisements, and the cost to invent portable nuclear accelerators they strap to their backs, they're on the verge of bankruptcy. And then, fortune strikes: A customer calls. A posh New York hotel has a problem with a ghost bothering guests, and they soon find themselves with a reputation around the city, and their business is a-booming.

Unbeknownst to the boys in gray, the reason business is a-booming is because of the second-coming of a Sumerian demigod known as Gozer. With the reincarnation and the physical manifestation of Gozer comes certain side-effects, like a vast increase in paranormal activity. After an interference from an overzealous EPA investigator named Walter Peck (William Atherton, one of the best bad guys in movies), the Ghostbusters' business is closed down, destroyed and they along with their new teammate Winston (Ernie Hudson) are in jail, unable to help fight back Gozer and keep the city from being destroyed by it.

Ghostbusters is a damn near perfect movie. There's something so great about how it all worked out. The movie went through many revisions and drafts and every new decision they worked out, or some decision that fell through requiring compromises to be made, ended up benefitting the final product. It's a work of total serendipity. If John Belushi had played Venkman, or if John Candy had played Louis Tully instead of Rick Moranis, or if Eddie Murphy had been Winston instead of Ernie Hudson, or if Paul Reubens had played Gozer, the same magic might not have been there. It ended up coming together and congealing with a series of very happy coincidences.

The movie plays around with genres a bit, and each one they play with, they go into fully. It works as a comedy because it's hilarious—one of the funniest movies ever made. It works as a horror movie because when it gets down to it and wants to scare an audience, it takes the time and care to build up tension before letting all hell break loose. And it works as an adventure film, with the film's climactic showdown on the rooftop of Dana's apartment building being completely thrilling. Usually movies that build to a final showdown of special effects and noise and lights ends up looking like a derivative spectacle and the fun and comedy just ends up stopping there. With *Ghostbusters*, seeing it all go down is just part of the fun, because there's an actual commitment to these characters and we care about seeing what happens to them.

Ghostbusters has been one of my favorites since I don't even know when. I feel like I've been watching this movie my entire life. Whenever I wonder if the reason I love it so much is maybe because I'm a bit blinded by nostalgia, I just watch the sequel or the remake

and see the differences immediately. The original *Ghostbusters* is a smart movie that was never overly concerned with being flashy. Everything that happens, happens organically because the plot is totally character and dialogue driven. The film's biggest laughs aren't from some ridiculous stunt or elaborate special effect, it's from the quieter moments between characters, and that makes all the difference.

Runtime: 107 minutes.

The Godfather (1972)

The Godfather is one of those Sacred Cow Movies that, for years and years before I ever saw it, I would just hear again and again how great it is, and how great its sequels are, and I would assume that nothing could ever live up to that hype. We've all been burned by some over-praised classic that is, by all definitions a technically great movie, but still can't live up to the impossible expectations we've created for ourselves.

The first time I saw *The Godfather* I was twelve-years-old. It was a lazy weekend and my dad and I hit up the local small-town video store and rented it and decided to make an evening out of it. He and my mom made a big, rich dinner and threw it on after we'd stuffed our faces, tired and content, the perfect condition to watch a movie like this—totally devoid of distraction.

Whenever I see a movie I love at first sight, I remember the occasion vividly. I remember the dimness of my parents' house with the lights off. I remember laying on the couch with a big, pillowy comforter over me. I remember being *instantly* hooked from the get-go, the music swelling and the opening lines, "I believe in America," while the camera ever-so-slowly tracked back to reveal more and more of the room, while Vito Corleone meets with people who need his help, something he can't refuse on the day of his daughter's wedding.

The Godfather is based on the novel of the same name by Mario Puzo. The book is good. It's a good, pulpy, kind of ridiculous book that has some salacious prose. I read the book, finally, for the first time only a few years ago and the entire time I was reading it, I kept thinking, "Man, what a great movie." Francis Ford Coppola wisely excised some of the more questionable subplots involving oversized genitals and a surgeon from Las Vegas, and kept the story focused on the Corleone family through the years, from New York to Sicily to Nevada. He took a pretty good book and turned it into one of the benchmarks of American cinema.

Michael Corleone's transformation from American war hero to brutal mob boss that rules with an iron fist is one of my favorite descents into evil in fiction. Other antiheroes in film and TV, like Walter White's transformation, begins with good intentions: He wants to provide for his family when he learns he's sick and then gets caught up in the lifestyle, realizing how good he is at it, and how much he loves it deep down inside. Michael, on the other hand, believes that he's better than it, that he's somehow above it all, but his reason for getting caught up in the lifestyle is based on the most petty of all motivations: Revenge. Visiting his father in the hospital, he mouths off to a cop that winds up punching him in the face, causing serious damage to his jaw, cheek and sinuses. The humiliation is too much for Michael to handle, so he masterminds a meeting between the cop and Solazzo, the gangster behind the failed execution of Don Vito, and executes them both with a bullet to the head in a restaurant, and sends a message to the rest of the New York families that the Corleones are not to be underestimated ever again, that attempting to bring harm on the family will bring that harm back around tenfold.

One of my favorite things about *The Godfather* is in how it's shot. Francis Ford Coppola and Gordon Willis, the cinematographer responsible for the look of the film, have created something truly unique in *The Godfather*. Much of it is told in the shadows, with bodies and faces obscured, only blobs of faces appearing and softly speaking terrifying lines, or commanding murders that they'll never see. Much of it is also told in very simple set ups. The camera will be placed somewhere as a master shot, but instead of cutting between the master and an internal or an external reversal, the shot simply remains

uninterrupted and allows the action to unfold, almost like a play. In other scenes that employ a more traditional editing flow, with close-ups for added emphasis, there's always something almost operatic about how the blocking unfolds, like each scene is almost a self-contained short story. Or sound effects will be utilized to great result; consider the squeaking shoes echoing through the hospital's corridors, or the rushing train getting louder and louder as the moment of truth comes for Michael to pull the trigger on Solazzo.

As much as I respect and admire the sequel, my personal love and appreciation goes to the first film. The technical craft that went into *The Godfather Part II* is better, more polished. The structure of the film is more experimental and audacious. I adore the flashback sequences with a young Vito that were in the novel. But I'll just never love it as much as I love the original. The original just clicks with me emotionally in a way only few films can, or ever will. It's one of my favorite movies. *The Godfather II* is simply a great film.

Runtime: 175 minutes.

Goodfellas
(1990)

There's a shot early on in Martin Scorsese's *Goodfellas* where a group of gangsters get out of a car and you can see the carriage lift tremendously as they exist. This one, simple shot conveys how much weight these guys carry, how much perceived power that they have over everyone else around them.

This was the first time seeing a movie that I recognized as a visual metaphor, and seeing that it could be done in a way that was so *cool*. It wasn't heavy-handed. It didn't draw attention to itself. Martin Scorsese seemed to be saying so much in such a simple way, specifically to enhance the story... not to exaggerate some half-baked poeticism. It was the best way to convey the aura of these characters without some lengthy dialogue sequence—it was just good old-fashioned filmmaking: Economical, efficient and brilliant. I was twelve years old at the time, and it had blown my young mind.

Goodfellas tells the true story of Henry Hill through the ages, from a boy in Brooklyn, watching the neighborhood Mafioso in awe, all the way up to an adult now in the Witness Protection Program. Scorsese pulls no punches. He portrays the life of crime with a brutal honesty, showing how someone can be seduced by it and then all the horror that comes with it.

Ray Liotta plays Henry as an adult. Joe Pesci plays his childhood friend Tommy, a violence-prone loose cannon. Robert De Niro plays Jimmy "The Gent" Conway, an Irishman with an adoration of crime, primarily hijacking and thievery. Lorraine Bracco plays Karen Hill, Henry's wife.

The film is written by Martin Scorsese and Nicholas Pileggi, based on Pileggi's book *Wiseguy*. Though the movie (and the book) are both about Henry Hill, the movie is *really* about Scorsese. Scorsese made a movie about someone else as a means of making a reflection on his own life. He directs the film in a way that has this, "What if this were *my* story?" feeling hanging over it. Scorsese grew up in similar neighborhoods, similarly enticed by the empty promises of a life of organized crime—the quick money, the neighborhood respect, and the unspoken danger of being killed because of it. For a lot of people, going into "the life" seems inescapable. Becoming a part of it just seems like a logical step... where some people apply to college, some people will just end up as a crewmember of a crime family. And *Goodfellas* is a reflection on that part of the world, in the neighborhoods of New York, where young men who have nothing are willing to kill or be killed in order to survive.

In a lot of ways *Goodfellas* is almost like the anti-*Godfather*. They're both extraordinary movies, but whereas *The Godfather* is this operatic, sweeping epic, *Goodfellas* is a hyper-realistic movie that very much takes place in the world as we know it. It's not interested in plot twists or milking anything for drama, it's just telling a story that has actually happened, and has happened a million times before. The most surprising thing about *Goodfellas* is that it can tell its story without heaping on judgment at every opportunity. Instead, it has respect for its audience. It's more concerned with telling us the why and the how behind everyday details in the sometimes-intoxicating life of crime, or showing us why someone would be drawn to it, as in the long,

unbroken shot through the club, the whole world unfolding before Henry and Karen.

In writing this book, I was torn between writing about *Goodfellas* and *Casino*, its spiritual sequel. *Casino* is almost a clinical look at the complexities and inner-workings of the mafia, while *Goodfellas* is essentially a personal anecdote on what life on the inside was like. They're both fantastic, and while I don't think anyone needs to choose between the two (why not just like both movies?), my personal preference veers toward *Goodfellas* specifically because of the story of Henry Hill and seeing him transform from a naïve child, to a hardened criminal, to a scared man who has nowhere left to go, so he does the unthinkable and rats out his friends in order to save his own tail—betraying his own code of honor, because he doesn't know what else to do.

Everything about *Goodfellas* is brilliant. From a technical standpoint, in terms of cinematography (Michael Ballhaus has put some of his best work into this), editing and everything else, it's an incredible, breathtaking picture. The screenplay and the direction are, to me, the best Scorsese's ever done, and that's saying a lot given his impressive career. The acting, from everyone involved, makes the actors invisible; all you see are the characters that they're portraying, whether they're hanging out and braying laughter or stomping some poor guy's face in. *Goodfellas* is a movie to watch play out while in the hands of a master. Movies just don't get much better.

Runtime: 148 minutes.

The Graduate
(1967)

Dustin Hoffman is a phenomenal actor who's been great time and time again through the decades no matter what kind of movie he's working on or what the role requires of him. But for my money, I don't think he's ever been better than he was in *The Graduate*, as the neurotic, constantly-anxious Benjamin Braddock. No matter what he does, there's this omnipresent awkwardness that permeates every

interaction he's involved in. Even when being seduced by a woman like Mrs. Robinson (Anne Bancroft), who's doing all the work, and making his job as easy for him as possible, he still manages to make the entire encounter... weird. The way he uncomfortably fondles her breast, the high-pitched, nervous train whistle coming out of his nose when his anxiety level increases. Everything just has to be a goddamned disaster with that guy.

The Graduate is about Benjamin, coming home from college one summer, depressed and disillusioned. He's a degree-holding graduate now, and his life is ready to begin... the problem is, he has no idea what he wants to do. Life itself doesn't make sense to him anymore. Everyone else, however, seems to have these grand plans of what he's supposed to do next, including a hilariously vague tip to get into, "Plastics." Benjamin wonders, "Exactly how do you mean?"

The night of his welcome home party, he drives Mrs. Robison home and her intentions are very clear not only just to us, but to Benjamin too, who is so overwhelmed with life right now, he can't be bothered with such a mind-boggling proposition as to have sex with not only a married woman, but a longtime family friend. She offers herself to him and his reaction is, "Jesus Christ!" and "Let me out!" A few nights later, he calls her up and agrees to the arrangement. They meet at a hotel under a different name, and he treats her coming up to his room like a secret agent awaiting orders. He tells her to go up to the room and he'll come in separately. He doesn't realize that no one else gives a damn what he's up to.

Benjamin spends the summer involved in his affair with Mrs. Robinson. He spends his nights with her and his days lounging in his parents' swimming pool, drinking beer. His directionless, meandering life has only gotten worse after getting involved with her. They're simply using each other as an outlet for physical release. They're nothing more than sexual objects to each other, and the emptiness of the release only works to make him feel even lonelier than he did before.

Upon the insistence of his parents, Benjamin takes Mrs. Robinson's daughter Elaine out for a date. Mrs. Robinson is furious. Benjamin is dumbfounded. He insists he doesn't want to go out with her, just that he *has* to. And, of course, after trying his hardest to sabotage the date,

he falls for her. Hard. Genuine human emotion, the thing he's been craving. He likes her, she likes him... of course it can't work out that easily. Nothing ever does.

The Graduate is a movie I've seen copied a lot, trying to nail that upper-class angst, that feeling of worthlessness, even when you have it all... the emptiness of privilege, I guess I'd call it. There's something genuine about *The Graduate* and how it portrays its existential dilemmas, underscored by Simon & Garfunkel crooning, "Hello darkness, my old friend..." It's hard to peg or emulate that emotion just right. It's a delicate balancing act to acknowledge the opportunities available to Benjamin and to also acknowledge that he, too, is susceptible to hardship, without being a crybaby. Life isn't easy for anybody, especially if you've been emotionally-neglected for such a long time, and that feeling of worthlessness is a hard one to shake without support.

Mike Nichols is one of those great directors for actors. The movie has its fair share of elaborate camera work and set pieces, like the finale at the church, ending with Benjamin and Elaine rushing out to catch the bus, but the thing that's always going to pop out is the performances. There are no weak players in *The Graduate*, there's a uniformity of excellence from everyone in the cast. Even though a limited role, when *Mr.* Robinson shows up unexpectedly to ask Benjamin if he's intentionally ruining his life, it's such a great moment, deftly balancing menace and humor. With a weaker actor, the scene wouldn't have worked—it would have been too much on this side or the other, being too serious when it should be funny or too wacky when it should be terrifying. The way it works out has it both ways, and that's not an easy thing to pull off. *The Graduate* is full of little moments like that.

Runtime: 106 minutes.

Grave of the Fireflies (1988)

Studio Ghibli is probably best known for the animated films of Hayao Miyazaki like *Spirited Away* and *Princess Mononoke*, these gorgeous

modern-day fantasies that are made for people of all ages—whether you're four or forty or beyond, those movies are going to be equally magical. Their secret to success is that they don't ever talk down to their audience and they immerse themselves completely in the world of their films. They believe the reality of their creations and work tirelessly to bring those stories to life through state-of-the-art animation and incredible scripts.

Grave of the Fireflies is one of their lesser-known works. It isn't directed by Miyazaki, instead by Isao Takahata, who has gone on to direct other features like *The Tale of Princess Kaguya*, and the direction is much more somber than previous movies in the studio's filmography. It has a sadness that permeates every frame of it. And also unlike Studio Ghibli's past works, *Grave of the Fireflies* doesn't represent a magical world, it represents our own world, in all its despair, based on a semi-autobiographical short story by Akiyuki Nosaka about his life at the end of the World War II and the death of his sister.

The film begins with the discovery of the dead body of a young boy named Seita, whose spirit is reunited with his sister Setsuko, and he begins to tell the story of how they had both died. Perhaps knowing what's going to inevitably happen at the film's finish only serves to make the whole thing even more unbearable to watch. Knowing that the two children will starve to death taints every small success that they have, such as navigating a bombed-and-burning Japan, with an unbelievable sadness. After surviving an aerial bombing that leaves their mother dead, Seita and Setsuko take shelter with their aunt, who grows increasingly bitter about having taken them in, as their food supply dwindles down to almost nothing.

The title *Grave of the Fireflies* represents a total loss of innocence for the children. After leaving their aunt they take refuge in an abandoned bomb shelter and use fireflies as a source of light. When the fireflies die, Setsuko, horrified, wants to know why they had to die and why their mother had to die. Seita and Setsuko's outlook on survival now becomes grim and hopeless. A naïve hopefulness of childhood is now forever gone as they march closer and closer toward their own demise.

Akiyuki Nosaka wrote the original short story as an apology to his sister who had died of malnutrition in similar circumstances near the end of WWII. Seita represents an idealized version of what he wished he would have been to her, a person who would do anything to help her... but has said that, in reality, when he found food, he ate it, burning with guilt and remorse. The short story and the animated film adaptation were a means of showing the brother that he wished he had been to her.

Grave of the Fireflies is probably the truest example of an anti-war film that I've seen. There's no sort of message about how horrible atrocities need to be committed in order to secure freedom, or how sacrifice is for the greatest good. All of that is irrelevant. "The greater good" is of little importance to two children who starve to death as a result of governments hurling weapons of mass destruction at each other's civilians. And no blame is placed on anyone other than the situation that is the hellishness of war. War... this unglamorous, shapeless thing, this murderer of millions, and celebrated when the fog clears.

My sister recommended this movie to me under the warning that it was going to hurt. And it does. *Grave of the Fireflies* is one of the most painful movies I've ever watched. It's not some bullshit endurance test where you have to squint and suffer through graphic scenes of gore, it's a movie that goes right after your soul. It's almost relentless in parts, sort of like a gorgeously animated version of the existential dread of Cormac McCarthy. It's an important examination of the suffering of the casualties you *don't* see in movies about war: Children. Orphans. Broken families. This kind of suffering pushes everyone to the breaking point. People who were once full of love and kindness can become animals when they have no food, shelter or hope to survive. Movies like *Grave of the Fireflies* should be required viewing for everyone of a certain age.

Runtime: 89 minutes.

Halloween
(1978)

Halloween was such a groundbreaking film when it came out, it's hard to contextualize just what a big deal that it was, what a game-changer it was for horror movies (and movies in general)... it created, in effect, an entire sub-genre: The slasher. Slashers have been around, in some form or another, long before *Halloween*, beginning with the Grand Guignol and all the way up to the Giallo flicks that were big in Europe in the 60s and 70s. But *Halloween* was something else entirely. It took a barebones approach to moviemaking, simplified the monster down to a terrifying enigma, and just let him run amok. There were many imitators to follow, including a slew of increasingly-inferior sequels, and as a result, the original *Halloween* gets lumped in with those movies and a lot of people actually seem to have forgotten that *Halloween* is a great movie.

It's not just an effective slasher movie, like one of the better *Nightmare on Elm Street* sequels, I'm talking about a *great* movie, something that, regardless of what era you watch it in, is always going to have the same effect on an audience. It's a brilliant piece of filmmaking that distills fear down to its purest essence. It's like boiling horror into crack rocks. The elegance and simplicity that make *Halloween* work so well are completely lost in its sequels and that god awful remake helmed by Rob Zombie. What makes Michael Myers work as a villain is that he's, in effect, pure evil. He's a motivationless blob, referred to in the credits of the original as "The Shape," and to give an amorphous blob of pure malevolence any sort of backstory is to completely misunderstand the point of the original. To watch *Halloween* and to think, "What was Michael Myers like as a kid?" is like watching *Star Wars* and envisioning all the cool new designs on light sabers that could potentially sell more toys.

As a child, Michael Myers (in a breakthrough Steadicam shot simulating his perspective, something that had never been done on this scale before), grabs a knife, walks through his house, pushes open the door to his sister's room and stabs her to death. He is apprehended by the police and eventually serves his time in a mental asylum, overseen by Dr. Loomis (Donald Pleasence) who comes to

believe that young Michael is not merely some psychopathic murderer, but actually a vessel which houses pure evil. On the eve of Halloween, almost exactly 15 years to the day after he killed his sister, Michael escapes.

The following evening, with hardly any parents in sight, like some sort of macabre version of the world of Charlie Brown and the Peanuts gang, Laurie Strode (Jamie Lee Curtis) and her friends are stalked one by one by Michael and murdered. Meanwhile, Dr. Loomis makes his way to Michael's hometown, knowing where he's being drawn to, to help stop the murders.

The white mask Michael wears is appropriate, given his blank personality. The white face is featureless, allowing us to project whatever fears of our own that we have upon it. It also photographs well… there's something unnerving about the way it slowly emerges from the shadows, starting with a small, inchoate sphere glowing, growing and then giving shape to the unmistakable form of Michael Myers, a shining blade by his side.

John Carpenter's direction and Dean Cundey's cinematography work perfectly together in order to achieve the perfect look and feel of *Halloween*. *Halloween* plays like a funhouse ride, with Michael Myers frequently serving as the "surprise!" jump factor. Whereas camera work traditionally flows from left to right, Michael will often pop into frame from the right side, an intentional way to knock the viewer askew, letting them know that they can never predict where he's going to be or what's going to happen next.

Even though I actually like *Halloween II* quite a bit, it's sort of a shame that it exists at all because it takes away from the fantastic ending of the original that asks the question, "Can you ever destroy evil?" The question is much more important than any sort of answer… looking down on the grass below and expecting to see the body of Michael Myers, which has mysteriously vanished. Answering the question with a rather glib, "Eh, probably not," doesn't hold as much impact as the mere *idea* that evil is intangible and indestructible.

I'm an unapologetic fan of the slasher genre, but there's a definite difference between a guilty pleasure I might have like *Sleepaway Camp*

and to the legitimate greatness of *Halloween*. *Halloween* was a big deal, a movie that gave life to the career of John Carpenter, something I will be eternally grateful for. It also doesn't fall victim to something that draws me out of every horror movie that falls victim to it: It doesn't over explain the horror. Why Michael is a murderer is irrelevant. Why he's drawn to his old house doesn't matter… that he *does* kill and *is* drawn to a place is scary. That's all I need to know. The less I know, the better.

Runtime: 93 minutes.

Hamlet 2
(2008)

Comedies like *Hamlet 2* require a lot of finesse to pull off. Dana Marschz (Steve Coogan) is a sad sack, someone who had a lot of hope for their future but failed at realizing his dream of becoming a renowned actor. The problem is that he just doesn't have the talent. He has the passion, sure, and the energy and the excitement, it's just that he's not very good… at anything when it comes to the theater. For the movie to continually shit on the guy would be so easy to do, but where's the fun in cynicism when it comes to some guy who just wants so desperately to be good at the thing that he loves?

Dana, having given up on his dreams of being an actor, lives in Tucson, Arizona, a place the narrator (also Steve Coogan) describes as, "Where dreams go to die." He is a high school drama teacher, constantly battling freshman high school newspaper theater critic Noah Sapperstein who ravaged his last play, an adaptation of the film *Erin Brokovich*. The problem, Noah explains, is that all of his plays are based on existing Hollywood properties, maybe he should try something different. When Dana's eyes flood with excitement and he proclaims he's going to do an original one, Noah makes it clear that's not really what he meant… just that there are other plays that weren't movies he could try. But, it's too late. Dana is already hard at work.

The problem with *Hamlet*, Dana says, is that it's a huge bummer. It's so sad. Everyone dies at the end. Why couldn't it have worked out for everyone? Dana's play, a sequel to *Hamlet*, sets out to correct everything that made him so sad about the original, and give him a chance to work through some daddy issues vicariously through Hamlet.

Dana's plan to write an original play is plagued with problems—namely, that he's having a difficult time writing it due to a lack of talent. On top of that, budget cuts to the school have forced everyone else with a canceled elective to join theater. A crop of Hispanic kids, which Dana views as an opportunity to bond with some inner-city kids like *Dangerous Minds* and other movies he loves so much, join the theater class. But the now-overcrowded classroom has tensions between kids, between the nerdy kids who've been with Dana since the beginning and the tough kids who are seemingly too cool for the play.

The play very quickly takes on adult themes that the school is uncomfortable with and that gives the principal just the excuse that he was looking for in order to finally get rid of theater. "You can't have a school without a drama department!" Dana cries. "Sure, you can," Principal Rooker succinctly replies without hesitation.

There are problems aplenty for poor Dana. At home, his wife has decided to leave him for another man. He breaks his years-long sobriety and falls off the wagon. The future of the play is uncertain. Everything looks hopeless. Like I said, it would be easy to make a movie about kicking someone when they're down, but *Hamlet 2* isn't that kind of movie. It's not interested in such wallowing in misery just for the sake of it, to laugh at the misfortune of someone else. Instead, it's oddly uplifting when we finally see Dana's play come to life on the stage and to see the audience fall in love with his vision.

To be clear, *Hamlet 2* is a stupid, stupid movie, loaded with incredibly puerile humor, non sequiturs and general silliness, and that commitment to such silliness is essential to the overall charm and success of *Hamlet 2*. It wouldn't have worked as a more serious movie. It wouldn't have worked as a darker movie with a more dramatic vision. It needed the goofiness of Steve Coogan who can

overdramatically exclaim that a piece of bad news feels like he was just raped in the face without the emphasis of the joke being on the naughtiness of the word—what's funny is how distraught he is, and Steve Coogan understands that about his delivery. Also essential is the performance from Catherine Keener as his miserable wife, who seems to be delivering a performance from another movie entirely, confused and angry about why she's in *this* movie.

With *Hamlet 2* it's important for us to be on Dana's side, even when he makes terrible decisions that we shake our heads at. When he proposes writing a sequel to William Shakespeare's *Hamlet*, with Jesus Christ as a supporting character who has access to a time machine, we're thinking, "There's no way this is going to work," but the secret success of *Hamlet 2* is that it *does* work, and in a weird way, is almost magical.

My girlfriend showed me *Hamlet 2* with the warning that it was *really* silly and that I would probably hate it. Instead, I loved it right away and it rocketed to the list of my favorite comedies.

Runtime: 92 minutes.

Happy Gilmore
(1996)

I first saw *Happy Gilmore* when I was 10, and it's a perfect movie for a 10-year-old. I don't mean that in a shitty way—if anything, it's a compliment. It's a funny movie regardless of what age you see it, but to really appreciate it, you have to be a prepubescent child. *Happy Gilmore* has an innocence and naivety perfectly in line with that of a young kid.

Adam Sandler stars as Happy, a man with rage issues who is a hockey player at heart, but unfortunately is terrible at skating, so his dreams of becoming a pro never came to life. Hockey is just in his blood. His dad taught him how to do a slap shot, but was unfortunately struck and killed by a rogue puck. Why this didn't make Happy terrified of the sport is never addressed—I assume because it's a silly, knowingly

stupid movie. And because it's an Adam Sandler movie, there has to be a little old lady involved. This time around, it's his grandma, a sweet woman who helped raise him. Because of some issues with having not paid her taxes in some time, she owes the IRS somewhere around a quarter of a million dollars, and unless she comes up with the money in 90 days, they are going to seize her house.

A happy (ugh) coincidence leads Happy to challenge some of the movers during the repossession of his grandma's house to see who can hit a golf ball the furthest. Happy's experience with hockey and his deceased dad's patented slap shot allows him to smack the golf ball incredibly, incredibly far. He seems to be a natural at it. He teams up with a one-handed ex golf professional named Chubbs (Carl Weathers) who lost his appendage to an alligator years ago, effectively ending his career. Coaching and guiding Happy through the game allows him to relive his past successes vicariously through the young prodigy. Winning a series of tournaments, he begins to amass the small fortune that Happy requires in order to save his grandma's house.

Of course, there's time for a little bit of romance, as there always is in these kinds of movies—it's not enough to win the house back, you have to win the affection of a no-nonsense woman, like Virginia (Julia Bowen), the PR director of the Pro Golf Tour. And of course, a movie like this is only as good as its villain, and Christopher McDonald as Shooter McGavin is one of my all-time favorites. He's an arrogant asshole, a smug jerk and all-around nasty person. He's also involved in one of the movie's best moments, where he threatens that he eats pieces of shit like Happy Gilmore for breakfast, to which Happy responds, "You eat pieces of shit for breakfast?" "N-no..."

I know it should go without saying, but comedies like *Happy Gilmore* only work if they're funny. The plot is pleasant enough and free of cynicism, and everything that happens is formulaic and well-worn enough to not ruffle any feathers, but if the jokes don't land, there's no point to be there at all. Luckily, *Happy Gilmore* is a very funny movie. It's one of my favorites. It's loaded with great lines and great supporting roles, especially from Ben Stiller as the terrifying nursing home orderly who runs the place like a sweatshop and asks Happy's

grandma for a nice, warm glass of shut the hell up. And then there's the famous, hilarious fight scene between Happy and Bob Barker.

It's hard to imagine, but there was once a time (a brief period of time, spanning a little over five years), when a new Adam Sandler movie was met with excitement. *Genuine* excitement! The problem, I suppose, isn't that he never grew as a comedian, it's that he gave into his worst impulses. Rather than never growing and never changing, never evolving his comedy, he *devolved*. His funniest movies were certainly crude, but they had heart. There was a plot and context to surround the bodily humor. His later comedies, something like *Grown-Ups*, is nothing more than a platform for those unfunny jokes, and an excuse to get paid to hang out with his friends for the length of a shooting schedule. I'm not so uptight that I can't find the inherent funniness of a fart (farts *are* funny), it's just that a fart by itself isn't... A man farts. So what? A man farts in an elevator? And he's panicking before someone can smell it and inevitably knows it was him? *That's* funny. And the Adam Sandler responsible for Happy Gilmore would know that.

Runtime: 92 minutes.

A Hard Day's Night
(1964)

The first time I saw *A Hard Day's Night*, I was nine-years-old and it was playing on PBS. It was a big event, the movie's 30th anniversary, I believe, and before the movie started there was even a documentary about the film's cultural impact, interviewing people like Roger Ebert. I remember watching the documentary and wondering what the hell the big deal was. So what, the Beatles were in a movie together. Who cares? The Monkees had a television show and it was *terrible* (I lived on reruns of old shows back in the day; how little has changed).

The film opens with Beatlemania at its height. The Fab Four are running, running, sprinting to make it to a train, all the while they are being chased by a mob of screaming and frantic girls. I asked my dad

what would happen if the girls had caught up to the Beatles and he said, "I don't know, they'd probably rip their clothes off or something." And it was right then and there that I wanted to be a Beatle.

A Hard Day's Night is shot in black and white, an unusual decision for the time, considering the enormous popularity of the Beatles and shooting it in color would have been the most obvious and commercially visual choice for the film. But director Richard Lester wasn't going for that, he wanted to create something different, something *special* for his movie. Yes, it was a movie to cash in on the success of the Beatles. No, it was not going to be some formulaic bullshit comedy that's instantly forgotten once you leave the theater. It was, instead, a pseudo-documentary about an imagined day in the life of your average Beatle. It's shot handheld, with a real-life grittiness to it, with film grain popping and dirt spots shining through.

The plot is virtually nonexistent, which is appropriate for this kind of movie. Its plotless, meandering nature is the precise kind of format that works for this kind of picture—instead of being a hindrance, it's the movie's strongest asset. The over-plotted silliness was tried with mixed results on their next outing *Help!* which shines in spots, drags in others. John, Paul, George and Ringo go from gig to gig in *A Hard Day's Night*, with musical interludes and montages galore. They take a train to a hotel, they record a televised musical performance and play a concert at the end. That's about all there is to it. There are, of course, dramatic complications, like Ringo getting arrested, and the gang worried if they're going to make it to the concert on time. They do, of course, make it on time and the crowd goes absolutely ape-shit in a way totally appropriate to the phenomenon of the Beatles—replete with fainting and crying girls.

Some movies can coast by on style. Instead of style over substance, the style *becomes* the substance—*A Hard Day's Night* more or less created the template of the music video that would be imitated, expanded upon and eventually refined for MTV. *A Hard Day's Night* is kind of a cocky movie that knows it's going to be good, because it certainly has the talent and the ambition to back it up. So, the movie is a breezy exercise in "cool." It gives us, the audience, a chance to hang out with the Beatles for a day, see an incredibly exaggerated and often

hilarious view of what it might be like to be them. They volley back witticisms with the press, run from mobs of screaming girls, play some music, have some laughs, and always have a great time no matter what they're doing, unless Paul's fictional, shifty grandfather is involved in a duplicitous scheme.

In a weird way, I've always been surprised that not more filmmakers or bands have taken the formula of *A Hard Day's Night*. It's an easy enough one to follow and to make unique enough to be specific to whoever the focus of the film is going to be. Singers still get starring vehicles, but when's the last time you saw a movie starring a band, *about* the band? I mean, don't get me wrong, I breathe a sigh of relief that whatever terrible boy band out there today doesn't have a feature-length vanity project, but I'm surprised that the studio heads haven't thought of it. The music doesn't even need to be *good*. The groundwork has already been laid, so all you have to do is have a flimsy plot, some jokes, five musical numbers and you have an absolutely assured success.

The beauty of *A Hard Day's Night* is that it didn't have such shallow motivations. It was definitely a financial success, a huge hit at the time, but it wasn't a greedy cash-grab. It was intended to be a good movie, and it is. It remains fantastic today and has aged very well.

Runtime: 91 minutes.

The Holy Mountain
(1973)

The truth behind my initial reaction to Alejandro Jodorowsky's 1973 psychedelic trip into religion, politics and philosophy, *The Holy Mountain*, is that I hated it. My friend Tim had shown it to me, convinced I was going to love it as much as he did. I *hated* it. I didn't just dislike it, I fucking *hated* it. I hated everything about what I perceived to be the highest level of pretension that I had ever seen committed to celluloid. The hallucinatory images felt too forced to be sincere. Whatever actual point the movie seemed to be making felt

too shallow to have any real impact on anyone. Everything it seemed to say—which felt so pleased with itself with how oh, so profound it all was—was like something a 19-year-old who tried LSD for the first time would preach to his friends until he was out of breath ("Did you know that time is like an illusion, man?").

Years later, I revisited it, and guess what? I was wrong. *The Holy Mountain* is a gem of a film, something of the likes we'll never, ever see again. Not in our lifetimes, anyway. There's an honesty to *The Holy Mountain*, a kind of look into the mind and id of the film's maker, and what it reveals is a lot of strangeness—and that's great. I applaud personal filmmaking of all kinds. It takes a lot of guts to put it out there for the whole world to see and openly embrace who you are. Scorsese's best movies reveal his fears and insecurities. Jodorowsky's films reveal the same, but through bizarre imagery which at turns can be either hilarious, or haunting in its absolute, unblemished beauty. So, Tim... something like twelve years later, I was wrong. And you were right.

The plot, such as it is, is similar in a way to the template formed by the great *Seven Samurai*, a sort of popularly imitated (or homaged) story in which a team consisting of the best-of-the-best is assembled to perform a mission. This time, the team assembled is for the mission of self-discovery, and each member represents a planet. An alchemist played by Alejandro Jodorowsky and a Christlike figure known only as the Thief both represent Earth. They, along with the other planets, burn their money and belongings in a symbolic form of starting over and redefining who they are as people. Ten in total, they venture to an island that is home to the holy mountain of the title, to find nine immortals who live atop the mountain and find the secret to eternal life. What happens on the mountain... I guess I could, technically, spoil it, but it makes so little logical sense in any traditional definition that it wouldn't make much of a difference, but I should implore you to watch it one day, just to see what does, in fact, happen and be surprised—pleasantly, or angrily, it doesn't matter—by what is revealed.

When I do these write-ups, I like to spend a little more time talking about the plot, and my favorite scenes, or include a snippet of dialogue

that really sums it up. *The Holy Mountain* is unlike any other movie I've ever seen, so I'm just left with a series of images that stick in my mind, like a woman who has tiger heads for breasts that are vomiting milk. It seems more appropriate to talk about the works that influenced the film, like the teachings of Gurdjieff, because everything about *The Holy Mountain* seems to be designed to influence outside reading, to pursue both spiritual and religious enlightenment. Or perhaps more appropriate to talk about the preparation that Jodorowsky underwent by not sleeping for an entire week, and also by using LSD and giving psilocybin to the actors in the film.

In the documentary *Jodorowsky's Dune*, Alejandro Jodorowsky says that one of the reasons he made *The Holy Mountain* was to make a film that simulates an LSD experience. Some people have incredibly religious or spiritual experiences when taking hallucinogens, and for those people I think that the visuals and the themes of *The Holy Mountain* would speak more personally to them. I've done hallucinogens a number of times and I've had *profound* experiences of self-discovery but never anything like the ones spoken of by people like Ram Dass or Timothy Leary. I wonder if I *had* had those experiences, would my initial reaction to the movie have been different? Would it have spoken to me on a more personal level? Because right now, *The Holy Mountain* isn't a movie I relate to on any personal level, but it is a movie I admire tremendously because of its courage to delve into such personal themes, and because of the craft involved—it's an incredibly well-made movie with a commitment to oddities, and I adore the audacity of it.

Runtime: 114 minutes.

The House of the Devil
(2009)

The House of the Devil begins with a fictional statistic regarding a portion of the population who believed in satanic cults in the 1980s. The statistic is false, but it's funny to think back to a time when satanic cults were the biggest fear people seemed to have. Everything goes in

waves, I suppose. In late 2016, there seemed to be a bizarre, mass hysteria of murderous clowns luring people into the woods. Back in the 80s, though, in Reagan's God-fearing America, people were terrified that they were going to be kidnapped and forced to be Lucifer's bride. A while back, I saw an old episode of *Unsolved Mysteries* that postulates that the Son of Sam killer was not only David Berkowitz, but a baby-sacrificing, cloaked gang of murderers. That was just the climate of the time, for some reason.

It's fun to flash back to a specific era of fear and to pretend that the panicky flavor of the month is reality. That's part of the charm of *The House of the Devil*, it treats everything with such earnestness. The plot is silly by design, but it's absolutely not any sort of parody. *The House of the Devil* is brilliant, subtle stuff and it's scary as hell. It takes breaks to laugh and break the tension, only to throw more and more at the audience in unexpected ways.

Jocelin Donahue plays Samantha, a broke college student in desperate need of money. She accepts one of those jobs that only seems to exist in horror movies, that everyone watching the movie is screaming at her to not take, to get the hell out of that house and never look back. She agrees to be a babysitter for the terrifying and peculiar Mr. and Mrs. Ulman (Tom Noonan and Mary Woronov), and at the last minute it is revealed that she won't be watching a child at all, but rather the elderly mother of Mrs. Ulman. Mr. Ulman assures Samantha that nothing in terms of responsibility will be changed, she's simply there to watch the house, and that they *had* to lie because no one else would have agreed to the job had they told the truth, and all they want is a night out. She agrees under the condition of another $400.

Samantha's friend Megan (Greta Gerwig) tries to convince her to leave when the situation presents all the red flags, but Samantha *needs* the money and decides to stick with it. Megan leaves, but agrees to swing by later to get Samantha after, leaving Samantha alone in the giant, spooky house.

It's in the quieter moments of the film when director Ti West shows his talent with building tension. He's a natural at it. It harkens back to some of the earliest rules of tension, like the example Hitchcock gave about seeing people eating lunch, with the viewer knowing that

there's a bomb under the table, but the characters are oblivious to it. Samantha dances through an empty house with headphone clamped to her ears, blissfully ignorant of the evil surrounding her, while we know something that she doesn't, and it gnaws at us as we watch her try to enjoy her lucrative evening.

The House of the Devil is good enough that I can forgive its sort of rushed ending. It's an imperfect ending tacked onto one of my favorite horror movies of the 2000's. What happens was absolutely bound to happen, something that took great care and time building up to, but should have been something altogether unexpected. It should have been something more intangible. Fear is an emotion directed at the unknown, and any sort of reveal is to define the nature of the horror, and demystify it. To go for such a slow burn and then define everything is, I suppose, expected. That's just the way it goes. But I wish that there was a way to keep everything wrapped up in an enigma and ramp up the lingering terror, to do something like H.P. Lovecraft at his best, where the mere *idea* that something supernatural exists is enough to drive the main character to madness. I know I sound overly harsh, but I did enjoy the ending, I just wish there was *more*. Because I'm greedy.

Movies like *The House of the Devil* exist to remind us what horror movies are capable of. They're capable of incredible stories that are small in scale, but pack as much of a wallop as some sweeping epic does. Most of the action of the film is contained to one location, and it's brilliant. Ti West proved himself as one of the foremost horror directors with this film and has since provided himself again with *The Innkeepers* (which I love almost as much as this one) and had only a few missteps. I can't wait to see what he brings us next.

Runtime: 95 minutes.

Jackie Brown
(1997)

When it first came out, *Jackie Brown* was considered a disappointment because it wasn't *Pulp Fiction*. It was much more of a straightforward

picture. It made a profit, sure, but *Pulp Fiction* was a colossal, monumental success. And because of that, *Jackie Brown* remains something of an anomaly to Quentin Tarantino's filmography—which is a shame, because it also represents his first and only real attempt at "mature" filmmaking, whatever that means. Don't get me wrong, I've enjoyed just about every movie he's made (some much more than others, but I regard them all with fondness), but *Jackie Brown* is kind of a glimpse at what could have been. If *Jackie Brown* had been more successful, his directorial output may have been totally different. Would we have still gotten *Kill Bill* if that were the case? I don't know. I'd hate to miss out on that, but I am glad we have *Jackie Brown* to re-watch, relish and enjoy.

Jackie Brown tells the story of a struggling flight attendant named Jackie Brown (played by Pam Grier) who gets busted by ATF agent Ray Nicolette (Michael Keaton) and LAPD officer Mark Dargus (Michael Bowen) who are working on a joint investigation together on Ordell Robbie (Samuel L. Jackson), a gun smuggler. Jackie's job is as a courier, she smuggles money to and from Mexico for Ordell for his firearms transactions. Nicolette and Dargus cut Jackie a deal: If she helps them catch Ordell, she gets to go free.

The problem is, there's a lot of money at stake here. We're talking $500,000... enough money for Jackie to start over and have the life she's always wanted. Jackie discovers she's capable of much more than she ever gave herself credit for, playing both sides of the operation. She tells Ordell about the plan to get him on board. She goes back to the police and tells them he knows. Her plan, unbeknownst to either side, is that she wants to keep the money for herself.

A movie like this *needs* a great supporting cast, and *Jackie Brown* has one of the best. Robert De Niro plays Louis, Ordell's friend who just got out of prison for a bank robbery. Louis is a nice guy and a great sidekick, but he isn't all there. The details of the scheme go way over his head. Bridget Fonda plays Melanie, Ordell's quasi-girlfriend he has a house with by the beach. She and Louis are hooking up regularly, and she has her own plans for keeping the money. Robert Forster plays Max Cherry, the bail bondsman who falls head-over-heels for Jackie

the first time he sees her. He and Jackie have deep conversations about age and happiness that you rarely get to see in the movies. Their relationship isn't a superficial one, it's genuine, and it's so well-written I wish that they had their own movie together, some inconsequential movie where everything works out fine for them in the end and we get to just hear them talk.

It should go without saying, because every Tarantino movie has a great soundtrack, but *Jackie Brown* boasts one of the *best* soundtracks, including everyone from Johnny Cash to the Delfonics.

Jackie Brown is the only movie of Tarantino's based on an existing property, the novel *Rum Punch* by Elmore Leonard. Elmore Leonard is a perfect fit for Tarantino's style, because they both have a knack for portraying criminals and thugs as likeable folks, with killer dialogue; a sort of "honor among thieves" motif, in a way. Some of my favorite moments in the movie don't have anything to do with the story itself, it's in these moments when they're hanging out at Melanie's beach house, just talking. Later on in the film, there's a great moment where Ordell leans in and begins to contemplate what went wrong with a simple money swap, and the camera pushes in on him, and you get to see someone genuinely think, trying to figure out what happened. It's moments like these that help sell the reality of the movie. Every movie, no matter how grounded in life it might be, or how surreal another movie might be, needs to sell the reality to the audience. A movie about real people like *Jackie Brown* needs to do as much work selling itself as a sci-fi movie needs to in order for us to buy the situation and believe that what we're seeing is real in some way. *Jackie Brown* excels at it. We believe that we're not watching actors reciting lines of dialogue, but instead that we're just watching people trying to con each other out of half a million dollars, and we can see the different ways they each convince themselves that they're the good guy of the story.

Runtime: 155 minutes.

Jaws
(1975)

For better or worse, *Jaws* is the movie that pretty much created the summer blockbuster film event as we know it. The massive, massive success that it had was, at the time, completely unprecedented. For a budget of $7 million, it went on to make $260 million in the U.S. and a total of $470 million worldwide. That record would later be shattered by *Star Wars* just two years later, but until that happened, a shark with an appetite for beach-goers ruled the movies. *Jaws* was a cultural phenomenon the likes of which had never been seen. Monster movies (especially those produced by Universal, who also made *Jaws*) were always a thing, but this was the first time people were terrified of a monster that actually exists in this world that we inhabit. I feel like *Jaws* is responsible for the fear we all have, no matter how well we know the statistics, when we dip our toe into that big, blue ocean.

The film begins with a cold open worthy of the best of the best of horror films. A man follows a woman from a party, where she goes swimming. He passes out drunk, and she continues to swim, gliding through the water. The perspective shifts to the eyes of a shark swimming up through the water, toward her kicking legs. She jerks. She gasps. Something pulls her and she screams. She screams bloody murder, begging for God to come save her. Suddenly, she is pulled under the water. Silence.

Roy Scheider stars as Police Chief Brody, a man terrified of the water, yet lives on an island that gets thousands of tourists every summer to hit the beaches. "It's only an island if you look at it from the water," a drunk Brody explains to Hooper (Richard Dreyfuss), his partner in finding the bloodthirsty shark. In the beach community of Amity, one man can make a difference, unlike his life as a New York City police officer, where his efforts never seemed to matter.

After another victim, this time a young boy, is eaten, Brody pleads with the mayor (Murray Hamilton) to shut down the beaches to save lives. The beaches, though, and tourist dollars at local shops and restaurants, are the only real source of money that they have, and if the beaches are closed, they're going to find themselves broke. With

the waters packed with swimmers from all over, tragedy of course strikes again. Chief Brody, Hooper and the Ahab-esque shark hunter Quint (Robert Shaw) head out into open waters to find, and to kill the shark once and for all.

The final reel of the film switches gears and into a seemingly different genre altogether, but no less thrilling. Somehow, out on the turbulent seas, *Jaws* becomes more claustrophobic and more cramped, stuck inside the quarters of Quint's small ship. The ocean becomes threatening instead of majestic.

When the shark is finally revealed in all its glory, in a shot where it pops out of the water to eat chum slopped out by Brody and he mutters the immortal line, "We're gonna need a bigger boat," is such an earned, classic moment in cinema. Up until now, the most we ever saw of the shark was either its fin, or a silhouetted shot of it, mouth agape, swimming toward a man's leg. By now, the story of the malfunctioning robotic shark behind the scenes is legend. The shark was supposed to be seen much, much more often throughout the film, but serendipity stepped in and prevented it from happening, forcing Spielberg to mount tension from a mostly-unseen monster lurking somewhere beneath the waves.

One of my all-time favorite moments in *Jaws* is kind of a rip-off when you really sit down and think about it, and it's a total afterthought, something Spielberg went out and shot after the film had wrapped because he felt that he could earn one more scream from the audience. The set-up is this: Brody and Hooper are investigating a ship out on the ocean and in the side of it is a gigantic hole ripped in its hull. Hooper studies the hole and finds a shark tooth. While he's prying the tooth loose, a severed head pops into view—a classic jump scare. The musical cue even has a literal *scream* built into the chord, so it works the way a laugh track would work for a sitcom—instead of telling us when to laugh, the movie tells us that we should scream. And we do. It's just a fantastic, well-deserved jump scare (one of the best in film history), but it's so cheap. It's so dumb. It shouldn't work, but somehow it does. If you even study the *logic* behind that severed head scare, it doesn't make sense, because later when confronted by Brody and Hooper, the mayor seems to be more phased by a dropped tooth

than anything else... because the scare was a last-minute addition to the film, plotting and continuity be damned.

A movie like *Jaws* is such an amazing, rare treat when it comes to horror movies. It's a movie that contains real thrills and screams. A lot of movies have copied its plot where a mayor or someone in a position of minimal power knows there's a threat and ignores it because there's money to be made, but no one has ever really successfully imitated what it is that actually works so well about *Jaws*... the fact that it's actually scary. The writing, the performances, the cinematography, the directing... they're all top-notch. The success of *Jaws* and how much good, quality work went into it can be summed up by Quint's speech he gives about the USS Indianapolis. It took a rewrite by Shaw himself and a draft by John Milius to get it perfect. And it's damned near Shakespearean in its final form, the way Robert Shaw seems to wince in pain remembering the way a shark's eyes roll over white when it sinks its teeth into someone.

Runtime: 124 minutes.

Jurassic Park
(1993)

All these decades later, *Jurassic Park* remains one of the best special effects movies that's ever been made. Following, in some ways, his success that he had with *Jaws*, Steven Spielberg makes a conscious decision to not show the dinosaurs too early on. The move begins with them alright, when a security guard is killed by a velociraptor, but the film wisely only shows us bits and pieces of them. An eye here, a snout there, but mostly it remains hidden. Spielberg doles out visuals in spectacular moments, and there are several reveals hidden throughout the film, each one as spectacular as the one before: When we see the brontosauruses for the first time; the sick triceratops laying on its side; when the tyrannosaur escapes its paddock; and the scene that finally, in the film's final reel, shows the raptors capable of opening doors.

Jurassic Park is a theme park where the attraction is living, breathing dinosaurs, behind electrified fences, in all their glory. The creator, Mr. Hammond (Richard Attenborough), was drawn as a child to the spectacle of a flea circus, with little animatronics and moving parts that would convince children they could actually *see* the fleas, even though deep down they knew the fleas didn't really exist. As an adult, he wants to make something that appeals to the imagination of a child, but do it for real. No more illusions. He utilizes cutting-edge technology to extract dinosaur DNA from a mosquito encased in amber and clones the extinct animals to exist in our world today. Prior to officially opening, he has a trial run and invites a team of experts to win them over: Paleontologists Alan Grant and Ellie Sattler (Sam Neill and Laura Dern), cynical mathematician Ian Malcolm (Jeff Goldblum), the lawyer Gennaro (Martin Ferrero) and Hammond's grandchildren Tim and Lex (Joseph Mazzello and Ariana Richards) to target the child demographic that he has in mind.

Because this is essentially a monster movie, it doesn't take long before things go wrong. Dennis Nedry (Wayne Knight), one of the computer programmers for Jurassic Park, is hard up for cash and takes an offer from a competitor to smuggle out some of the dinosaur embryos so that a team of scientists can analyze them and make some of their own. In order to get out in time to meet his deadline, he shuts off the security system, leaving the electrified fences inoperative. On his way, he wrecks his jeep and is eaten by a dilophosaurus—a little dinosaur that spits venom into the eyes of its prey to blind them and then devours them. With Nedry dead and no way to restore power to the fences, the dinosaurs begin to escape. In an incredible scene, the t-rex escapes, wreaking havoc along the way, and separates Grant and the children from the rest of the group.

The moment where the t-rex escapes from its paddock is great filmmaking. It hits every emotional beat, and the way it builds and builds to the inevitable is masterful. It's absolutely terrifying. It's a wonder to behold the special effects that look like real animals—the tyrannosaur's pupil even dilates when a flashlight is shined into its eye. When the t-rex attacks the vehicle that the children are inside of, the camera rarely leaves the inside of it, with the exception of a few

establishing shots for the sake of clarity. We're with them through the entirety of the ordeal.

There's a small moment during the t-rex scene where Tim closes the door of the vehicle he and Lex are in right under the nose of the dinosaur and its head jerks toward the kids. The only thing that move served to accomplish was that it ended up putting him and his sister in even more danger, but come on... who's not going to close the car door when there's a giant, man-eating dinosaur outside?

Equally thrilling are the scenes involving the too-smart-for-their-own-good velociraptors. You can see subtle little movements in their heads when they begin to solve a problem and they feel not like the creation of a special effects team, but actual, intelligent animals.

My complaint with many similar movies is that dinosaurs are animals and they kill primarily to eat, or when they feel threatened. In a lesser movie, the dinosaurs would be reduced to killing machines. In *Jurassic Park*, the dinosaurs behave logically. The t-rex eats when it's hungry and it attacks when it feels threatened. Instead of pursuing Grant and the children, it snacks on a stampede of gallimimus that unwisely get too close to where it's hiding in the trees. The velociraptors behave a bit more insidiously than that, but for the most part, the dinosaurs in *Jurassic Park* look and behave like animals that might actually exist. They interact with their environment and the ground shakes and booms when they come near, water rippling in a glass as they come closer and closer. They're not just special effects, they're almost real, and the special effects, that are still amazing today, really help sell that illusion. It was a wise choice to only use CGI only when totally necessary, using traditional effects for closeups. An overabundance of CGI can reduce an effect to nothing more than a cartoon, which is sort of what happened with the silly *Jurassic World*—that and a lot of really, really bad writing.

I re-watched the first sequel, the Spielberg-helmed *The Lost World: Jurassic Park* and even though it's not very good, I have to admit that I sort of admire it. It tried to be completely different from the first movie. It looks different. It *feels* different. It takes on a whole new style, opting out of futuristic park setting and going for an island adventure movie, sort of like a cross with *King Kong* and *Godzilla*, but

with state-of-the-art special effects. It didn't work. It didn't work, but it tried, and I can't fault it for that. It didn't simply tread in its predecessor's giant-sized footprints, it wanted to be something special, a unique sequel that stepped out from underneath the original's shadow. The way I like to explain *The Lost World* is to imagine it as a meal, and Spielberg is the chef. He had some really interesting ingredients and unique ways of preparing them, but something must have happened, like an approaching deadline, so all of that wonderful stuff got lost under a bunch of salt. And the overall result isn't *bad*, it's just... eh. I'd rather order something else.

Runtime: 123 minutes.

Kill Bill Vols. 1 & 2
(2003/2004)

One of the most fun experiences I've ever had watching a movie is when my girlfriend and I spent a lazy Sunday making food, drinking beer and wine, and watching both volumes of *Kill Bill* in a row. If you've got a little over four hours with nothing to do, there are a lot worse ways to kill time. We just made a day of it. It was supposed to have just been the one movie, but when the first one ends on that terrific cliffhanger, we just couldn't resist, and pressed forward.

Kill Bill, in a weird way, feels like a very personal movie to Quentin Tarantino. It's probably his most fun movie that he's ever made—it's just pure entertainment, giddy in its execution. But it reveals a lot about who he is as a person, and not many of his movies present that glimpse into his psyche that *Kill Bill* allows for. I mean, *Pulp Fiction* is fucking amazing, no one's disputing that, but what does it say about Quentin Tarantino, except that he likes old TV shows and movies? *Kill Bill* is like Quentin Tarantino cranked up and allowed to run wild, with nothing holding him back. Anything is possible in this world, this total world of make-believe.

Quentin Tarantino's movies all take place within a shared universe, and there's a certain continuity that continues throughout his filmography, with little things like brand names (Red Apple cigarettes, etc.) and character names that pop up multiple times. *Kill Bill* is no

exception, except that it doesn't take place in the same world that *Pulp Fiction* or *Reservoir Dogs* does, in that Uma Thurman's "Bride" character will never meet Mia Wallace. Instead, *Kill Bill* exists in a purely cinematic universe, so while Mia Wallace may never meet the Bride, she would maybe see *Kill Bill* in the theater. *Kill Bill* is a movie that would exist for his characters in his shared universe to watch, and that explains why it's so gleefully over-the-top, much more so than anything he's ever done before or since (with the exception of maybe *Death Proof*, which appears to similarly be something of a movie within a movie's universe).

Kill Bill is a revenge tale set in a world that's not quite a western, not quite a martial arts film and not quite a sleazy exploitation film of the grindhouse era. Instead, it's somehow all of that, with a unique Tarantino spin on it that makes it something extraordinary. Unlike the many filmmakers that fancy themselves to be of the same vain, Tarantino doesn't homage a specific film or a genre because it looks cool, he does it because he genuinely loves it, and that love comes across when you actually see the movie. Midway through *Kill Bill*, when it switches formats to temporarily become an anime film to tell the story of O-Ren Ishii, it's not because he's trying to buck trends and do something off the wall, it's because he loves anime, and it also served a narrative purpose as being the best way to tell that piece of the story—there are extremes you can go to in an animated film that would be too intense for live action.

On the day of her wedding, the unnamed character that we only know as the Bride until near the end of the second volume (Uma Thurman) sees her fiancé and his family brutally slaughtered. Bill (David Carradine), the Bride's former boss, mentor and lover, puts a bullet in her head. She goes deep into a coma and awakens several years later to find that her unborn child had been ripped from her belly. After enlisting the help of legendary sword marker Hattori Hanzo (Sonny Chiba) to make her a blade worthy enough to cut the gods, she carves a path of destruction all the way up to the last person on her list of people to kill: None other than Bill. Before Bill, she must kill her fellow assassins who were also responsible for her attempted murder.

Each volume of *Kill Bill* tells a different portion of the story in its own unique way. The first volume is more focused on the action, climaxing with the incredible "Showdown at the House of Blue Leaves" in which the Bride must battle a mask-clad gang known as the Crazy 88s. There's not really 88 of them, they just chose that name because, according to Bill, they "thought it sounded cool," but there are a whole hell of a lot of them. As arms are hacked off and torsos are impaled, she moves closer and closer to her final target, O-Ren Ishii, the friend who betrayed her.

The climax of the second film is much quieter, but no less thrilling, when she finally meets Bill. The power and strength and intelligence of *Kill Bill* is to know when the movie needs to be loud and over-the-top, and then to know when to play it subdued, where the appropriate mood for the story should be somber instead of silly.

There's a lot of heart to the *Kill Bill* movies, and my enjoyment of them increases each time I see them. They feel like a rare chance to have Quentin Tarantino open his head, dump out the contents and allow you to discover, along with him, all of the things that he loves—from films like *Shogun Assassin* to concepts like Superman and his identity crisis to the great music that makes up the soundtrack. While I don't think *Kill Bill* is necessarily his best movie, I do think it's his most intimate, and on those grounds I adore it. I feel like *Kill Bill* must have been such a treat to create that every movie Quentin Tarantino has made since feels like a weaker and weaker version of what he'd captured with *Kill Bill*.

Kill Bill, Volume 1 runtime: 93 minutes.

Kill Bill, Volume 2 runtime: 137 minutes.

Kingpin
(1996)

Kingpin has no right to be as good as it is. None. It was the anticipated follow-up to Bobby and Peter Farrelly's *Dumb and Dumber*, and they went ahead and made another road trip movie of sorts. This time,

instead of two mentally-challenged friends on the road to deliver a missing briefcase, it's a disgraced bowler who once had a lot of promise, whose name has become a verb for when you fuck up really bad, and his protégé, an Amish man who needs money to save his community. It repeats a formula and twists it here and there, and it should have been awful. But, instead, it's a great movie.

Roy Munson (Woody Harrelson) was once a young man with lots of promise. He was a dumb, naïve farm boy with a love of bowling, passed on to him since he was a child from his father. He made the mistake of getting mixed up with Ernie "Big Ern" McCracken (Bill Murray, who steals every scene that he's in), who tried to use Roy in a scheme to rip off some good old boys who weren't having any of it, and put Roy's hand right into the ball return. Roy loses his bowling hand, replacing it sometimes with a cheap, rubber prosthetic or with a hideous metal claw. He now finds his days soaked with booze, living in a dingy apartment that he has to perform cunnilingus on his hairy, chain smoking landlord to get extensions on the rent for. "Oh, it wasn't that bad," she chides Roy while he vomits afterward.

Roy crosses paths with Ishmael (pre-crazy Randy Quaid), someone he sees a lot of himself in. Ishmael is as naïve as Roy once was, and has the same promise with bowling. Bowling is the one thing he treats himself to that his Amish community knows nothing about—an innocent-enough vice he keeps a secret. Roy sees the lucrative possibilities inherent in Ishmael, with Roy sort of assuming the Big Ern role in their relationship. And Ishmael needs Roy's guidance, once he finds out that he needs a massive amount of money to keep the Amish community from being seized for bad debts.

The dysfunctional duo becomes a trio when they're joined by Claudia (Vanessa Angel), who aids them in their various hustling schemes for some quick money here and there while on the road on their way to a tournament, the winnings of which promise to solve all of their financial problems.

Big Ern returns for the final showdown, now considerably older and rocking a combover that raises to the heavens. The showdown now isn't just about the money, it gives Roy an opportunity to redeem

himself and his wasted life and take back the name "Munson" so that it's no longer synonymous with failure.

Kingpin has an oddly epic feel to it. It spans time through decades and distance across the entire country. It has moments of pathos that are earned, that aren't sappy and aren't cynical, like when Roy visits his hometown and has a profound feeling of guilt when he tries to figure out what all went wrong. He tells Claudia that he never visited back home, not even after his father died, because he was so ashamed of himself and what he'd become.

The secret to what makes *Kingpin* work as well as it does is that we actually care about the characters. After seeing everything they've gone through, it's not just a perfunctory beat in the story to see them face off against the man responsible for everything that's gone wrong for Roy, it's important to see them rise up victorious. But because *Kingpin* isn't a traditional, lazy exercise in formula, not everything always works out the way that it's supposed to.

Bill Murray is, of course, incredible in *Kingpin* and every scene that he's in is laugh-out-loud funny, and the way he sells lines makes it all work, like when Roy is eating cereal sloppily, so Big Ern suggests he just finish his breakfast outside. But the great thing about *Kingpin* is that during that big chunk in the middle that's devoid of Bill Murray, we don't necessarily miss him. The movie works just as well without him, and so the character is used sparingly. He's a bookend to the film, introducing us and then closing it out. In a movie that wouldn't have worked as well as *Kingpin* does, all of the scenes without him would have suffered—instead, he's like an ingredient to be used thoughtfully so as to keep him from being overpowering.

Kingpin is one of my favorite examples of a stupid movie that takes a lot of intelligence and wit to work. There are plenty of gross gags involving poop (somehow the one involving floss is the grossest of all), or raunchy sex jokes, but the real strength of *Kingpin* is its heart.

Runtime: 113 minutes.

L.A. Confidential
(1997)

L.A. Confidential is one of those rare examples of a movie that's better than the book. *L.A. Confidential* is a good book, but it's a *great* movie. What director Curtis Hanson and co-writer Brian Helgeland did was remove some of the pulpier plotlines involving a Black Dahlia-esque serial killer, and just stuck to some of the juicier bits involving police corruption, the mafia, heroin, and a strange service for hire where prostitutes undergo plastic surgery in order to look like famous movie stars of the time.

Guy Pearce plays Ed Exley, an ambitious young police officer who wants to make personal history for earning a detective's rank at a younger age than his father did. The opportunity comes for him on Christmas Eve when his fellow LAPD officers are caught drunkenly beating a group of Mexicans suspected of jumping some cops on their beat. He rats out those involved, with a deal to jump rank. This doesn't make him popular around the precinct, but it gets him exactly what he wants.

Kevin Spacey plays Detective Jack Vincennes, who hasn't done any real police work in years. He's too busy being the technical advisor on a *Dragnet* ripoff called *Badge of Honor*. After the Bloody Christmas scandal breaks loose, he's put on temporary suspension from the show and is put on vice detail as punishment.

Russell Crowe plays Detective Bud White, a good man with deep problems stemming from childhood. He abhors violence against women and takes a special interest in domestic cases, beating the men involved within inches of their lives. After his friend and partner Detective Stensland is disgraced and fired following Bloody Christmas, he vows to get revenge on Exley, no matter the cost.

Bud's no-nonsense attitude and utilization of violence at any cost to extract information from suspects gains the attention of Captain Dudley Smith (James Cromwell), who takes him under his wing. Together, and with a team of likeminded detectives, they beat and maim their way to a sort of justice that borders on vigilantism.

Everything changes, though, on a night when Ed answers a call for a shooting that occurred at an all-night diner called the Nite Owl. When he arrives, everyone inside has been killed. The reveal of the carnage is such a chilling moment, shot almost like a horror movie. Ed pushes in the door and creeps in, and notices that something is wrong right away. Little things, like the griddle still operational but with no one around, the food on top burning to a crisp. He notices a hole in the wall, smattered with a small bit of blood, and follows a trail to the bathroom, where he finds that everyone has been executed and stacked on top of each other. One of the victims is Bud's ex-partner Stensland.

Exley and Vincennes, in their own separate journeys, begin to notice the rampant corruption within the LAPD and team up to find out what's happening. Bud, too, who was underestimated as a mindless thug, begins to use his natural talent for detective work to piece together details that don't seem to make much sense under close scrutiny. The Nite Owl murders were pinned on a couple of African-Americans who appear to have had nothing to do with it. The murders, it seem, were orchestrated in order to keep some witnesses quiet.

The movie is about Los Angeles in the 1950s and is shot in a similar style to movies of that era, with a great supporting cast to back up the sometimes-confusing script. Kim Basinger plays Lynn Bracken, a prostitute from Bisbee, AZ who looks like Veronica Lake. She begins a relationship with Bud White, and her motivations are never totally clear... life has been hard on her, and she does what she can to survive. Danny DeVito plays Sid Hudgens, the publisher of a sleazy tabloid called Hush-Hush, one of those rags that back in the day would publish stories about which members of the Hollywood elite were secretly gay.

L.A. Confidential works on multiple levels. On one level, it's a great detective story—the way the mystery unfolds, bit by bit, is nothing short of great writing. On another level, it works as call-out to 1950s Hollywood, in all its glitz, glamour and exposing its seedy underbelly. And in overall direction and storytelling, it's absolutely top-notch stuff. The way that the violence is framed, and sometimes explodes unexpectedly, is incredible. The scene where Exley chases down a

suspect with a shotgun that leads to a bloody confrontation in an elevator is perfectly filmed.

This along with *Jackie Brown* and *Boogie Nights* form a perfect trilogy of great, genre-defining films set in Los Angeles that had all came out in the same year, 1997.

Runtime: 138 minutes.

Martin
(1978)

Martin is not your average vampire movie, and Martin (John Amplas) is not your average vampire. He might not even be a vampire at all. The sun doesn't reduce him to ash, it just sort of irritates his eyes is all. And he doesn't have fangs, or hypnotic powers... he uses razor blades and hypodermic needles filled with drugs, instead. When the film begins, he boards a train and sneaks into a woman's cabin. He drugs her, rapes her, and uses a razor blade to cut open her arm and drink the blood that spills out of her.

When he arrives at his destination, he is greeted by his granduncle Cuda (Lincoln Maazel), who treats Martin as a curse. He believes Martin is a vampire, and he assures the young man that if anyone in town winds up dead because of him, he won't hesitate to put a stake through his heart.

Martin's cousin Christina doesn't understand why Cuda is so mistrustful of Martin. Cuda assures her that Martin is no young man, he is actually 80-years-old and has the paperwork to prove it. Whether this is a fact or some sort of dementia-induced paranoid belief is never revealed. Even when we see flashbacks of Martin from generations ago, it's unclear whether this is Martin's fantasy vision of what he thinks of himself or if these flashbacks are genuine.

At night, Martin calls in to a local radio station and tells stories about being a vampire, and what it's like to be afflicted with vampirism. Martin squashes a lot of popular misconceptions about what it means

to be a vampire. It's not like in the movies, he says. In the movies, vampires always have lots of ladies, and it's not like that for him at all.

Before long, the temptation and the thirst for blood is too much for Martin and he takes to prowling and stalking his next victim. It, of course, doesn't go as planned, and he barges in on a woman he expects to be alone, only to find her in bed with another man while her husband is out of town. Martin's need to feed continues through several more nights, jeopardizing the arrangement he was with his granduncle, who is growing more and more suspicious of him every day.

Martin's hunger subsides when he begins a doomed romance with an older woman that is destined for failure. To Martin, it's the happiest thing in the world to finally be able to indulge in what he calls "the sexy stuff" but for Mrs. Santini, it's a cry for help.

The ending to *Martin* is shocking, unexpected and altogether brilliant. It's such a good movie that my roommate at the time years ago, this impossible-to-please movie snob, at the end of the movie even said, "That was a pretty good movie." *Martin* is George A. Romero's most mature movie—in a lot of ways it reminds me of a bright spot in his filmography akin to *Jackie Brown* in Quentin Tarantino's filmography. It's unlike anything he's done since. Stylistically, it's pretty similar to *Season of the Witch* (not a great movie, but one I enjoyed a lot more than many other people), but the combination of drama and all-out horror is just so perfectly executed here. *Martin* looks and feels like it was shot by a small documentary crew. It has this cinematographic look that's washed out, the city itself crumbling all around Martin, like his very presence in any city brings about its destruction. It's a movie that could have only been made in the 70s.

George Romero is a gifted filmmaker in a lot of ways. He's a great storyteller; he can write, he can direct, he's just suited for the craft. But one thing he's incredible at, and really shows a talent for here, is in editing. The pacing and cutting of *Martin* is award-worthy. The way it transitions back and forth between what could possibly be a dream or a memory with absolute clarity—in the sense that we understand it's ambiguous by design—is amazing stuff.

Romero's *Dead* films are rightfully classics, but *Martin* is an underappreciated gem that needs to be rediscovered. It's unexpectedly good. It's much better than you would think it would be. It has a loneliness to it that, to me, is so unique to the movie and the way it's shot. Lots of movies deal with isolation and loneliness and convey it through their visuals, but *Martin* really excels at it, and somehow pulls off the impossible by not only asking us to watch a movie with such a despicable main character, but to somehow sympathize with him. After all, all the film is asking us to do is the same thing every vampire movie before it has already asked, it's just that this time it shows his nighttime proclivities in graphic, unrelenting detail, without apologies.

Runtime: 95 minutes.

Miracle Mile (1988)

A phone rings.

A phone rings and you answer it, expecting a call. A wrong number. The person on the other line, you think, is pulling your leg. The end of the world, they say. The nukes are coming and it's not a matter of if, it's a matter of when—only a few hours and the world as we know it will end. What do you do? Do you say anything? Is the ensuing panic justified, as the death rattle of civilization, or is it much ado about nothing... innocent lives being lost in a senseless riot?

This is the reality of the criminally underseen 1988 film, *Miracle Mile*, a masterpiece that is receiving newly-found cult appreciation.

The film is haunted by a loneliness, taking place in a Los Angeles populated by the up-all-nighters, the occupants of a coffee shop at 4:00 a.m. while the rest of the world is fast asleep. The score by Tangerine Dream floats somewhere between surreality and waking life, perfectly capturing a moment in between dreams and in between life and death.

In a way, *Miracle Mile* almost seems to represent a sort of anti-*Armageddon*, or anti-*Transformers*, where destruction isn't celebrated; it's shown as being an absolute hell on earth. In today's modern era of Hollywood blockbusters where entire cities are destroyed for the sheer spectacle of it, it's hard to imagine there was an era of the 80's that was terrified of the reality of the Cold War going nuclear. Movies like *The Day After*, *Threads* and even *Terminator 2* (though it had fun with destruction, the nuclear blast dream sequence is intentionally unpleasant by design) portrayed annihilation with a fearful eye.

When you see a great film, you always remember the events surrounding its viewing. You remember who you were with, where you saw it and on what format. I remember reading about *Miracle Mile* from *Videohound's Cult Flicks and Trash Pics*. The review drew me in and I remembered thinking, "I have to see this movie." Months later, my girlfriend and I were talking about those Sunday afternoon movies on network TV that sometimes accidentally play weird, legitimately great movies. The movie she told me about sounded vaguely familiar and it clicked.

"That's *Miracle Mile*!" I said.

"Well, let's go rent it," She replied. "I haven't seen it since I was a kid."

We got the DVD from Netflix in the mail and I don't think a word was uttered between us throughout the viewing. We watched it again the next morning.

The emptiness and the expansiveness of the Los Angeles as seen in *Miracle Mile* reminds me of *Night of the Comet* in the best possible way. In the same way that Springfield in *The Simpsons* and Baltimore in *The Wire* are characters unto themselves, I feel that LA in *Miracle Mile* is a living, breathing entity. It shows the city in a way that's more real than we typically see in other movies that take place in the city, but it has an otherworldly, ethereal quality.

Anthony Edwards and Mare Winningham, as the couple in the middle of the chaos, are perfectly cast. The set of circumstances that bring them together in the beginning, and together in the end, lead to a finale that is somehow as romantic as it is suffocating. It's simultaneously the sweetest moment and pure, personified fear. In its

own way, Miracle Mile might be one of the most romantic tragedies ever told.

Steve De Jarnatt, writer and director of *Miracle Mile*, had initially written the movie as what was to be the *Twilight Zone* movie, but refused to change his bleak ending. As such, the version of *The Twilight Zone: The Movie* that we have now is much, much different—focusing on different stories instead of one standalone plot. Despite objections from various studios and various backers, De Jarnatt stuck to his guns and made the movie exactly the way he wanted to. And we thank him for it. *Miracle Mile* is a hidden gem just waiting to be discovered by new generations of film viewers again and again, thrilling, charming and scaring the absolute shit out of those not knowing what to expect.

Mr. De Jarnatt was gracious enough to answer some questions for me that I had about the film and its legacy.

VideoBilly: The ending, in which Harry and Julie find themselves trapped in a helicopter at the end of the world, sinking into a pit of tar, is absolutely terrifying... yet, the way he consoles her and tells her that a direct hit by a nuclear explosion will turn them into diamonds, is incredibly sweet. It's almost a perfect scene, balancing so many emotions without missing a beat. Do you remember how you thought up that scene? You fought very, very hard to keep the ending as you wrote it—was it a personal scene for you?

Steve De Jarnatt: It must have been a primal thing. I never considered another ending. The couple meets among extinct species – and at the end they are those species (as will all will be). As you pointed out – I turned down many possibilities to make a different movie. Even Warner Brothers who developed and supported it – would have allowed this ending to take place – but then Harry would wake up – and it was all a dream – and it all started happening again. Even that seemed too compromised to me. And I don't think an audience would have liked it either.

What else is there at THE END? Other than to be with someone – and in this romance – Harry found the ONE. We all will have the same climax of our life stories – but when the time comes if there is some

shred of hope (which is what humanity has that more noble [less cognitive] creatures do not) – we can endure it a little better.

VB: There are certain films that create an atmosphere, dependent entirely on the locations where it's filmed. What drew you to the locations, namely the diner and the La Brea tar pits, all within just a couple miles of each other?

SDJ: The tar pits. This bubbling crude in the middle of the metropolis fascinated me from the first time I ever saw it. A portal to the past. Tried to stay true to geography (and came very close to doing that)

Johnie's Coffee Shop is as we left it a quarter of a century ago. We were amazed when we were able to get back in there for a supporting cast reunion for the Blu Ray extras. It was ghostly – and all the bulbs we put in the signage outside – still working.

VB: In recent years, Miracle Mile has enjoyed newfound status as a cult film. It seems people have really identified with its themes and its characters and the music. Why do you think it's had such an enduring legacy?

SDJ: While tainted with some 80s affect (hair, etc.) – it seems to appeal because it breaks expectation formulas that few Hollywood movies do anymore (or even did back then). It is not a ride everyone enjoys and I know there are as many 'haters' as well. But that to me is better than being something that is easily forgotten. Word of mouth was out there – but a book by Walter Chaw (who does commentary with me on the Blu Ray) and a bunch of fans who made friends watch the film had built slowly over the years. The Blu Ray of course has amplified the fan base now. Hope to have a website up in the near future with more.

VB: What other films, books or television shows influenced you when you were making Miracle Mile? It has such a unique visual style, we would be curious to know what, if any, films and filmmakers you were paying homage to.

SDJ: *Day of the Locust* – the book, not the film. *The Last Wave* – (Peter Weir) haunted me with its premonitions of an 'end'. Cornell Woolrich stories. The empty streets of LA have their own magical imagery and though it's an 80s film – we did not do a street wet down or use a lot

of smoke (the tropes of most films of the era). Though the score gods of the 80s, Tangerine Dream, are an essential ingredient. Any film or story where one journey – spins off into another darker one – with compounding moral choices – (*Dog Soldiers* – made into *Who'll Stop the Rain*, say – or *Deliverance*, *North By Northwest* – many others)

VB: Outside of *Miracle Mile*, you've had quite a career. You co-wrote *Strange Brew* with Rick Moranis and Dave Thomas; you directed *Cherry 2000*; and you directed a remake of the "Man From the South" story on the 1980s revival of *Alfred Hitchcock Presents* (the same story was also kinda-sorta retold in Quentin Tarantino's segment of *Four Rooms*), as well as tons of other TV shows including *ER, Nash Bridges* and *Lizzie McGuire*. I also hear you're writing fiction, too. What's next? Anything you can tell us?

SDJ: I may or may not write more scripts (and am just beginning an academic career – teaching in Ohio University's MFA Film Program) but I got my own MFA in fiction a few years ago (made the Best American Short Stories, etc.) and that is my forward trajectory, working on that craft — no meetings, studios notes, spending years scraping up budgets. I had a good long run – 28 straight years of work – so no complaints whatsoever.

Runtime: 88 minutes.

Mulholland Drive
(2001)

David Lynch is the real deal. When some people try to make a movie that's odd, it can come across as a curiosity made for the sake of simply being quirky. When David Lynch makes a movie that defies logical explanation, it's clearly a creation pure to his own vision. Rather than concoct little oddities, he employs a genuine dreamlike quality to his works. "Surreal" in reference to David Lynch is an understatement.

Mulholland Drive is a film assembled from the remains of a pilot to a potential television show that had been declined to be picked up. Upon rejection, David Lynch shot an ending and made a movie out of

it. The result we're left with is subplots that, in a television show, would grow and have season-long arcs, but in a self-contained movie, appear and disappear without resolution. In anyone else's film, this would be frustrating and nonsensical, but in the world of *Mulholland Drive*, there's an otherworldliness to it that helps make the film great.

A nameless woman, known only as "Rita," (Laura Harring) an adopted moniker she assumes after surviving a murder attempt and car accident that occurs on Mulholland Drive, stricken with amnesia, stumbles into the life of Betty (Naomi Watts), an aspiring actress new to Los Angeles. Betty's arrival to Los Angeles with a sparkle in her eye is corny as all hell (intentionally so), presenting an idealized life that doesn't exist, and the impossible decision to go to Hollywood and just make it. Her chance encounter with Rita almost seems like fate. Everything works out a little too perfectly, tinged with this nauseating feeling of discomfort. In a David Lynch movie, when things seem to be going *too* well, there's something nasty bubbling in the works.

Rita and Betty go about solving the mystery of Betty's true identity. Rita has a strange blue key, the truth of which is left wide open to interpretation—nothing about its true nature, nor the box it opens, is ever explicitly spelled out for the audience. The only thing we're clearly told is by the emcee at Club Silencio, who informs us that everything is an illusion. The key and the box seem to represent the collision of two worlds, one idealized and full of hope, where Rita and Betty are lovers. The other, where Rita and Betty are ex-lovers, Betty is a failing actress, and jealousy leads to awful decisions. Which world is the real one? Is Betty envisioning the truth of herself as a bitter failure, or is she simply seeing a vision of what might have been? Is the box magic or does it exist only in her head, a tool utilized by her subconscious in a dream moments before her death by suicide?

It's these unanswered questions that are the strength of *Mulholland Drive*. I sometimes get tired of having to be hit over the head with clues again and again. Sometimes, I want to draw my own damn conclusions. Sometimes I want to watch a movie that doesn't hold my hand and guide me through the plot. Sometimes I want to be given a map and allowed to explore for myself—my interpretation of events is going to be different from someone else's, and that's completely okay.

Films are supposed to invigorate your imagination, not staunchly restrict it to a singular vision. The difference between invigoration of the imagination and the restriction of it is like the difference between the theatrical cut and the director's cut of *Donnie Darko*.

I've gone back and forth over the years on how I feel about David Lynch's films, and I've finally made peace with them and have accepted the fact that I love his movies. Not *all* of them, no, but when he's on a roll, he's one of the most twisted visionary directors of any era, and *Mulholland Drive* is probably the best example of his movies that works as summing him up as a whole. The films he makes, and the style he employs, has been imitated endlessly, but no one can make a movie (or a TV show) quite like him. In many of the parodies I've seen, where someone tries to reimagine, say, *Return of the Jedi* as directed by Lynch—he'd been offered the job as director of that film, but turned it down—all we're seeing is a series of avant garde images, nothing really within the realm of Lynch, or employing any of his trademarks or obsessions with the seedy underbelly hiding in every happy pocket of America.

My favorite scene in *Mulholland Drive* seems to have nothing to do with anything, a non sequitur of sorts, but the rest of the movie wouldn't have the same impact without it. A man at a diner explains to another man a terrible dream the night before that took place in the very same diner. "There's a man in the back of this place," he explains. "I can see him through the wall. I can see his face. I hope that I never see that face ever outside a dream." The man he's telling the dream to assures him it's just a dream, nothing more, and he'll prove it to him by taking him out back. Everything starts to play out exactly like the dream did. When the two venture out back, they *do* see something, and the shock of it, the way the figure steps into frame, and back out, is scary as hell, and the way the man who had the dream reacts, by being so panicked and full of fear that he faints, makes it one of the scariest moments and best jump scares I've ever seen.

Runtime: 147 minutes.

Munich
(2005)

Munich is a meditation on violence. Not just the violence that haunts the world we live in, but the way violence is portrayed in film. To me, there are two Steven Spielbergs: There's the Steven Spielberg that made a fun movie loaded with peril and violence with *Jurassic Park* in 1993, while later that same year the other Spielberg made *Schindler's List*, whose violence is rendered so realistically that I found myself having to look away from the screen at times. There's a world of difference between the two films, and Spielberg knows that. He knows that film violence can be fun, and it can be used to teach a powerful lesson. It was the Spielberg from the latter half of 1993 that would go on to make *Munich*.

Spielberg is in rare form with *Munich*, setting a tone of cynicism that I'd never really seen from him before. The movie doesn't attempt to answer the question of whether or not Israel and Palestine can ever get along. That's an unanswerable question. The movie, instead, focuses on the absurdity of violence and predicts that violence is something in our worldwide cultural fabric that's here to stay. It's too easy to use violence to temporarily solve big problems for it to be done away with any time soon. The whole situation is a vicious, ugly cycle with has no discernible end in sight.

The proverbial cycle of violence at the center of the film begins at the 1972 Summer Olympics in Munich, when Israeli athletes are kidnapped and killed by Palestinian terrorists. But, really, it all started long before that. Generations and *generations* before that. The Israeli government retaliates by assigning Mossad agent Avner Kaufman (Eric Bana, stretching his acting chops in his second-best performance, right after *Chopper*) a team of assassins to find the men responsible, and kill them.

There's a line I remember from the TV show *Gunsmoke* about how when you kill a cougar, your problems are over... but when you kill a man, your problems have just begun. Revenge is never a cut-and-dry operation. No one retaliates against someone and doesn't wind up with a new set of enemies. The road to justice in *Munich* is paved with

blood. The concept of justice itself appears to be a muddied, ambiguous concept, with the constant pursuit of it a pointless endeavor… you might as well try to reach the end of a rainbow, both exercises being equally futile.

Avner's assembled team consists of fellow Jews who are experts in various fields, from all around the world. Daniel Craig plays Steve, the getaway driver. Mathieu Kassovitz plays Robert, the explosives expert. Ciarán Hinds plays Carl, the one who cleans up any messes left behind. Hanns Zischler plays Hans, the document forger. The film begins like a standard espionage film with a pretty clear cut vision of who's good and who's bad, but begins to obscure the line of morality as it goes along. Methods used to collect information begin as questionable-but-justified, but quickly move into pretty shady territory. And before long, Avner begins to suspect his own government of trying kill him, to tidy up all their own loose ends of the operation.

Munich is a stripped-down, unromantic version of how assassinations work. This isn't James Bond sipping martinis in a tuxedo and eliminating a threat with a cool quip, this is a team of men sleeping on mattresses on the floor together, going without showering for days at a time, and suffering emotionally for the things they've witnessed for the rest of their lives.

The portrayal of violence in *Munich* is, to me, best summed up with a scene where Avner and Steven execute a woman who killed one of their team. The film doesn't flinch in its portrayal. She offers herself to them, disrobing and exposing her naked body. They shoot her with homemade zip guns, using a smaller caliber bullet to make their weapons virtually silent. In most movies, there would be a spray of blood and she'd be dead. In *Munich*, the bullet smacks her body and moments later, blood beings to drool out. She staggers, she wheezes, she suffers. The scene is designed to make you feel awful when you're watching it… you're not watching some awesome scene of revenge, you're watching a brutal, violent reaction from men who have convinced themselves that they are on the correct side of history, and have justified such actions to themselves.

Runtime: 164 minutes.

Near Dark
(1987)

I just want to admit right off the bat that I'm not the biggest Kathryn Bigelow fan. That's not to say she's not talented or a worthy director, her stuff has just never been for me. *Point Break* is a decent, corny movie action flick with some good performances that gets a ton of praise that I just don't understand. Did we see the same movie? And then there's *The Hurt Locker*, the movie that won her an Academy Award (well, two, since she won for Best Director *and* Best Picture), a movie that I feel is one of the most overhyped, overpraised movies I've ever seen in my life. We can argue the significance of the ending until the cows come home, but I thought it was total bullshit.

So, she might not be my favorite director, but that's okay. She doesn't have to be. She doesn't need me or my validation. But I will forever appreciate her work because she did make *Near Dark*, easily the best film she's ever made. *Near Dark* is also one of the top five or ten vampire movies of all time, easy.

Caleb (Adrian Pasdar) makes the mistake of falling in love with a vampire. Mae (Jenny Wright) is beautiful, mysterious… sort of like the archetypal fantasy of obsession. She embodies this type of dream woman that doesn't exist in reality, a drifter on her way through town, bringing a bit of beauty and pale-skinned brightness to his small-town existence. They hit it off and before the night ends, she bites him on the neck.

The next day, the inevitable happens—he begins showing all the telltale signs of vampirism. Because he's a character in a movie, it isn't blatantly obvious to him right away that he's turning into a vampire. Sunlight causes his skin to burn. There's literally no other thing it could be. Mae, along with her "family" of degenerate outlaw vampires, swoop him up in an RV. They want to kill him, but Mae convinces them not to by telling them that she bit him, turned him into one of them, so if they kill Caleb, they'll be killing one of their own. The leader of the pack, Jesse, decides to give him a week to see if he's got the stuff to be one of them.

The vampire-nomadic lifestyle they lead takes them from town to town, where they can feed on local townsfolk and get back on the road without staying in a place too long to ever arouse suspicion from law enforcement. The undead outlaws reunite three actors from the cast of the film *Aliens*. Jesse is played by Lance Henriksen, Severen is played by Bill Paxton (who continues the tradition of gracing his bit roles with tremendous strength) and Diamondback is played by Jenette Goldstein. Bigelow knew James Cameron (she would later marry him, too) and recruited members of the cast of Cameron's film *Aliens* because they would already have an established rapport with each other that would make their familial interactions more natural. It works fantastically, and the performances from all three of them are great, but even if it had been a failed experiment, I'm never going to complain about getting the supporting cast from *Aliens* back together for any occasion. And you've gotta love Bill Paxton slicing people up to the tune of "Fever" as sung by the Cramps.

Unfortunately, I have a major gripe about the way the movie ends. I'm not going to spoil it, but the way everything gets resolved takes *deus ex machina* to the next level. What happens is fucking *absurd*. It's so absurd that how everything works out used to be how the movie *28 Days Later* ended, but the filmmakers decided it was too stupid and went with something else. Luckily, it only takes about five minutes and everything that happens before it is grade-A, awesome material. It's such a good movie that I'm willing to just look the other way when it comes to the eventual denouement and pretend that whatever happens is really, I don't know, a dream or something.

Near Dark is a great horror movie and a great neo-western. It's a must-see for just about everyone with a casual interest in either genre. The performances are all amazing—even from the shitty kid from *River's Edge* and *Teen Witch*. The music by Tangerine Dream, whom Steve De Jarnatt calls "the score gods of the 80s" put some of their best work into this movie.

At the time of its release, *Near Dark* was an unfortunate flop, probably because there was too much competition at the time when it came to vampire movies, but *Near Dark* really is the best of that late-80s crop. As much as I enjoyed *The Lost Boys*, it's fluff compared to the

awesomeness of *Near Dark*. In recent years, *Near Dark* has enjoyed a cult status. Obviously trying to wring some money from it somehow, the DVD version I have is a reissue from the studio that makes it look like some unauthorized *Twilight* sequel.

Runtime: 94 minutes.

Network
(1976)

Jesus Christ, do I love *Network*. Obviously, when it came to writing this book, some reviews were easier to write than others. Some reviews I would bang out in an hour and be totally satisfied with. Others, I would struggle and struggle and struggle to find exactly what I was even trying to say and why I felt the movie was worthy of being one of the 101 movies I would be writing about. *Network* is, bar none, the movie I dreaded writing about most. My process for writing is pretty simple: I had the movies I wanted to write about in mind and I would go down the list. Sometimes I would jump around—if inspiration hit, I would hop down to the R's and do *RoboCop* because an idea hit me and I had to commit my thoughts to the page right now or I'd lose it. When it came to *Network* I skipped it, moved down the list, and promised myself to come back to it later. I briefly considered simply making it my last review, but I thought that put too much emphasis on it and how difficult the task was going to be, so here I am, finally getting around to the goddamned thing, doing my best to tackle why it's such a momentous, special film to me.

Network is a movie that has only grown in relevance over the years. It was relevant, obviously, when it first premiered, following the sensationalistic treatment of the suicide of Christine Chubbuck (and the events that led to her death), as well as the string of robberies committed by Patty Hearst following her kidnapping. Never in a million years could Paddy Chayefsky, the writer of the film, have predicted where television news wound up today in all of its disgusting glory. *Network*, in 1976, was supposed to be a chilling premonition of things to come if the news media was to be left unchecked, not a goddamned

instruction manual. Watching *Network* today is no longer seeing an extended social satire, but to see a warning that had been ignored and a bitter prophecy fulfilled.

One night, on live television, Howard Beale (Peter Finch) says that he's going to kill himself on the air next week for everyone to see as a result of finding out he's going to be let go for declining ratings. He is, of course, fired for it, but given an opportunity to go out with some quiet dignity and announce his "retirement." Instead, he uses the platform to launch into a monologue over the futility of life. The thing is, Howard's tirades are getting incredible ratings. So, the network does the logical thing when faced with that kind of viewership and money-making potential: They give him a show. On his show, he has complete freedom to say whatever's on his mind. In one of those instant classic moments in film history, he shouts, "I'm as mad as hell! And I'm not going to take this anymore!" imploring the country to chant along with him, and they do. They open their windows and shout their anger to the night sky for all to hear.

Beale's only real friend, Max Schumacher (William Holden), watches all of this unfold, powerless to do anything about it, except for watch the further exploitation of Beale. Beale quickly adopts his new persona, morphing from someone who was once a quiet, professional news anchor to a frenzied, quasi-messiah. Beale makes the unfortunate mistake of publicly decrying a merger-acquisition deal between the network he works for and a large conglomerate from the Middle East. He is brought in to meet with Arthur Jensen (Ned Beatty), the network's chairman, who launches into a diatribe about how the modern world *really* works. The diatribe changes everything about the way Beale sees the world, but his new world outlook isn't so great for ratings. The way the network deals with the flat-lining viewership is only slightly ridiculous today, something I hope and pray *remains* a piece of satire. But if the rest of history follows *Network*'s trajectory, who the hell knows?

Network is one of the greatest scripts ever written for a film, and thankfully the script is given a deserved director in Sidney Lumet, one of the all-time greats for getting special performances from actors. During the "I'm as mad as hell" speech, he would have Peter Finch do

take after take after take, each time telling him that the last take was crap or garbage, finally getting Peter Finch to scream, "I'm as mad as hell!" because, man, he really was mad as hell at that point.

Faye Dunaway's performance as Diana Christensen, the head of the network's programming, is expertly played... she's a clearly intelligent woman who doesn't think of herself as a bad person at all, and has convenient ways of justifying her loathsome behavior. If you watch this movie and scoff at the ridiculousness of her cutting a deal for a docudrama about terrorists, remember that in the years that followed *Network*'s release, we've had a filmed (but never aired) reality television show about the Ku Klux Klan and that we currently live in an era of "fake news."

Runtime: 121 minutes.

Night of the Living Dead/Dawn of the Dead (1968/1978)

The first time I saw *Night of the Living Dead*, I was 11 years old. Before seeing it, it was such a generically tossed-around title, I never gave much thought to it. To me, it represented a sort of generic, black and white zombie movie that existed in my mind only as a sort of abstract concept. On Halloween night, my brother told me that they were going to be playing *Night of the Living Dead* and it might be some good, corny fun. We could watch it and make fun of it like the robots on *Mystery Science Theater 3000*.

When the movie began, I was set to laugh my ass off. It began with warbling, distorted music, evidence of an extremely low budget. It reminded me of some of the Ed Wood movies my parents had laying around, like *Plan 9 from Outer Space*. A brother and a sister named Barbara and Johnny (Judith O'Dea and Russell Streiner) arrive at a cemetery—of *course* it begins at a cemetery, I probably cynically thought—for their once-a-year visit to their father's grave. Things begin cheesily enough when Johnny remembers how he used to scare her in the very same cemetery when they were children, taunting her

with, "They're coming to get you, Barbara…" and when they see a man coming up the path, making his way toward them, Johnny says, "Look! There comes one of them now!" Johnny has no idea how right he is. The man is a zombie and it attacks Johnny, and during a scuffle, Johnny's head smashes against a headstone, killing him.

This is right about the point I shut the fuck up and watched the rest of the movie in complete silence, mouth agape, wringing my hands nervously the entire time.

Barbara flees from the undead killer and after totaling her car, seeks refuge in a farmhouse, which, unbeknownst to her, is also the safe place of a few other survivors of similar attacks who are hiding in the basement. According to radio and television broadcasts, the world is going to hell all around them. The recently dead are returning to life, with an appetite for the flesh of the living. Today, this is the standard, unoriginal template for a zombie movie. Back in 1968, this was the first of its kind, and it was goddamned groundbreaking.

While the world outside is crumbling, the situation inside the house is no better. Ben (Duane Jones) and an ornery man named Cooper (Karl Hardman) battle with each other every step of the way. Cooper's daughter was bitten by one of the zombies outside, and she's in the basement dying, so his only motivation is to think of himself and his family. Nothing else matters.

The ending of the film, which by now is a legend in horror films—but I still dare not spoil—is one of the most perfect endings. It raises so many questions and lays the groundwork for the thesis in so many of the best horror films, asking us who the real monsters are… us, or them? Monsters are a convenient excuse for man's inhumanity to man, and gives us a sort of demonized scapegoat, but the real, ugly truth is that the worst things to happen to us in real life happened because of our fellow man.

Prior to *Night of the Living Dead*, George A. Romero ran a successful career shooting short films and commercials. He even did some work for *Mister Rogers' Neighborhood*. *Night of the Living Dead* was his first film, and it was one hell of a first film. Almost fifty years after its initial

release, it remains one of the best, scariest films ever made... certainly, far and away one of the very best zombie movies ever made.

In the ten years that passed between *Night of the Living Dead* and *Dawn of the Dead*, Romero made some interesting film choices. He did the fantastic vampire tale *Martin* (also reviewed in this book). He also made some odd choices that worked better than others—I liked *Season of the Witch* more than most people. But it was the zombie movie that kept calling back to him, and when he returned to it, I don't think anyone expected him to capture lightning in a bottle again.

The first time I saw *Dawn of the Dead*, I don't know what I was expecting. I knew that, by reputation, it was supposed to be a worthy sequel. I knew Roger Ebert liked it and that, of all people, Leonard Maltin liked it too, so I figured it was worth a shot.

Dawn of the Dead ramps up the post-apocalyptic nightmare vision, beginning with a television studio that falls into a chaotic mutiny when outdated information on shelters for survivors of the zombie outbreak is to be posted, regardless of how many people will be killed as a result of it. Even in the End of Days, some people still care more about ratings than safety.

The action cuts to a SWAT team clearing out a low-income housing project whose inhabitants have ignored orders to clear out their dead. One of the officers, clearly unhinged, begins shooting people at random, blasting a man in the face with a shotgun, causing his head to literally explode—not something I was expecting, at the time, to see in a sequel to *Night of the Living Dead*. *Night* had some gore, but today it boasts a PG-rating. *Dawn*'s level of violence, had it been rated, would certainly be NC-17.

Two of the reporters from the television station, Stephen and Francine (David Emge and Gaylen Ross) team up with two of the SWAT members, Peter and Roger (Ken Foree and Scott Reiniger), having mutual friends, and steal a helicopter to make it out of the city that is being consumed by not only hordes of the living dead, but by madness.

Instead of settling on a similar siege scenario as its predecessor, *Dawn of the Dead* becomes a social commentary and satire on consumerism, having their refuge be not a farm house (though they do stop by the

same town from the original film), but a massive shopping mall. As the corpses shamble through the stores and up escalators, it's clear that they're us. These zombies are brought to a place, running on pure instinct, that was important to them before death. What was important to them was a goddamned mall, a place to buy useless shit.

Dawn of the Dead is every bit as good as *Night*, with a nastier edge to it. The ending isn't quite as cynical, but it's still shrouded in hopelessness. The situation of the world has no indication of ever getting any better, and our survivors are going to have to be on the run for the rest of their lives.

Night of the Living Dead Runtime: 96 minutes.

Once Upon a Time in Mexico: 127 minutes.

Office Space
(1999)

Mike Judge is one of those people whose TV shows and movies are funny because he understands human nature. He just gets people. What makes a show like *King of the Hill* funny isn't that it's about a bunch of rednecks. The humor isn't based on them being so backward or so stupid that we laugh at them. What makes *King of the Hill* work is that we are given a chance to sympathize with a cast of characters that we might not always necessarily agree with, but the show makes it a point to always portray them as human. They're not caricatures, they're nuanced, complex people. Similarly, *Office Space* only works as well as it does because Mike Judge really does understand the politics and working environment of an office job. If you've ever worked in a sea of cubicles, chances are you might have had a boss like Bill Lumbergh. You might have had a coworker like Milton. Hell, you might have even fantasized about stealing money from the company that steals a piece of your soul every day, like Peter eventually does.

Work sucks. Let's face it, having to work fucking sucks. We can have pride in our work and in our jobs (I know I do), but wouldn't we all rather be millionaires who can pack up and go to the beach one day,

have champagne on the Eiffel Tower the next and never have to worry about getting up early ever again? Even without the money, I think a lot of people would sacrifice a lot of financial securities in order to never have to work again, as long as you knew you could survive. Work is just such a time-consuming thing we all have to do. About a third of your day is spent working, another third spent either getting ready for work or recovering from it, and the final third spent sleeping in order to give you the strength and energy to work, with enough time left over to cook dinner, read a chapter of a book and maybe watch a couple episodes of a TV show. Weekends, traditionally, are the days where you can get your shit together and spend time with your family and take care of the chores you didn't have the time or energy for during the week because you were so exhausted from work.

Since we pretty much all have to participate in this daily rat race, whether you work in an office or do physical labor or work at a restaurant or retail, something about *Office Space* is totally relatable and embodies the frustrations we deal with on a daily basis. Peter (Ron Livingston) hates his job even more than most people do. Whereas when most people hear a dumb comment from their boss, they can simply shrug it off, but not Peter. He can't do it anymore. He's completely had it. One day, under the suggestion of his girlfriend, Peter visits an "occupational hypnotherapist" who helps him relax, to forget all about his worries caused by his job, the anxieties associated with having to go to a place he hates five days a week (sometimes six, depending on if his boss needs him). The hypnotherapist dies of a heart attack during the session of relaxation, so Peter never snaps out of it. He becomes the person we all wish we could be, but don't have the courage to act on. He blows off his boss's request to have him play "catch up" at the office over the weekend. He goes up to a girl named Joanna (Jennifer Aniston) that he has a crush on and asks her out. He rolls into work in flip-flops. He guts fish that he caught at his desk. He's run out of fucks to give.

When Peter finds out that his friends Michael and Samir (David Herman and Ajay Naidu) are going to be fired as part of some corporate restructuring, the three of them decide to put into effect an idea that Michael had for years, stealing from the company a la the movie *Superman III*, where they skim tiny bits of money from the top,

pennies here and pennies there, and move them to another bank account. With itty bitty little bits going missing, no one would ever notice. The problem is that some mathematical formula got screwed up somewhere, and huge sums of money get swiped all at once. It's only a matter of time before they all get caught and go to prison for their theft.

Office Space is at its best when it's mocking the day-to-day of the typical 9 to 5. Bill Lumbergh (Gary Cole), is a great character because he's certainly a villain, but never acts *villainously*, he's just an annoying boss and something of a gutless coward who never tells poor Milton that he had been fired years ago. But the way he enters a scene, props his arm up on a cubicle partition and begins his, "Yyyyeeaahhh," you just know he's about so say something stupid. Lumbergh is the best kind of villain, one that we've actually met before.

Runtime: 90 minutes.

Pan's Labyrinth
(2006)

When I was 21, I was working the night and overnight shift at a call center for a hotel chain. Sometimes my shift would end at 12:30 a.m., and sometimes that's when my shift would *begin*, and I'd get off right when everyone was just showing up for work. I was a vampire. I didn't get to see my friends very often, and luckily they didn't seem to think it was weird when I'd show up at their place at 9:30 a.m. on a Saturday with a 12-pack of beer after having worked all night, ready to get my drink on. They were just waking up, but that didn't seem to bother them too much. God bless casual alcoholics.

One of my favorite things to do during this time was on payday I would stop by the Super Walmart on my way home, because it was the only place open after midnight that sold both beer and movies. I would pick up some beers, pick up one of the latest DVDs that just came out and head home, a 45-minute drive away, where I still lived with my parents in Anza, CA. I would turn off my headlights on my crawl up the dirt

driveway, tiptoe into the house as quietly as I could, go into my room and watch my new movie while I quietly drank beers. It was sort of depressing, I realize this, but it was also a lot of fun. It was my little ritual I treated myself to every other week, and I saw a lot of good movies this way, but my favorite movie I bought and watched this way was *Pan's Labyrinth*.

Pan's Labyrinth is Guillermo del Toro's masterpiece. He's done tons of great movies that I love and cherish, but *Pan's Labyrinth* is his ultimate, realized vision and it's just about perfect in every way. It's a spiritual sequel to his other brilliant film *The Devil's Backbone*, set once again in Spain during their violent Civil War against fascism. In this film, a young girl named Ofelia (Ivana Baquero) discovers a world of magic that may or may not exist, filled with hideous creatures, incredible wonders and a series of tasks that must be performed for an anthropomorphic faun (the always-great Doug Jones, who also plays the terrifying Paleman) that lives in the center of a labyrinth, whose motivations are never quite clear.

The movie is divided into two worlds: The real world and the magical world. The real world is, by far, the scarier one of the two. In the world of magic, Ofelia can hold her own against the monstrous Paleman that has eyes in its hands and bites fairies in half. In the real world, she is powerless against the fascist Captain Vidal that her mother has married. Vidal is cruel and ruthless, using killing as a means of keeping control of any situation. I remember years ago pro-life groups cited that even a monster like Vidal appreciates the preciousness of life, but when he says to keep Ofelia's mother's unborn child alive at *any* cost, the line is intended to be a chilling reminder that life, to him, is expendable as long as he ends up with what *he* wants.

What ends up happening over the course of the film in the realm of magic is left to the viewers' interpretation of these events. A lot of events that unfold have two possibilities: There was either a happy coincidence, or supernatural forces were at work behind the scenes, aiding Ofelia. I have my own belief of how the movie unfolds, as I'm sure many other people do, too. I choose to believe that the world of magic that Ofelia enters is for real. It's too amazing and beautiful and perfect to dismiss as a delusion.

Films like *Pan's Labyrinth* leave me with this unique feeling when I'm watching them, where this wave of emotion washes over me and I know I'm watching special. It's not that I'm watching a good movie, it's that I'm watching something very, very special—a one in a million kind of movie that had everything work in its favor. Everything about it is top-tier filmmaking. The special effects are some of the best you're ever going to see, and the combination of practical effects and CGI that bring the faun creature to life is the kind of painstaking filmmaking that symbolizes why we go to the movies, to see an illusion brought to living, breathing life. And no one colors the movies the way Guillermo del Toro does. It's so easy to slap a digital filter on something, but in a film like *Pan's Labyrinth*, the colors all mean something… the golden, amber hues, the cold blues, they all represent a different world.

Runtime: 118 minutes.

Pee-Wee's Big Adventure
(1985)

I've never been afraid of clowns, but one of my earliest memories of a movie scaring me to literal tears and screams is the scene where Pee-Wee Herman (Paul Reubens) returns from shopping at a magic supply store, only to find his bicycle stolen, and the robotic clown that he had it locked up to looks down at him and laughs maniacally while Danny Elfman's score swells into violent stabbings at stringed instruments.

Pee-Wee's Big Adventure is Tim Burton's feature-length directorial debut, and gave him a showcase for all of his talents and trademarks as a director. *Pee-Wee's Big Adventure* is ostensibly a film meant for children, with a plot that is appropriately fanciful, light and full of wonder, but contains some of the most terrifying images of his career. I think the one people are most scarred by is the sudden, unexpected transformation of truck driver Large Marge into a claymation creature with popping eyeballs and long, slithering tongue darting directly at the lens of the camera. She snaps back, now normal, as if nothing had happened at all. The world that Pee-Wee lives in is a world where

anything is possible—a world that is, at turns, both wonderful and riddled with potential danger around every corner.

Pee-Wee loves his bike. And why shouldn't he? It's a great bicycle, a giant beast of a Schwinn Phantom, complete with tiger's head on the front. The bicycle looks awesome, but also packs jet boosters for emergency getaways and is capable of dropping sharp objects for popping the tires of any nagging pursuers. It's the pride of his life, in a life filled with so many other awesome things like a big, giant house that has a machine that makes breakfast, a cute dog named Speck and a kinda-sorta girlfriend named Dottie (Elizabeth Daily). When Pee-Wee's bike gets stolen, he goes through hell and back to reclaim what's rightfully his.

Following some dubious prognostication from Madam Ruby, a local fortune-teller, Pee-Wee hits the road toward Texas, where his bike has been foretold to be stored in the basement of the Alamo. Lacking a car, Pee-Wee hitchhikes his way across the country. His travels introduce him to a colorful array of people, from all walks of life. He thumbs a ride with an escaped convict—a man with a real violent temper who cut the tag off a mattress. He meets a woman who dreams one day of traveling to Paris. He befriends a motorcycle gang that first wants to kill him, but he wins their hearts by dancing to the song "Tequila" on top of a bar. Part of the charm of *Pee-Wee's Big Adventure* is that almost everyone likes Pee-Wee. The movie wouldn't have the same innocence to it if Pee-Wee were constantly annoying people on his journey to get his bike back. Instead, everyone wants to see him get his bike back as much as we do.

Pee-Wee's big adventure ends with a chase around the Warner Bros. studio lot. Because of the various sets Pee-Wee crashes, the movie gets to shift genres just about a dozen times. One minute, he's being chased through a beach party movie, the next he's interrupting Godzilla's destruction of Tokyo. I love that in this world, Warner Bros. apparently produces B-movies from niche genres as its main export.

The script, by Reubens and Phil Hartman (yes, *that* Phil Hartman), has a lot of fun playing with conventions and, rather than subverting them, embraces them wholly and loves them. It's a road movie in the purest sense, introducing us to new sights and sounds with every location and

exaggerating every place we're at. *Pee-Wee's Big Adventure* is sort of like a fanciful, child-appropriate version of *On the Road*.

This film and the character of Pee-Wee himself are acquired tastes. If you have a low tolerance for things that are annoying, you might be in agony while watching this movie. With *Pee-Wee's Big Adventure*, Paul Reubens made a transition with the character. Prior to this, Pee-Wee was involved in more adult humor. When Warner Bros. expressed interest in a Pee-Wee Herman movie, they weren't thrilled with the idea of it being a family film, but after Paul Reubens had been gifted a bike that he ended up loving, he knew the film had to be about Pee-Wee and a bicycle, and that's just how it sort of came together. After the film's huge box-office success, *Pee-Wee's Playhouse* was created, and after that became a hit in its own right, Pee-Wee Herman was forever going to be an icon in the entertainment world for children.

Well, until he got caught jerking off in a pornographic movie theater, that is, which in Paul Reubens' defense is probably the most normal thing he's ever done in his life. In recent years, though, the character of Pee-Wee has had a bit of a renaissance, and I'm glad to see it. So, he's kind of a weirdo. So what?

Runtime: 91 minutes.

Planes, Trains & Automobiles (1987)

John Hughes is no stranger to mixing comedy and heartfelt drama, but never has he ever been more on point than he is with *Planes, Trains & Automobiles*, the story of two men trying to make it home to see their families by Thanksgiving, with the world seemingly conspiring against them to prevent that from ever happening.

Neal Page (Steve Martin) is on business in New York City, trying to get back home to Chicago during the nightmare traveling season that is Thanksgiving. He hails a cab, only to have it stolen from him by a traveling salesman named Del Griffith (John Candy in probably the performance of his lifetime). After flights are delayed, diverted and

then canceled due to severe snow storms, Neal finds himself crossing paths with Del again and again. The two seemed destined to cross paths on their mutual journey home. They share a room at a motel for the night and of course find themselves at odds with each other. They have a sort of "odd couple" type dynamic in their close living quarters with Neal being the fastidious one and Del being the slob.

As the title suggests, Neal and Del use all means of transportation in an attempt to make it to their destination, which by now seems like an impossibility. The idea of making it home by now feels like having the gods expressly trying to stop it, like with Odysseus. The two eventually take a train that ends up breaking down, stranding the passengers by a field in Missouri, forcing them to have to walk on foot for many miles.

They board a bus together and Del tries to rally the bus together to get everyone's spirits up by singing a song. Neal tries "Three Coins in a Fountain" to crickets. After an awkward amount of silence passes, Del gets everyone to sing the theme song to *The Flintstones*. It's in little moments like this where John Hughes excels. He just seems to understand the language of film when it comes to building up his characters. It's easy enough to outright say Neal is uptight and kind of an asshole, but something like the scene on the bus shows him as someone who is, sure, uptight and doesn't really relate to working class folks because of his economic privilege, but he's also a man with a fragile ego and when Del is able to get everyone excited in a way he wasn't able to, he feels embarrassed about it. It's a funny moment, but you can also see Neal's hurt shine through on his face.

The bound-to-be-together duo cross paths once again and get a rental car together. In a surprisingly terrifying scene, Del gets his sleeve caught trying to take off his jacket while driving, and the car ends up getting turned around on the freeway. Neal wakes up and sees some people on the other side of the freeway screaming, "You're going the wrong way!" and Del brushes them off as drunks, "How would he know where we're going?" This scene has all the intensity of something in an episode of *Breaking Bad* or even a Hitchcock film, but at the same time, it's goofy enough to keep us laughing. To successfully juggle so many emotions in this scene is just perfect, to have our hearts pounding in our chests while we giggle uncomfortably.

Their car gets stuck in the middle of two semi-trucks barreling down on them, stripping off a good portion of the exterior. Then, it catches on fire. It's still drivable so they do what they gotta do and keep driving the twisted metal wreckage that doesn't have any working gauges or any means of keeping the snow off of them.

Planes, Trains & Automobiles is a very funny film, but also has emotional scenes that don't feel out of place. We learn to really like Neal and Del during our journey with them. It's more than just about getting home, it's about learning about yourself, and both of them end up doing a lot of growing up. In the motel room, when Del tells Neal that he likes himself, it's not just Del telling a guy off for being a jerk, it gives him an opportunity to actually hear himself say it, that he's made peace with who is as a person. That such a scene could exist in the same movie where Neal accidentally dries his face off with Del's underwear is a testament to how in control of the tone John Hughes is—I like the majority of what he's done in his career as a director, but he's never been better than he is here.

I watch *Planes, Trains & Automobiles* every single year and I never find myself getting tired of it. I laugh at the same jokes every year and find myself getting teary-eyed during the more emotional scenes. It's like having an old friend over for dinner and catching up.

Runtime: 93 minutes.

Pulp Fiction
(1994)

Pulp Fiction was the first Quentin Tarantino movie I ever saw. I didn't see it until I was 14-years-old, but I remembered when it had first came out, it was one of those "big deal" movies that for whatever reason I didn't really have any interest in seeing. It had been quoted and parodied endlessly following its initial release, so in a way it felt like I had already seen it, at least some of its most famous scenes, as reenacted by TV shows like T*he Simpsons* and *MadTV*. Something

about it always felt... I don't know, like a sleazy exploitation of violence under the package of being cool. It didn't interest me.

Fast forward six years later, and I remember seeing Roger Ebert and Martin Scorsese talking about the best films of the 1990s on TV. Roger Ebert's longtime partner, Gene Siskel, had recently died, and Martin Scorsese had filled in as a guest for an episode, and they each shared their favorite movies of the decade. One of the movies that they discussed was *Pulp Fiction*. I'll never forget the love that they had for it, or the way they talked about things I had never even considered as being important to a movie. The famous scene where Jules (Samuel L. Jackson) and Vincent (John Travolta) talk about the small differences between the United States in Europe, including what they call a Quarter Pounder with Cheese in Paris, was to me, just a funny scene. Ebert and Scorsese discussed how it brought us into the movie by seeing people casually shoot the shit and talk the way people actually talk. Sure, these characters were gangsters, but gangsters don't always talk about crime, money, women or the plot—sometimes they just talk.

By the time I finally got around to seeing it, despite the overwhelming hype behind it (the movie *is* described as being responsible for revolutionizing cinema as we know it, and for creating an enormous amount of 1990s popular culture), I loved it immediately. I watched it alone, on tape, having borrowed it from one of my friends, and watched it sitting up in my bed with my back against the wall. I remember watching the whole thing in its entirety, all two hours and thirty-eight minutes, and wishing that there was more. I didn't want it to end.

Sometimes when I see a scene in a movie that's perfect, my eyes well up with tears a little and I have to blink them away, feeling a slight burn on the inside of my eyelids. It's not because the scene is sad or too beautiful to handle, it's just because the scene is *perfect*. Most of the movies in this book have at least a couple absolutely perfect moments that cause this reaction, but *Pulp Fiction*'s first perfect moment is the opening scene, where Pumpkin (Tim Roth) and Honey Bunny (Amanda Plummer) plot the robbery of the very diner they're eating breakfast at. The best way I can describe *Pulp Fiction* is as a

series of incredible scenes, one after another, until the film's finish. Every scene, whether it's violent, funny or some sort of bizarre grotesquerie, is incredible. The whole film, from beginning to end, is one of the most perfect movies ever made.

Pulp Fiction's success is dependent almost entirely on its style, which it seems to have almost created from scratch, by way of borrowing here and there from established styles throughout film, television and the seedy pulp novels from which it takes its name. What you wind up with is something that plays like a B-movie from the 1950s' wet dream of what it may have been if not for the limitations of censorship, scored with surf rock music from the 1960s, and cooler-than-cool dialogue that waxes philosophical and theological at unexpected moments. Uma Thurman as Mia Wallace, with the way she smokes cigarettes and rocks that black wig with the bangs, is an icon of the decade.

The film is divided into three chapters, which go back and forth chronologically over the course of the timeframe in which the events take place. We begin with the prologue: Pumpkin and Honey Bunny plotting the coffee shop robbery. Then, we move on to hitman Vincent Vega, taking his mobster boss's wife out for a friendly evening while he's out of town. Next, there's the story of the boxer (Bruce Willis), ordered to take a dive during a fight, but at the last minute refuses and collects a bundle of cash and tries to skip town, only to wind up in a situation stranger than anything he could have ever expected. Last is how Jules and Vincent have to take care of a corpse whose head has exploded all over the inside of their vehicle—and Jules' determination to change his life to a more peaceful meditation.

Pulp Fiction is a lot funnier than most people seem to remember. Most remember the grisliness of certain scenes, but not how literally laugh out loud funny it can be during some of the most intense moments. My favorite example of the film finding humor in intense moments is the scene where Vincent has to take Mia, who accidentally overdosed on heroin, to his dealer's house to inject adrenaline into her heart to save her life. What ends up happening once they arrive is like something that would happen in real life. The dealer and his wife get into constant arguments with each other over small stuff, like whether

or not she's seen his little, black medical book. "I never saw no medical book," she says. "Trust me, I have one," he replies, exasperated.

Note: I also wanted to include an entry on *Reservoir Dogs*, a movie I love very, very much, but I already had a lot of Tarantino going on in this book and I couldn't seem to part ways with any of my existing entries. I will, however, go on record as saying that as far as directorial debuts come, they don't get much better than *Reservoir Dogs*. I was preparing to make a movie of my own once, and I set about studying *Reservoir Dogs* as my inspiration... see what Tarantino did with his own movie that I might be able to emulate without any sort of budget. After the movie was finished I was like, "Well, goddamnit, maybe that wasn't the best movie to study, because there's no way I can start off with a script that good."

Runtime: 154 minutes.

Punch-Drunk Love (2002)

Every comedic actor has that one movie where they get to shed their funnyman persona and do something serious. The results on this vary. Bill Murray has *Razor's Edge*. Ben Stiller did *Permanent Midnight*. Robin Williams has a handful of movies, most of which are actually pretty damn good. Adam Sandler, of all people, got to do the "serious" thing under the direction of Paul Thomas Anderson and the results were... not what you'd expect at all. Because of course not. Paul Thomas Anderson doesn't make movies the way anyone else makes them. Before ever seeing their pairing for the film *Punch-Drunk Love* all I'd ever heard was that it was a real stinker, an experiment that failed in every single way. One of my friends—I can't remember who—said it was worth a look, at least, even if I did indeed end up hating it. So, I checked it out and it gave me this weird, overwhelming feeling that no other movie has ever given; it was like a feature-length panic attack inside of a dream inside of a character study. I fell in love with the movie the first time I saw it and that feeling has never dulled or subsided. The constant panic the movie is in helps us feel like the main

character does, like we're always on the verge of a heart attack, until the very end.

Adam Sandler plays Barry Egan in the performance of his career, a man on the verge of breaking down. He owns a business and wears the same blue suit whenever we see him. He has seven overbearing sisters. He's prone to crying unexpectedly and has bouts of random acts of destructive violence, like when he shatters the glass in his sister's house or completely destroys a bathroom at a restaurant.

One morning, stepping outside his place of business in the wee hours of the morning, he witnesses a car accident, a single vehicle flipping and rolling down the street. Another vehicle, a van, pulls over on the side of the road and abandons a harmonium, an instrument with a keyboard that pushes air out to make music. The van takes off down the road. Barry eyeballs the harmonium for hours before he finally runs out and takes it to keep in his office.

Barry meets a woman named Lena (Emily Watson) who asks if she can leave her car in his company's parking lot for a little bit. Lena doesn't tell him until later, but she already knows who he is. She's one of his sister's coworkers. She saw a picture of him, developed a crush, and decided she wanted to meet him. Before long, their attraction is mutual. They're both emotionally-damaged people and their being together just feels right.

During a moment of self-loathing and loneliness, Barry calls a phone sex line that ends up being run by a man named Dean Trumbell (Philip Seymour Hoffman) who makes money by blackmailing those unfortunate enough to have called his business. When Barry refuses to play ball, things get violent for him.

Barry also has a scheme going on in which he takes advantage of an error in a promotional program that an airline hasn't caught yet. The airline is offering bonus miles for people who buy certain products. Barry exploits a pudding pack where each individual cup counts toward overall miles, so he can hit up a 99 Cent Store, buy up all their pudding and wind up with enough airline miles to be able to fly basically anywhere for the rest of his life. The movie seems to be building to a climax involving those miles, but sometimes life doesn't work out that

way. Because Barry loves Lena so much, he uses his own money to see her in Hawaii, because he isn't about to let anything get in his way at this point.

Barry's growth and evolution throughout the movie to channel his anger and rage toward actual threats against his happiness instead of against himself, is one of my favorite character arcs of any movie or show. Seeing him confront Dean over the phone and then driving out there to actually meet the guy is like a showdown worthy of a kung-fu movie, but instead of fists, it's pure emotion.

Punch-Drunk Love could only have been made by Paul Thomas Anderson. The way the movie leaves mysteries as mysteries and never broaches the subject again is something wholly unique to his style and sensibilities as a storyteller. Whatever happened with the car accident at the beginning has a meaning, but he doesn't want to spell it out for us. Whatever we, the viewer, make of the event is what's important. The score by Jon Brion is his best, and sometimes whole scenes are elevated because of Brion's discordant score that embodies the madness that Barry sometimes feels inside himself. And the performances are all great. It goes without saying that Philip Seymour Hoffman, one of the greatest actors of his or any generation, plays Dean perfectly. But Adam Sandler as Barry isn't just some comedic actor trying out something more serious, he really does become the character, and the performance is legitimately great.

Runtime: 89 minutes.

Raiders of the Lost Ark
(1981)

My dream has always been to own my own movie theater. And in this dream, I don't have to worry about ticket sales, attendance, bills or money in any way. Because it's a dream. In my "owning a movie theater" fantasy, the first movie I always planned on screening was *Raiders of the Lost Ark*. *Raiders* has, to me, always represented precisely the reason why it is that we go to the movies. We go to the movies for different reasons. We see comedies to laugh. We see

dramas to cry. We see horror movies to scream. We see movies like *Raiders of the Lost Ark* to experience the full spectrum of human emotion on display, wrapped in an essence of pure fun.

In case you've somehow never gotten around to seeing this movie, it's about the coolest college professor of all time, Indiana Jones, who triples as a part-time antique collector and battler of Nazis. A movie's opening is important because it introduces us to the action, the characters and exactly what it is that this movie is supposed to make us feel. *Raiders*' opening is pure magic, one of the most magnificent openings of all time. We open on the jungles of South America. It's hot. It's humid. It's dangerous. Three mysterious figures trek through the thick of the rainforest in pursuit of we know not what. Sweat beads their brows and betrayal strikes, but the mysterious fedora-wearing silhouette is no naive explorer and anticipates this. He steps out of the shadows and emerges as... Indiana motherfucking Jones. Golden skulls, angry natives, rolling boulders and yet another betrayal follow. But this is all in a day's work—or a day's pastime, rather—because the next we see of him after his miraculous escape is a normal, humdrum life of an academic teaching a class.

Spielberg has made more "important" films in his tenure as a director. He showed us the horror of the Holocaust in *Schindler's List*. He showed us the price of revenge in *Munich*. He showed us the absurdity of the legality of slave ownership in *Amistad*. But, *Raiders of the Lost Ark* represents Spielberg at his best and his purest. He's a storyteller by nature and has a million things that he wants to throw at us, so with an idea hatched by George Lucas and fleshed out by Lawrence Kasdan, he has an opportunity to do whatever he wants, and embellish whatever elements he wants, without completely overwhelming an audience.

Years and years ago, during the summer when TV shows used to be nothing but reruns, I remember flipping through the channels and stumbling across the very beginning of *Raiders of the Lost Ark*. It was right at the part where Indy and a young Alfred Molina were making their way through an ancient temple and I was psyched. Network television at an afternoon hour finally paid off. For all the bullshit you have to drudge through, at least PBS was playing Indiana Jones unabridged—and in widescreen! I kicked back and relaxed, only to have

the film dissolve and have Harrison Ford sitting in that classic black-background-and-table set with Charlie Rose asking him questions in those low, hushed tones replete with polite chuckles for good measure. It was about as depressing as Bart Simpson being forced to watch, ugh, Klassic Krusty ("Now, are we in the middle of an economic crisis?" "Well, Krusty, that depends on how you define 'crisis.'").

Howard Hawks once said that a "great film" can easily be defined as a movie containing three great scenes, and no bad ones. If this is true, *Raiders* features the brilliant beginning that climaxes with a rolling boulder, the chase scene that rivals anything in *Bullitt* or *The French Connection*, and the fabulous ending involving melting Nazi faces and exploding heads.

Raiders of the Lost Ark represents, in a way, the best impulses of a filmmaker who has freedom and total control over their movie. It represents a desire to tell a story in the most unabashed manner possible. Someone like Martin Scorsese would represent the opposite end of the spectrum: Wanting to express one's innermost personal desires and psychoses, audience be damned. Spielberg's *Raiders of the Lost Ark* represents an almost childlike and innocent need to tell a story that appeals to the broadest audience possible.

Indiana Jones saves the day in the end through pure machismo and intellectualism. He represents a male fantasy of what it means to be a man, someone who can effortlessly stomach a kill-or-be-killed world and totally excel at it. Karen Allen as Marion is a wisely character who can hold her own… she can drink just about anyone under the table and she's not afraid to pick up a burning log in order to bonk someone over the head.

Runtime: 115 minutes.

Ratatouille
(2007)

The night I saw *Ratatouille*, which was opening weekend, I remember wanting to see it with *someone* at least, I didn't want to see a cartoon

made for children by myself. I texted a friend of mine to see if he wanted to see it with me and he said yes (thank god) and we ended up having a very fun night together. It must have been some holiday weekend when it opened because I got stuck in one of those DUI checkpoints and when the police officer asked me if I had been drinking, I said no, and he asked what I was doing for the evening I said, "I saw a Pixar movie, *Ratatouille*," and he grunted back at me, "Isn't that for *kids*?" Sure, but whatever… I'm not drinking and driving, so what do you care, dude?

Before Pixar was around, Brad Bird was already something of a legend in animation. He was involved, in some capacity, in just about everything I love. He did work for *The Simpsons*, *King of the Hill*, *The Critic* and directed the animated film *The Iron Giant*. Pixar and Brad Bird finally joined forces that resulted in *The Incredibles*, an amazing collaboration of storytelling and technical skill. Just a few years later, they worked together again to create my personal favorite, *Ratatouille*, a movie obsessed with portraying the fine details of someone else's obsession—in this case, it's a rat who loves to cook. The film spends painstaking time creating meals with essential details like how the inside of a restaurant's kitchen operates. Even though I know I'm essentially looking at 0s and 1s in a combination to simulate something that's not really there, but when garlic is being sliced and tossed into a digital soup, my mouth starts to water.

Cooking has always been a passion of mine, something passed on to me from my parents and shared as a family, and my totally un-guilty pleasure is that I love watching movies that partake in food porn. Hell, the food porn is one of the primary reasons I liked the TV show version of *Hannibal* so much (when Hannibal cracks open baked clay to reveal a human leg tied up with herbs, I realize I was supposed to be shocked and disgusted, instead my stomach growled). Sometimes when I watch cooking shows on PBS, I wait for the "money shot" where the last detail is added to a dish to make it perfect. *Ratatouille* is up there as being one of my favorite movies about food.

Remy (Patton Oswalt) is a rat that's ashamed of what he is. He sees his own species as nothing more than disgusting creatures not above eating trash for the rest of their lives. The problem, he believes, is that

they don't take any pride in what they eat, and there are so many amazing flavors out there to enjoy. In one scene he tries to explain to his brother what it's like to combine foods and as he talks a colorful array of lights dance above his head; when his brother tries the same thing, the colorful array of lights are dull and confused. He just doesn't get it.

Remy's father, Django (Brian Dennehy), warns him about humans. He warns Remy that, sure, he might like the way they live, but humans are dangerous. They won't think twice about killing a rat, and that's why they live on the outskirts of visibility in human society, because there's no way for them to get along.

After an incident in a farmhouse in the French countryside, Remy is separated from his family and is washed to the city of Paris by way of storm drains and the sewer. Remy follows his nose to a restaurant and befriends the well-meaning doofus Alfredo (Lou Romano), who works in the kitchen. Together, with Remy's talent for cooking, and with Alfredo's talent for being a human, they take the world by storm with the meals that they cook. Remy is the brains behind the operation and Alfredo is the much-needed human face.

Ian Holm plays Skinner, the owner of the restaurant who suspects something is wrong. Peter O'Toole plays Anton Ego, the restaurant critic who can make or break a restaurant with one single review. "I don't like food," Ego threatens at one point. "I *love* it. If I don't love it, I don't *swallow*." A movie like this is only as good as its villains, and Skinner and Ego are both great. Skinner is a manipulative, angry little man, influenced by greed. Ego is someone who used to have passions, but the world corrupted them into bitterness. Ego's review at the end of the movie is amazing writing, and the way Peter O'Toole delivers it, with such passion, makes you appreciate the wonder and magic of films like this by Pixar. You have a film made for families and children of all ages, and it refuses to talk down to them or dumb things down and, instead, contains a monologue worthy of some esteemed play. Everyone, of any age, deserves quality entertainment, and that's something Pixar understands.

Brad Bird is an expert at animation. *Ratatouille* contains as much subtlety in performance as a live-action film. He knows the way people

move and how they react to situations. When Colette (Janeane Garofalo) is so aghast and heartbroken in one part, she tries to raise her hand in anger, her eyes flood with tears, and she drops her hand defeated, knowing that no matter what she does it won't change her disappointment. It's a great little moment. Brad Bird's commitment to his projects can best be summed up with this: Pixar makes it a point to drop Easter eggs for their next project in whatever film you're currently watching. It's kind of a neat thing they do, where they drop a subliminal little advertisement for what's to come, because they're already well involved in the development in it, since every film they create takes such a long time to make. Brad Bird did them one better by having some characters in the TV show *King of the Hill* wear t-shirts containing the logo from *The Incredibles* some five (or more) years before that movie's eventual release.

Runtime: 111 minutes.

The Road Warrior
(1981)

As much as I liked the latest *Mad Max* movie, *Fury Road*, my favorite will forever and always be *The Road Warrior*. The ranking goes: *Road Warrior*, *Fury Road*, *Beyond Thunderdome* and then the first, the original *Mad Max*. They're all good, but *The Road Warrior* is a special movie, a breakneck piece of action that begins with excitement and never once lets up for a minute. Even in the quieter moments, there's a constant siege of tension, so throughout the whole film, we're in for one hell of a wild ride.

The Road Warrior is one of those rare examples of a sequel that not only lives up to any hype or expectation, but completely outdoes those expectations and outshines the original film. *The Road Warrior* is vastly superior to the original *Mad Max*, which is still a fine film. It's a good movie, but *The Road Warrior* is something else entirely. It's like if you had one of those examples of an amazing sequel, like *Aliens*, *The Empire Strikes Back* or *The Godfather Part II*, but imagined that the movie it was following was merely a decent film. It'd be like if the 1999

version of *The Mummy*, a movie I find to be a tremendous amount of fun but nothing too special, had been followed by fucking *Aliens*.

The film begins with Max (Mel Gibson) being chased by a violent gang of bandits in the post-apocalyptic Australian outback. Right off the bat, the director George Miller is letting us know exactly what kind of movie we're in for. Max manages to cause two of the vehicles in pursuit of him, to crash and loses them. He stops once safely away in order to investigate an old crash site for fuel, including a scrapped-together-looking autogyro—a sort of one-man helicopter—and is ambushed by the Gyro Captain (Bruce Spence). Max gets the upper-hand and keeps him as his prisoner, in exchange for information on where to find fuel, something rare in this world, and the Gyro Captain says he knows a place where Max can get plenty.

Max and the Gyro Captain make their way to a walled-off city that, according to the Gyro Captain, has the fuel that Max wants. They observe it from a distance. The city is besieged by a deadly gang, including a couple of members of the gang that had been in pursuit of Max in the beginning, led by the maniacal Lord Humungus, a leather-thong-clad psychopath that wears a hockey mask. Max and the Gyro Captain watch as a small group, who tries to make it out of the city, are stopped and killed by the gang. In a brief window of opportunity, Max rescues the sole survivor of the attack and he and the Captain gain entrance inside the city. Max uses the wounded man as a bargaining chip in order to get gasoline for his car, but when he dies, the leader of the compound Pappagallo (Michael Preston) says there is no deal.

In order for Max to get what he wants, he is dragged into a situation he wants no part of: He has to help the people inside the compound escape the city, away from the gang, and get to somewhere far away they have in mind in order to create a new settlement.

The Road Warrior spends the time to allow us to get to know the motley crew of wasteland survivors, like the feral kid with a talent for throwing a deadly boomerang, so that when the final showdown of the film begins, we have something invested and feel heartbreak when some of them inevitably die. There are real emotions at stake and that's part of what makes *The Road Warrior* such a great movie, the time it invests into building up characters for us to care about. In so

many other action movies, there's no reason for us to be thrilled or excited by explosive, dangerous sequences, because we just don't care what happens to anyone. When something explodes, it might *look* cool, but in order to be engaged, we have to care about the consequences of that explosion.

1981 must have been a year that spoiled a lot of moviegoers. Between the ending sequence of *The Road Warrior* and the incredible chase sequence in *Raiders of the Lost Ark*, there was no shortage of incredible car stunts. But, on top of those two movies, you also had the immortal badassedry of Snake Plissken coming to life in *Escape from New York*.

A couple months ago I was watching that movie *What Women Want* because I'd never seen it before, and there's a scene where Mel Gibson does this whole Fred Astaire dance sequence and I remember thinking, "Holy shit! People used to love this guy!" It's strange to think of it now, but there was a time when Mel Gibson could do no wrong—the world was his, and he had won everyone's heart, and it was because of amazing performances like the one here in *The Road Warrior*. Man, did he fuck *that* up.

Runtime: 94 minutes.

RoboCop (1987)

RoboCop has always been there for me.

I won't name the film, but one time I went to the movies with my girlfriend, my sister and my sister's boyfriend, and the film we ended up seeing was goddamned *dreadful*. Easily, one of the worst things I'd ever seen. I remember looking over to my girlfriend and making a face and she asked, "You wanna get outta here?" I almost shouted, "YES!" but instead I just whispered the same thing to my sister, who nodded enthusiastically. She whispered to her boyfriend and we all four got the hell out of there. While we were outside, we wondered what we were going to do next.

"You guys wanna go to my house, get drunk and watch *RoboCop*?" I asked. The suggestion was met with enthusiasm.

RoboCop is that good.

Years ago, back when I was 19-years-old, I found myself in one of the worst, most awkward situations I've ever been in in my life. It remains one of those cringe-worthy moments in my life, where sometimes the memory of it will come at me from out of nowhere and I'll physically shudder. I spent an awful two days in Irvine, CA, at the University of Irvine as the guest of one of the worst human beings I've ever had the displeasure of meeting. I'm going to cut to the chase and jump right to the part where I found myself alone in the lounge area of one of the dorm buildings. After some time, I made friends with a couple of the students there and they asked if I wanted to watch a movie with them. I said hell yes I did, and I had brought some with me if they were interested in perusing my collection. We settled on my trusty Criterion DVD version of *RoboCop* and for those 103 minutes (of course it was the uncut version) I forgot how miserable I was.

When I went through some tough financial times and I had to sell that DVD, I damn near cried. I sold that and my Book of the Dead Edition DVD of *The Evil Dead*. Oh, how it stung.

RoboCop is a cautionary tale of private industry run amok. The police force is now run as a business, and the suits at the top are looking for ways to cut expenditures. The way of the future appears to be in robotics, fully autonomous law enforcement machines that will follow orders and work for absolutely free—the only expenses would be for routine maintenance. Their prototype droid ED-209 is introduced to an excited boardroom, only to have it malfunction and brutally kill someone during the presentation.

Fortune strikes for Bob Morton (Miguel Ferrer) when an officer is almost killed in the line of duty. Officer Alex Murphy (Peter Weller) is all but dead, his hand having been shot off by a shotgun and a bullet put into his brain, but he clings to a technical form of life. Morton sees possibility in this. The ED-209 lacked that certain *je ne sais quoi* that artificial intelligence requires. It needs something tangible. Instead of

creating law enforcement *droids*, he wonders if cyborgs might be the ticket.

Murphy's body is almost totally scrapped in order to make the creation that will be known as RoboCop. His memories are wiped and he is programmed to be an efficient and dutiful police officer in the line of duty. He has no pesky emotions to cloud his judgment. Everything he does is to be done by the book and with the utmost competence. After a test run in the field, he's shown to be a smashing success.

The problems come when Murphy begins to remember who he was.

Murphy's old partner Officer Lewis (Nancy Allen) recognizes him, and he almost begins to recognize her. Meeting a face from his past begins to jog the memories that the creative team behind his creation were supposed to have wiped, but apparently only hid to his subconscious. Instead of sticking to the book, RoboCop grows sentience and bitter resentment and goes gunning for the people who had killed him.

RoboCop works as well as it does because of its many layers of brilliance. And I mean that without hyperbole. *RoboCop* is a goddamned brilliant film. On one level, it works as a fun, bloody action film. The bullets fly, the blood sprays and the action is always, always moving the story along and there's rarely a dull moment, or a moment devoid of carnage. The pacing is also incredible. According to a think piece written by Robert Lockard on the website www.dejareviewer.com, the film is almost completely symmetrical. Start out at the middle and move forward and backward through the scenes simultaneously and you'll see a conscious effort to have each half mirror itself in terms of revelations and plot developments. And though it's hardly a new idea, *RoboCop* is also a Christian parable. The film's director, Paul Verhoeven, said it was a modern retelling of an American Jesus Christ, in that if Christ were American, he would hit all the same beats of the New Testament, but be packing a gun to blow people away, pre-and-post resurrection. Near the end of the film, "RoboChrist" even appears to walk on water.

Runtime: 102 minutes.

The Rock
(1996)

The way I see it, everyone is allowed to like any two Michael Bay movies while getting to retain their pretentious "film snob" status. Every hoity-toity cinephile, or whatever they want to call themselves, can select two works from his filmography and come out unscathed. It doesn't matter which two, either. *Any* two. You can go with *The Island* and *Transformers* or *Armageddon* and *Bad Boys* and be completely fine, with no loss of credibility. I invented the rule, so I get to break it a little bit by applying math and saying that *my* two choices are *The Rock* and 50% of *Bad Boys II* and 50% of *Armageddon*. I almost like *Armageddon* as much as I almost like *Bad Boys II*, like there's something just underneath them that's dying to get out—like the moral awfulness of *BBII* or the genuine likeability of everyone that isn't Ben Affleck and Liv Tyler together in *Armageddon*. So the only complete movie of his career that I really, thoroughly enjoy without any shame whatsoever is *The Rock*, and goddammit, I love it.

Believe it or not but for quite a few years after he'd won his Oscar for *Leaving Las Vegas*, there was a time when seeing that Nicolas Cage was going to be starring in a movie was something that excited audiences. He'd proven himself to be a capable actor, worthy of praise because of how vastly distinct his top performances were—there's a world of difference between *Valley Girl* and *Leaving Las Vegas*. After winning his Oscar, he sort of reimagined himself as an action star, which was a smart move at the time, and only happened because *The Rock* (the very next project he starred in after his Oscar win) is legitimately enjoyable and he's actually great in it. His frequent returns to that particular role resulted in diminished results over time. To go from *The Rock* to *Con Air* or *Face/Off*, there's no shame in that, they're all enjoyable movies. But to go from Oscar winner to *Ghost Rider*? His reinvention of his image to action star resulted in about half a decade of really fun, quality stuff, but then deteriorated into... I don't even know what. But at least he still has the time to pop up in things like *Adaptation.* and *Joe* to remind us every couple of years what he's truly capable of as a performer.

The "rock" of the title refers to the great, big rock of an island off the coast of San Francisco, Alcatraz, the unescapable prison that housed many a criminal for a great many years, now closed and open to the public as a tourist attraction for people all around the world. Alcatraz once again becomes home to some dangerous men when Brigadier General Francis Hummel (Ed Harris) and his group of loyal defected Marines take the island by force and use it as their base of operations. General Hummel says that if he doesn't get what he wants, he will launch a rocket containing VX gas over the city, resulting in the untold deaths of innocent civilians.

Nicolas Cage plays Special Agent Stanley Goodspeed of the FBI, a chemical weapons expert called in to disarm the weapons. Sean Connery plays John Mason, a legendary prisoner who remains the only man in existence to have ever successfully escaped from Alcatraz. They need his help to break back into the island and navigate the fortress, to stop General Hummel from hurting anyone. It takes some thorough convincing, but Goodspeed and Mason are dispatched to the island to covertly disarm Hummel's rockets.

The two are brought to the island by a team of Navy SEALs. The plan, of course, has a major hiccup as soon as they arrive, which results in the deaths of their Navy SEAL escorts, the only people capable of taking on an elite squad of U.S. Marines. Goodspeed is a dork, just like you or I. He collects Beatles records. He's not cut out for this action movie stuff, which is part of why he's such a good character, and Nicolas Cage plays him with this nervous intensity that's perfect for the role. Sean Connery as Mason does the usual Sean Connery thing where he's a possibly-magical badass of inhuman proportions. The two of them have to work together against insurmountable odds in order to save the people of San Francisco from a terrible death.

Part of what makes *The Rock* work is because, unlike so many other movies directed by Michael Bay, is that it takes the time to establish its characters, especially the villain, General Hummel. Hummel isn't a soulless, evil man looking to get money and become rich, he actually has some redeeming qualities and he has a delicately nuanced duality. He wants the United States government to pay out $100 million toward families who had not been fairly compensated after men had

died under his command. Obviously, his mission is a massive overreaction, but he has motivations that make some sort of sense.

The supporting cast, too, of *The Rock* helps breathe some life into the picture. There's lots and lots of shooting going on, like explosions and graphically violent deaths, but the movie is enlivened by the performances of Michael Biehn, Tony Todd, David Morse and John C. McGinley, and it's these performances and fun dialogue that really elevate *The Rock* into a much higher category than it ought to be. It goes from schlocky fun to downright awesomeness. *The Rock* is one of the best action films of its era.

Runtime: 129 minutes.

Rocky
(1976)

If *Rocky* had come out in any other year other than 1976, it would have won the Academy Award for Best Original Screenplay. Instead, up against a juggernaut of a movie like *Network*, it really stood no chance. It's kind of a shame, because the screenplay really is quality stuff. It's very well-written, structured and contains a surprising amount of genuine emotion.

Rocky is one of the all-time great underdog stories. The movie itself mirrored the climb to success that its titular character went through, a low-budget film that ended up taking the world by storm, winning the hearts of audiences everywhere and had an incredible run at the box office. It eventually went on to win Best Picture at that year's Oscars, unlike Rocky himself who was a winner in the end without ever actually winning the fight. Perhaps it would have been more appropriate for the movie to have simply been nominated, but I think its eventual win was appropriate. A lot of people forget that the first *Rocky* movie is a great movie. It's the sequels that sort of tarnished the original image, each one more ridiculous than the last, but they kept making money so MGM kept cranking them out. It's hard to imagine that a movie as ridiculous as *Rocky IV*, which featured a not-at-all-

subtle Cold War allegory and love story subplot involving a robot butler, followed in a series of movies that began with genuine greatness. The fall from grace that the series went through reminds me of the increasingly-inferior entries to the *Halloween* franchise, because somehow, no matter how bad the movies got, both franchises ended up getting an actually-decent semi-reboot decades later (*Rocky* has *Creed* and *Halloween* has *H20*).

Sylvester Stallone, who stars as the main character Rocky, also wrote the screenplay. Stallone gets a lot of shit in the pop culture mainstream for being dumb, when he's pretty clearly not a dumb guy at all. The screenplay to *Rocky* contains some excellent writing. He also wrote the screenplay for *First Blood*, the original Rambo movie, which suffers the same reputation that *Rocky* does—where a really good first movie is forgotten and the sillier sequels have become the legend that everyone remembers.

Rocky is a small-time boxer in Philadelphia, barely making enough money to get by. He's certainly not paying the bills with his fights. When he's not in the ring, he collects debts for the neighborhood loan shark. He begins a romance with Adrian (Talia Shire), a shy woman with an alcoholic brother named Paulie (Burt Young). The relationship between Rocky and Adrian reminds me of the film *Marty*, where two lonely souls find happiness together, but because of their insecurities and because of outside influences from people like Paulie, they just don't believe that they deserve it, or that they're somehow doing something wrong by being together.

Usually romances in movies like this seem unnecessary, like a superfluous addition to give the audience a little something else or to pad the running time, but in *Rocky*, Rocky and Adrian being together is essential to the story. Paulie makes Adrian feel worthless for living with him and helping her out financially, and even though he makes great claims about how he's the one who matched her up with Rocky, he's jealous of anyone's happiness, especially when Rocky ends up getting his big break later. Talia Shire is great as Adrian, and when she explodes in rage at Paulie, it feels like something real.

Apollo Creed (Carl Weathers) is the Heavyweight Champion of the world, and he's coming to Philadelphia for the nation's Bicentennial for

a boxing match that promises to be an historic event. Imagine the biggest fight of your lifetime and multiply it by ten. The Creed Bicentennial match is supposed to rival Sonny Liston vs. Muhammad Ali. His intended opponent is injured and can't fight, so Creed decides to make things a little more exciting for everyone by recruiting a local boxer to fight. He chooses Rocky seemingly at random, because he likes his name and likes his style. Rocky realizes that a shot like this is something that will only come once in a lifetime and doesn't take that opportunity he's given for granted. He trains and trains and trains endlessly, seeking the expert advice of the cantankerous Mickey (Burgess Meredith), an ex-fighter with wisdom of the ring.

Rocky never fools himself into thinking he can overcome such astronomical odds to win the fight, but he wants to prove himself worthy of the chance he's been given. He just doesn't want to go into the fight and be made a fool of, so he gives Apollo Creed a fight that he never expected to get. Creed sees that Rocky means business in the ring and the two pummel each other for the full 15 rounds, something no one in a million years thought would happen. When the crowd begins to chant, "Rocky! Rocky! Rocky!" near the end of the fight, whether he wins or loses is completely irrelevant, because he's already won. He won the hearts of everyone watching through his determination and refusal to admit defeat until the final bell. And everything he went through up to that point, all the training, all the raw eggs he ate, all the steps he ran up, it was all worth it.

When the crowd loses its mind, the only thing Rocky cares about is seeing Adrian there for him. The whole movie is good, and is much darker and depressing than a lot of people give it credit for (it's a boxing movie in the purest tradition of the genre; boxing movies should be a little bit depressing), but the ending is really what makes it. It's one of the greatest endings of any movie. If you don't at the very least get a little misty-eyed, you're a damn cynic.

Runtime: 119 minutes.

The Room
(2003)

I'm an unapologetic lover of bad movies. There's always a certain amount of schadenfreude involved when watching a bad movie, though. Let's face it, when you're watching a movie like *The Room*, you're not laughing with the movie, you're 100% laughing *at* it. You're laughing because no other movie has failed in quite the same way that *The Room* has... a drama about human relationships that seems to have been written and directed by a Martian (Tommy Wiseau is probably the closest thing on Earth we have to a Martian, to be fair). But, I don't know, maybe it's because I have tried and failed miserably so many times myself to make a movie that I understand how easy it is to fuck up when telling a story and how incredibly hard it is to make a movie come out good. Studios sometimes spend hundreds of millions of dollars on movies that come out bad, too. Making movies is really, really hard, and if you don't know what you're doing, making a bad movie is the easiest thing in the world—I know we all fancy ourselves filmmaking prodigies like Robert Rodriguez who can make a cinematic masterpiece for only $7,000, but it doesn't always work out that way.

Most of the time, when a movie comes out bad, it's just bad. It's boring or it's stupid or it's insulting... it just lacks some necessary quality we look for in movies, and because of that, we don't enjoy it. What makes a bad movie good is when it's so bad that it takes on an unintentional level of humor and we can enjoy it on an ironic level. Some movies that know they're going to be bad end up trying to intentionally nosedive their movies into this realm, but it never, ever works. A self-aware piece of shit movie is just unwatchable. For a movie to be bad, and to enjoy it solely on that level of badness, it needs a certain earnestness to it. It needs to want to be good. It needs to want to say something noteworthy. That's why *The Room* works as well as it does. Writer/director/star Tommy Wiseau is obviously telling an incredibly personal story. He financed the entire project himself with an almost unfathomably high self-acquired budget of $6 million, and in his defense *The Room* does at least look professionally-made with decent cinematography and editing that allow us to look at decently-lit images with a clear narrative, so the whole thing at least

makes sense, which is saying a lot more than many other movies of this caliber.

The Room is about a really, really good guy named Johnny (Tommy Wiseau) who wants nothing more than to marry his "future wife" Lisa (Juliette Danielle). The thing is, he's *too* nice. He bores Lisa, so she cheats on him with Johnny's best friend Mark (Greg Sestero). The film is called *The Room* because the majority of it takes place in Johnny's apartment with characters popping in and out of it, something the director Tommy Wiseau said was a typical American thing, which… not really. I mean, people have guests over, and that's not unusual, but Johnny has guests when neither he nor Lisa are even home, and they treat it like it's the most normal thing in the world. People even eat fruit off each other and have sex while they have their own places to have such elaborate copulations.

Tensions begin to rise between Johnny and Mark as Johnny begins to suspect that something is happening behind his back. I think what I admire most about *The Room* is in successfully-understated moments where subtlety is actually achieved—the way Tommy will ask Greg something, and there's a little tinge of suspicion in his voice, but he drops it when he realizes it's not going to get him anywhere. There are a few of these moments scattered throughout the film where you can totally see what Tommy Wiseau was going for, but the totality of those little parts never congealed. What we're left with instead is a very strange movie that actually does succeed in providing its own unique view on the human condition, it just happens to be a terrible movie and that unique view on the human condition is riddled with a pronounced victim complex. Most movies that are similar in overall quality to *The Room* are usually horror movies or direct to video action movies, and it's rare to see a drama join their ranks, and that's refreshing.

Like I said, *The Room* was an incredibly personal project for Mr. Wiseau. You can tell that a lot of what happens in the film comes from a place of hurt and of bitter resentment. Writing the script was a kind of therapy to mend a broken heart. *The Room* has something to say, and by god it says it, although not with the best clarity. Even still, *The Room* is Tommy's vision, from beginning to end. Everything he wants

to say about life and love, he says it. A lot of what he says is questionable and he obviously views himself as some kind of martyr, but I have to respect him. It's not an easy thing to make a movie. It's especially not easy to make a movie as personal as the one that he made, and the ridicule he must have endured is something I doubt that I could have survived. But he's done more than merely survive, he's thrived. *The Room* has become a cult hit and people all around the world love it as much as I do and there's soon to be a movie out about the film's strange production, starring James Franco (who also directed) as Tommy Wiseau, called *The Disaster Artist*, based on the book of the same name by co-star Greg Sestero.

My friends and I all met Tommy Wiseau once. He attended a screening of *The Room* in person and when he arrived you'd have thought the fucking Beatles came in through the front door and the year was 1964 the way the crowd collectively lost its shit. He ran in with a football, tossed it around to a couple people, high-fived some others and when he came to me, he looked me up and down, made a face, and declined my offer of a high-five. Make of that anecdote what you will. I have no idea what it means, but I thought it was worth mentioning.

Runtime: 99 minutes.

Greg Sestero and Tommy Wiseau with my friends and girlfriend (author not pictured)

Rope
(1948)

Leave it to Hitchcock to take an idea like filming an entire movie in one long, unbroken shot and make it something incredible. I've seen the "one long, unbroken shot" thing before and it's rarely ever anything other than a gimmick. In *Rope* we're in confident, assured hands, a director who knows what he's doing, and Hitchcock is telling his story that way simply because it's the most appropriate way to tell that story. The technique of having no edits, no closeups for added emphasis and no over-the-shoulder reversal isn't an opportunity for the film to pat itself on the back for being so clever, it's to put us, as the viewer, in the middle of the story as it unfolds, and we're watching every sinister reveal in real time.

Rope is loosely based on the true story of Nathan Leopold and Richard Loeb, two friends who murdered a friend of theirs. True to the real life story, *Rope* follows two similar characters, here named Brandon Shaw and Philip Morgan (John Dall and Farley Granger), who kill their friend David, just to see if they can get away with it. They have a feeling of superiority over everyone else, believing themselves to be smarter and just generally better at everything than anyone they know. With their friend David dead, they hide the corpse in a large, wooden chest inside their apartment.

To take things a step further, Brandon and Phillip have a party at their apartment that same evening and even invite the victim's father and aunt over as a sort of sadistic game to watch and gawk at. They use the wooden chest that their dead friend is hidden inside of as a centerpiece to the party, serving food off of it, almost daring someone to catch them, and toying with their own hubris, stretching their luck as far as they can possibly take it. No one at the party has any idea that there is a dead body a mere foot below where they're grabbing food and snacks.

Also in attendance at the party is Rupert Cadell (Hitchcock regular James Stewart), Brandon and Phillip's old headmaster from their prep school days, a man they look up to and admire very much. Back in their teenage years, the three of them would often discuss philosophy such as the "art of murder" to show one's superiority and drop hints to him throughout the evening.

Brandon and Phillip's attempts at subtle clue-dropping backfires, with their attempts at subtlety just as well having been screamed from a mountaintop, as everyone at the party begins to suspect something is wrong when David neither shows up nor calls to say he's going to be late. His father, in particular, begins to suspect something terrible has happened. When David's father leaves, Brandon sends him home with some books that have been tied together with the rope he and Phillip used to kill his son.

As the evening progresses, Brandon keeps his composure, but Phillip becomes more and more unhinged, the stress of being caught weighing him down. Meanwhile, Mr. Cadell asks more and more

questions about David, like where is he, where could he have gone and why isn't he here right now?

Keep in mind, all of this is performed in what seems like one long take, with the camera moving about the small apartment. In one particularly incredible setup, one of the killers pushes through to the kitchen to hide the murder weapon (the titular rope), the double-swinging door whooshing back and forth in the foreground while he opens the drawer and drops the rope inside.

There's a reason why, all these years later, Alfred Hitchcock is remembered as being the "master of suspense." The amount of tension he builds in *Rope*, from such a simple premise, is brilliant. The film is based on a play of the same name by Patrick Hamilton, and what works so well about it is how many layers there are to the tension. Simply having the body at the party and the risk of it being discovered isn't enough. No, instead Phillip is on the verge of mental collapse, with a confession at the tip of his tongue, coming nearer and nearer to spilling the beans with each drink he gets for himself. Then there's the never-ending cruelty of Brandon, who delights in sadism. And Mr. Cadell's suspicion of them throughout the entire evening.

Rope seems to be the Hitchcock movie everyone forgets. When his best movies are listed, *Rope* rarely makes the cut. To me, I think it's one of is absolute best. I love just about everything about it. I love the way it builds to such a powerful climax at the end. I obviously love the way it's shot, which isn't some "cool" technique like I've seen exploited to death in other movies, but here it's a tool used to brilliant effect—and where would cinema be without this cinematographic experiment? Without *Rope* would the long takes of *Goodfellas* or *Children of Men* exist? But, most of all, I love the movie's outlook on self-perceived "superiority" and the dangers of believing your own hype.

Runtime: 80 minutes.

The Royal Tenenbaums
(2001)

You can tell by looking at a single frame of a Wes Anderson movie that it's one of his films. There's no mistaking him for anyone else. No one else composes shots like him, with such precise framing and careful art direction.

The Royal Tenenbaums is told like a storybook, complete with narration (care of Alec Baldwin), introducing us to a financially well-off, dysfunctional family of geniuses. Paterfamilias Royal Tenenbaum (Gene Hackman) is a terrible father, racist, petty and a liar. His wife, Etheline (Anjelica Huston), is an archaeologist and author of the book *Family of Geniuses*, referring to her and her children. Chas (Ben Stiller), is a widower and breeder of Dalmatian mice who twice sued his father, Royal. Richie (Luke Wilson) is a tennis expert and ex-professional player who left the game disgraced after an emotional breakdown. Margot (Gwyneth Paltrow) is the only girl of the children, an adopted daughter and playwright with a talent for keeping secrets… no one knows that she smokes cigarettes. Eli Cash (Owen Wilson) is not a Tenenbaum, but wishes he was one, a longtime family friend and writer who is sort of like an even-more-pretentious version of Cormac McCarthy, without the required talent to justify such pretensions.

Royal and Etheline divorce and Royal is estranged from his family for years, until he runs out of money and needs a place to stay. He pretends to be dying of cancer in order to weasel his way back into their lives and back into the house. Everything happens all at once for the Tenenbaums, with every member of the family suffering their own crisis, and they all return home—even Richie's pet falcon as a child, Mordecai, returns home after experiencing some sort of trauma of its own out in that wide world.

Etheline is beginning a new romance with her accountant, Henry Sherman (Danny Glover), which Royal doesn't take too kindly to. It's not that Royal is still in love with his ex-wife, it's that he's a jealous person and takes it as a sort of personal insult to see her be happy with anyone else. While faking his illness, he sets about ingratiating

himself back into the lives of his children, without ever actually apologizing for the years he spent as an asshole to them.

Everyone is dealing with their own issues while at the house, all under one roof. Chas, after the death of his wife, is obsessed with safety, to such a maddening degree that he's alienated himself from his children, the people he loves and wants to protect most. Richie is in love with his adopted sister Margot, something Eli calls, "Sick... and gross." Eli, meanwhile, is dealing with a bizarre drug addiction. Margot is depressed, stuck in a loveless marriage and is a serial philanderer.

Throughout all this, Wes Anderson sets a perfect mood from the beginning and earns its big belly laughs and it wins the more serious moments that flow naturally into the story, instead of acting like tangential sadness detours.

Wes Anderson wears his influences on his sleeve, but his movies never play like an endless parade of montages, instead all of his influences congeal into one solid vision. It's easy to parody Wes Anderson, only because the look and feel of his movies is something wholly invented and entirely his own. No one makes movies quite like he does. Sure, you can frame the way he frames, and you can mimic his precise camera movements, but there's a certain heart that he has that's not going to be duplicated. His heart is in the writing, and it's clear that his visual style is secondary to the love that he has for his characters, and everything in the story that happens to them. It's easy to mistake his work as being superficial because it's so beautiful to look at, but it goes much, much deeper than that, and that's where the real charm lies. I love the way his characters interact with each other, like in this scene where brothers Luke and Owen Wilson, playing the characters Richie and Eli, are talking:

Eli: What'd you say?
Richie: Hmm?
Eli: What?
Richie: I didn't say anything.
Eli: When? Right now? ... I'm sorry, don't listen to me. I'm on mescaline. I've been spaced out all day.
Richie: Did you say you're on mescaline?
Eli: I did, indeed. Very much so.

What a lot of people forget about Wes Anderson is that he has a knack for dialogue. It doesn't necessarily sound "realistic" when the actors recite it, but it has a timing to it and a music to it that always makes it so listenable.

Runtime: 103 minutes.

Rushmore (1998)

I think every fuck-off in high school fancied themselves a Max Fischer type. I certainly did. I got terrible grades in high school, while feeling intellectually superior in some weird, stupid way. As an adult, with years of hindsight on my side now, it's easy to look at Max today and write him off as a pretentious little brat, but when I was Max's age, I was a lot like him... except that I never wrote a hit play, or had half the actual talent he has.

Rushmore, the prestigious private school that Max (Jason Schwartzman) attends is, to him, a world unto its own. It's like Hogwarts in a way. He can't imagine ever wanting to leave. He dedicates his entire life to it. Every waking hour is devoted to Rushmore in some way or another, and much of his time is consumed by extracurricular activities. "Too many extracurricular activities, Max. Not enough studying," Dr. Nelson Guggenheim (Brian Cox), the school's headmaster tells him.

Max becomes enamored (and obsessed) with Rosemary Cross (Olivia Williams) a first grade teacher who works at Rushmore. Max's friendship with the local businessman and multimillionaire Herman Blume (Bill Murray) fractures when Blume himself falls in love with Rosemary and sleeps with her. "She's my Rushmore," Herman tells Max. "I know. She was mine, too," Max replies. Rushmore seems to represent any sort of unhealthy fixation with something... people, too. It's devoting yourself entirely to something and idealizing it in your head, making it out to be something that it's not at all.

The closest thing I ever had to my own Rushmore, this idealized place and school, was a camp I went to on a full scholarship in the summer of 1999 when I was twelve years old, a place called ISOMATA (Idyllwild School of Music and the Arts). I went for writing. I went to a high school out in the country in a very, very small town that didn't have much of a budget for anything in the way of the arts, so going to a place like ISOMATA blew my young mind. It was fucking crazy. People took the arts—every kind of artistic endeavor—with the utmost sincerity and seriousness, and it was unlike anything I'd ever seen before in my life. So, I know how Max must've felt when he got accepted into Rushmore Academy. I also know a thing or two about hating schoolwork and homework with a fiery passion and wanting to pursue extracurricular activities instead.

Anyone who Rosemary is with—whether it be her date to Max's post-play celebratory dinner, or Henry Blume—Max has an instant dislike and total jealousy toward. I remember one of the most jealous I've ever been of someone else is toward someone I'd never met. I had a really cool substitute teacher in high school who went by Mr. P, and he taught sometimes at ISOMATA. He knew I was into movies and that I'd gone to ISOMATA a few years before, and he said he worked with this kid there about three years younger than me (I was fifteen, he was twelve) who made a short movie he described as "pretty darn good." I rolled my eyes thinking, sure, this twelve year old is really gonna blow my socks off. I watched it, and it was really fucking good. It was... it was so good. And it pissed me off that this dude was fucking *twelve*. I was well into my teenage years and I was being bested *hard*. Like I said, I relate to Max in a lot of ways, and petty jealousy is one of those nasty traits we share.

When Blume begins sleeping with Rosemary, Max retaliates with a series of mean-spirited pranks to really get at him where it hurts. Max pumps bees into Blume's hotel room, he breaks apart his marriage by spilling the beans to Blume's wife about the affair with Rosemary and he cuts the brakes to his car, nearly killing him.

Rushmore wouldn't be half as good as it is if it weren't for Max. He's a great character, and part of what makes him such a great character is that he actually *does* have a lot of talent. The plays he writes for the

school, like his version of *Serpico*, is something I'd see in a second. The Vietnam epic he puts on for the public school he later attends looks amazing, and is apparently so beautifully written that it reduces a packed house to tears. But, he's also spiteful, egotistical and capable of such cruelty when he's feeling low, lashing out at the world around him—even people who love and want to help him.

One of my favorite things about Wes Anderson as a visualist is how he can build a character without using any dialogue. At the film's finish, we're introduced to a lot of new characters we haven't met before, but with little touches like clothing or props that they're assigned, we get a basic idea of who they are as people. It's economic filmmaking that doesn't insult an audience's intelligence.

Runtime: 93 minutes.

Saving Private Ryan (1998)

I'll never forget the first time I saw *Saving Private Ryan*. It left me feeling dazed, punished and beat up. All of my senses were overstimulated. I felt terrible. I felt sick. I didn't feel good at all—which, I suppose, was precisely the point of why the movie was made the way that it was. War is a terrible, stupid thing that we participate in. As a means of resolving conflict, it's fucking idiotic. Sometimes, unfortunately, there's no other way. *Saving Private Ryan* strikes a balance in a way that allows it to have its cake, and to eat it, too. It shows the men who landed on those beaches in Normandy as brave men who did the thing that scared them the most and triumphed over an axis of evil, while showing that war, itself, is a stupid, evil mechanism.

June 6, 1944, a massive operation called D-Day was launched by air and by sea. Captain Miller (Tom Hanks) and his men are a small part of that massive operation, and they hit the beaches by way of small landing crafts. Before landing, we're with them inside the boat, hearing explosions, the ring of artillery. Some of the men aboard the

ship begin to vomit from fear. Some of them pray. When the doors open, large caliber bullets rain down upon them, cutting them to shreds almost immediately. Every small bit of progress that they make is accompanied by loss of life. Every small bit of progress is marked by advancement toward the machine gun pillboxes on top of a hill, looking down at the beach.

In war movies, there's a terrible tendency to make the battle scenes look like action scenes, so when someone gets hit with an explosive, it looks lifted from an Arnold Schwarzenegger movie. In *Saving Private Ryan*, Steven Spielberg takes a pseudo-documentarian approach to it. We're with these soldiers every bit of the way and we're viewing events unfold with a clinical eye. When there's an explosion, it's not a cool, fiery spectacle to behold because we see the aftermath: We see a man hit the ground with a leg that's been severed. We see a man in complete shock casually pick his arm up from the ground and walk away with it. When we watch the Omaha Beach sequence unfold, it's impossible to imagine that we're watching a *successful* military operation from our side. Despite a massive amount of casualties and a tremendous loss of life, Captain Miller and his platoon make it up the hill and the U.S. and Allied forces mark a huge victory in battling Nazi forces out of France.

Back in the United States, the offices of the U.S. Army get word that the Private Ryan of the title is missing in action, possibly dead. The problem is, so are his brothers. All of them. General George Marshall decides that Private Ryan's mother should not have to endure such a loss, that she should have at least one son return home. Captain Miller is chosen to scour the French countryside in Normandy where he might possibly have gotten scattered from his jump as a paratrooper, and if he *does* find him, to send him home to his mother.

The mission of finding Private Ryan is PR bullshit. The United States Army does not particularly care whether or not Private Ryan lives or dies. Individuals might, sure, but as a whole, as a mechanism, it simply looks good to the newspapers to have such publicized compassion in a time of bloodshed. The operation to find the young man results in even more bloodshed, and even more casualties. Captain Miller watches as, one by one, the men under his command are picked off by

snipers or dragged into skirmishes against machine gun nests and finds a stray bullet to the stomach. All of this, to save one man. The mission is as senseless as the act of war itself.

The most successful aspect of *Saving Private Ryan* is its combat photography. Yes, the performances are all excellent, particularly from Tom Hanks and Tom Sizemore who plays his sergeant, Horvath. And of course the music by John Williams, one of the greatest living composers, hits all the right beats. But the battle scenes are the reason for the film's existence. Janusz Kaminski shoots the film mostly handheld and with a 45 degree shutter effect. The colors are muted to mimic the style of a camera from 1944 that somehow found itself accompanying a group of soldiers on a mission. And the violence is unflinching in its portrayal. Spielberg didn't want to simply make a war movie, he wanted to show us war, and ended up making one of the most realistic portrayals of it ever committed to film.

Runtime: 170 minutes.

Shaun of the Dead
(2004)

Upon its initial release, 2004's *Shaun of the Dead* was described as a zombie parody that was a little bit more than just a zombie parody. It was also a romantic comedy, dubbed altogether as a Rom-Zom-Com (romantic zombie comedy), but really, it's much more than that — it's much more than some flashy descriptor or ultra-specific genre moniker that looks good in a headline. *Shaun of the Dead* is, at its core, a movie about friendship. It's about friendship in all its forms.

Much emphasis is placed on the relationship between titular Shaun (Simon Pegg) and his ex-girlfriend Liz (Kate Ashfield), providing the plot with its romantic conflict, but an equal amount of tension grows between Shaun and his old college-roommate-turned-adult-life-roommate, Ed (Nick Frost). A friendship, like a romantic relationship, requires that both parties grow and mature. If someone is stuck in the same maturity level that they were ten years ago, the foundation on

which that friendship is built is going to crumble. If Shaun is at odds with Liz, who wants something more out of life than to drink pints of beer and eat pig snacks, then Shaun is just as much at odds with Ed, who is slowly whittling away at his sanity each time he has to stand in stunned silence when someone yells, "Stop defending him!" or calls Ed out on the meandering existence he very much thrives on.

The way I see it, *Shaun of the Dead* is divided into two distinct halves: there's everything that happens pre-zombie invasion, and then there's everything that happens post-zombie invasion. The two halves are mirrored by each other when something that had occurred in the first half happens again with a slightly darker (but often equally hilarious) twist. There's the tracking Steadicam shot from Shaun's flat to the corner store; "You've got red on you"; the "I'm not laughin'" fart joke; and "I'm glad *somebody* made it." When these gags are repeated in the second half, there's almost always a more dire, life or death situation at hand.

In the first half of the movie, Shaun is most closely-aligned in personality to his old buddy Ed, just sort of happy to be there and never really striving for anything else. In the second half of the movie, Shaun is most closely-aligned in personality to Liz, actively trying to improve on their given situation and do something for the betterment of him and his group of survivors, in order to make it through the night. By the very end of the movie, after seeing so much excitement – enough excitement for many lifetimes – everyone's given in to their own inner Ed.

Prior to making *Shaun of the Dead*, director Edgar Wright along with *Shaun* co-stars Pegg and Frost, had made a TV show called *Spaced*. Simon Pegg's character in *Spaced* describes friendship as the family of the 21st century, and that philosophy continues on throughout this film (and the other two in the Cornetto Trilogy, *Hot Fuzz* and *The World's End*, for that matter, as a sort of staple of philosophy to all their outings together). Though Shaun has a mother that he cares for very much, the family that he's made for himself is populated with friends of all types, and in the event that a zombie apocalypse should actually occur in reality, *Shaun of the Dead* is probably closest in nailing how it would go down: the fight for survival would be alongside

friends while also battling a hangover, and in between the screams, we'd probably all have a chance to grab a few beers together, because why the hell not? At the end of it all, if you were meant to be friends, friends you shall remain. And given the slowness of the zombie attackers, the whole thing would probably be resolved within 24 hours, as it is both here and in the case of George A. Romero's first zombie outing *Night of the Living Dead*, as opposed to his complete end-of-the-world scenario in his later flesh-eater flicks.

Shaun of the Dead is much more than some comedy that happens to be populated with limping, groaning, reanimated corpses that pop up to get shot. It certainly is that, and delights in how many homages to greats of the genre it can squeeze in, but genuine emotion comes from Shaun and Ed butting heads, seeing the hurt on Ed's face when Shaun has to hiss at him, "All you ever do is fuck things up!" and there's something truthfully sweet about the way Shaun says, "Thanks, babe," when Ed brings him a pint of beer.

And perhaps it's fitting that the very last scene of the movie isn't of Shaun and Liz, it's of Shaun and Ed, Ed now a member of the undead, playing a videogame for old time's sake while Queen's "You're My Best Friend" plays and it fades to the ending credits.

Runtime: 99 minutes.

The Shawshank Redemption
(1994)

Frank Darabont and Stephen King are one of those natural fits together, with the resulting movie coming out of their collaboration at the very least being pretty good. *The Green Mile* and *The Mist* don't live up to *The Shawshank Redemption*, but that's also true of about 90% of movies in general. Frank Darabont adapting Stephen King's material for movies sort of reminds me of the similar relationship between Tennessee Williams and Elia Kazan. Just... again, natural fits. Other directors have done Stephen King justice, as others have done

Tennessee Williams justice, but when you see the two names together, you know you're in for something good.

Tim Robbins plays Andy Dufresne, an innocent man convicted of murdering his wife and her lover in the first degree, sentenced to two life terms, back to back, one for each life lost in the brutal killing. According to Red (Morgan Freeman), *everyone* in prison, particularly Shawshank State Penitentiary, are innocent, so what makes Andy so special?

For the first couple of years of Andy's sentence, he sticks mostly to himself, never says much, and is repeatedly attacked, both physically and sexually, by a gang that goes by the name of the "Sisters." Andy finally emerges from his shell a bit when he talks to Red for the first time. Red, you see, is the guy who can get things for you in prison. He can get just about anything within reason. Andy asks him for a small rock hammer, a tiny little tool used to shape and polish small rocks, particularly ones found around the prison yard. At that moment, in a small moment, a friendship is born. The two hit it off and take an instant liking to each other.

Andy's talents take him far in prison life. In his life before the sentencing, he'd been a banker. He uses his natural skill with numbers to file the tax returns for the prison's employees. As a pet project, he writes a series of letters to propose additional funding for Shashank's library, which he eventually gets. He also becomes the warden's right hand man when it comes to hiding the money he's getting from bribes and other illegal activities.

As it turns out, Andy really *is* an innocent man. A truly innocent man. Proving this to anyone who can do anything about it proves to be impossible, because the warden has too much to lose if Andy should go free or open his big mouth and start blabbing about the activities that go on inside the walls of Shawshank.

Stephen King has no shortage of excellent film adaptations of his work, but *The Shawshank Redemption* is one of the best, and goes to show how much more to the man there is other than the usual works of horror everyone knows him by. *The Shawshank Redemption* is a classically great film, in that it tells the story of Andy Dufresne and his

incarceration without having to do a whole lot to subvert our expectations one way or another. It simply relies on the tools of filmmaking to make it as good as possible. The script and the dialogue are both excellent and contain so much humanity, humor and genuine surprises within. The cinematography, care of Roger Deakins, is incredible, particularly the helicopter shot that gives us a sense of geography and epic scope when Andy first arrives to the prison. The music is so expertly manipulative, but it works so damned well. It tells us exactly how to feel and when, but you can tell that the music means it, when it reaches such dramatic highs near the climax and has such conviction behind its intent. The direction by Frank Darabont is the best of his career, and he's so totally in control of the story that when you see the finished product, you can just see that you're in the hands of someone completely confident in their work. The editing has a fluidity in the way it cuts from shot to shot, some sweeping, some intimate, all for the express purpose of engaging us in the moving story of a man wrongfully imprisoned.

The Shawshank Redemption is also a movie with a lot to say, and it says it with subtlety, in a way that intertwines its musings on the problem with the system of rehabilitation in America with the story itself. Frank Darabont wisely keeps his film from being preachy, so when it has something to say, it doesn't stop everything to address its points, it allows the story to make its points for it—such as through the sad story of Brooks, a man who has no idea how to make it on the outside, without the order and day-to-day structure given to him by a lifetime in prison.

Runtime: 142 minutes.

Showgirls (1995)

Hollywood and the MPAA have always been uptight when it comes to sex. Violence, they seem to have finally gotten a little more lax on; gone are the days where *Friday the 13th* movies would hit the theaters essentially neutered, with all the best gore rotting on the cutting room

floor, or rendering the *Night of the Living Dead* remake essentially PG-13. But when it comes to sex, the board that determines what ratings movies get has always been uncomfortable around the subject of sex and doesn't seem to be getting any better. I don't know if it's because America was formed by sexless freaks who burned women at the stake or what, but relatively little progress has been made in that department. *Fifty Shades of Grey*, the "erotic" blockbuster everyone's grandma went to see doesn't even have the main dude, Christian Grey, hang dong in it. If you're going to show genitals, or acknowledge that women have orgasms in a movie, you're looking at an NC-17 rating for sure, which is sort of like a death sentence for a movie's return on investment. If no one under the age of seventeen can be admitted, you're looking at box office poison because it drastically limits the viewing audience.

Most movie theaters won't even show an NC-17 movie, which is the real problem. They see that rating and think of the nightmare involved with making sure no one underage is sneaking into it, lest some mommy watchdog group freak out over the content of the film and demand the theater chain pull it. The whole thing is a goddamned nightmare. But twenty-some years ago, a movie set about changing everything we know about movie ratings and the way we see sex in the movies. At the time, Paul Verhoeven was the guy to do this. He'd made one successful film after another, he had an unparalleled winning streak coupled with pushing the sexual content in his films to their limits—*Basic Instinct* had shown a microsecond of vagina and everyone went crazy for it, and it made over $100 million at the box office.

The future of film hinged on his experiment in big-budget sexploitation, *Showgirls*. Paul Verhoeven had a lot of ideas for the future of film, and the success of *Showgirls* was pivotal to that. He wanted mainstream Hollywood movies to feature erect penises without shame. Everything depended on *Showgirls*.

The problem was that *Showgirls* was really, really bad. *Really* bad. Easily a contender for one of the worst movies ever made. The plot is illogical, the performances are pretty much all terrible, and it all boils down to awful decisions in direction from Paul Verhoeven. *Showgirls*

being a good movie was of the utmost importance to his experiment with the Hollywood system, and he seemed to be directing the film from fucking Mars. The guy who directed *RoboCop* and *Total Recall* suddenly forgot how to make a good movie.

I think the reason I like *Showgirls* as much as I do—aside from the abundance of unintentional humor—is because I haven't quite pegged the truth about the movie: Is it just a really bad movie, or is the director pulling everyone's leg? The entire thing is so technically well-made and its big budget is put to good use in that it actually does look like a huge, sweeping epic of an exploitative character study, but there are moments where you have to stop and go, "No, no way! There's no way someone made this movie sincerely!" But that's one hell of an expensive prank to Borat everyone on.

Showgirls tells the story of Nomi Malone (Elizabeth Berkley shedding her image of Jessie Spano from TV's *Saved by the Bell*), who just wants to dance! We first meet her on the side of the road, where she's hitchhiking her way to Las Vegas. The film establishes, early on, that she doesn't take shit from anybody when she pulls a switchblade on the driver, who was getting a little too fresh for her liking. When they make it to Vegas, the guy takes her stuff and abandons her, leaving her broke and alone. Nomi lucks out when she meets Molly, who buys her French fries and a burger and gives her a place to stay while she gets her life together. The two have a strange live-in relationship together, because Nomi starts "dancing" at the Cheetah, a strip club, and Molly works as a costume designer for a big, nude show called "Goddess."

The star of "Goddess" is Cristal Connors, played by Gina Gershon, who seems to be the only person aware of what kind of film *Showgirls* is and chews as much scenery as possible. Cristal is a petty, power-hungry bitch who spends like 80% of the movie naked, sporting bedazzled nipples. When Nomi raises through the ranks of the naked Las Vegas hierarchy and becomes a cast-member of "Goddess", Cristal terrorizes her for seemingly no reason. She doesn't appear to be particularly jealous of Nomi, it just seems like she just enjoys acting like a cat batting around a wounded mouse. Cristal also very much wants to have sex with Nomi, just because. She almost has the chance, too, but right before they seal the deal, Cristal wants Nomi to realize

that she's a whore. Such a shame, too, they'd just had a lovely date where they shared mutual memories of eating doggy chow as children. What a turnoff, being called a whore.

Meanwhile, there's a whole subplot dedicated to Nomi's nipple-related erectile dysfunction. It seems that the screenwriter Joe Eszterhas has mistaken breasts for penises and just used a common male fear and affixed it to a woman. The problem makes no sense. And her eventual victory at the end, where she sports bright red, erect nipples and uses naked karate to beat up a rapist, is one of the stranger character arcs I think I've ever seen in a movie. The only other moment that comes close is *also* from *Showgirls*, where a sleazy character attempts to redeem himself in a moment that the film considers to be sweet, where he thoughtfully tells Nomi, "It must be weird… not havin' anybody cum on ya." Gee, thanks, dude.

So, with the colossal failure both critically and financially that *Showgirls* endured, the progressiveness in sexually-graphic films was halted. The next year, in 1996, Hollywood tried once more with *Strip Tease* which was similarly panned and flopped, reminding America that it's no longer the 70s, where films like *Beyond the Valley of the Dolls* could break box office records. Maybe America is ready for sex-camp again. Maybe enough time has passed. I mean, those films that celebrate psychological abuse, the *Fifty Shades* series, is making bank, right?

Only time will tell…

Runtime: 131 minutes.

The Silence of the Lambs (1991)

The Silence of the Lambs is a movie that took me a while to fully appreciate. The first time I saw it, I borrowed it from a friend when I was in high school and while I didn't think it was *bad*, my reaction was something like, "That's it? What's the big fucking deal?" To me, it was basically a feature-length police procedural like *Law & Order* with

better performances, R-rated violence and language and a bigger budget. It was nothing special.

Years later, I decided to give it another spin, and this time everything just sort of clicked and fell into place. *The Silence of the Lambs* is a movie that requires repeat viewings. There's a lot going on in the film, some of what it has to say being said through omission, as opposed to some grand statement, and sometimes just one viewing isn't enough to catch it all. There are visual metaphors galore over the constant themes of metamorphosis and change, and coveting the things we see every day. The death's-head moth doesn't just look cool (and let's face it, it does look really, really cool), it provides a lot of subliminal insight into Buffalo Bill's psyche and how he views himself.

Jodie Foster plays Clarice Starling, a cadet-in-training at the FBI Academy in Quantico. She's recruited for an unorthodox assignment for a cadet: Agent Jack Crawford (Scott Glenn) of the Behavior Science Unit wants Clarice to interview the notorious serial killer Hannibal Lecter (in a legendary performance by Anthony Hopkins) to see what he knows about a serial killer on the loose by the name of Buffalo Bill. Hannibal Lecter used to be a psychiatrist, one of the best, and Crawford thinks he might know something about Buffalo Bill's true identity. And even if not, Dr. Lecter might know a thing or two about how to catch them. Crawford recruits Clarice because he knows that he won't talk to an actual agent, but giving him a cadet—particularly a young, attractive cadet—might provide him with enough curiosity to open up to her, if only for a moment.

Clarice's first meeting with Hannibal Lecter is one of those perfect moments in film where even if you've seen the scene a million times, every time you watch it, your heart still pounds. At the Baltimore State Hospital for the Criminally Insane, Lecter is kept in a cell with floor-to-ceiling bulletproof Plexiglas instead of bars. Every safety measure must be kept in place, because the Doctor is a very dangerous man. He functions by gaining people's trust. When the right moment comes, he will strike, such as he did in a prior incident, prior to meeting Clarice, when he ate a woman's tongue. Clarice's attempt to interview and profile Lecter is met with disappointment, as he has no interest in her or her questionnaire, but on the way out of the cell block, a violent

lunatic named Multiple Miggs throws semen at her. She is appalled, horrified and completely humiliated by it. For some reason, Dr. Lecter feels for her in this moment and decides to help her, little by little. Dr. Lecter lives by his own code of honor, and seeing Clarice so vulnerable in that moment helps his respect for her grow.

In subsequent sequels, the nature of Hannibal Lecter gets more and more rooted in the supernatural. He knows things no human, no matter how smart, could know. He has a superhuman ability to do seemingly whatever it is he wants. In *The Silence of the Lambs*, he's a brilliant mind, but he's not infallible. When he profiles Clarice, he suggests she's a coal miner's daughter, trying to hide her identity and finally prove herself by climbing the ranks all the way up to the FBI. Through flashbacks, we find that she was actually the daughter of a small town police officer who was killed in the line of duty. He thinks he knows her so well, but the truth is he doesn't know a thing about her.

As Clarice and Crawford get closer to capturing their killer, they begin to find out the truth behind his murders. Both the film and the book state that Buffalo Bill is not a transsexual, he's someone who's neither trans or cis, he's someone who wants to reject himself completely, and he goes about it by kidnapping overweight women, keeping them in a pit to starve, and once they've lost enough weight, he murders them and skins them and uses their flesh to make a dress—a part of his metamorphosis, like the death's-head moths flying freely throughout his house.

Hannibal Lecter escapes from captivity after giving Clarice the last bit of advice he will give on Buffalo Bill and when he's gone, she's completely on her own. The FBI is on high alert for Clarice's safety, but she doesn't feel concerned. Hannibal Lecter murdering her would be something that he considers rude. Cutting off people's faces to disguise his own is fine, but to betray someone's trust is an unthinkable breach of his personal etiquette.

The Silence of the Lambs is a smart movie based on a smart book that did plenty of research and took great lengths to make the story feel as real as possible. The plot and identity of the killers, Buffalo Bill and Dr. Lecter, are cobbled together from multiple real-life cases, like the

relationship between Clarice and Lecter mirroring investigator Robert Keppel interviewing Ted Bundy in order to catch the Green River Killer. Ted Bundy similarly also escaped prison, but in real life he was re-captured (not before he killed again, though). And the house of Buffalo Bill, complete with a pit in the basement for holding prisoners, terrifyingly recreates the modus operandi of Gary Heidnik.

As great as Anthony Hopkins is as Dr. Lecter, much credit needs to go to Jodie Foster. She is pitch-perfect as Clarice Starling. Her absence in the sequel, *Hannibal*, was one of the things that movie couldn't recover from. As great as Julianne Moore is, the role of Clarice Starling belongs to Jodie Foster. She's incredible in *The Silence of the Lambs* and the way she tries to coolly shrug off abuse from the sexist world around her, are filled with these incredible moments in acting where she'll try to keep her composure, but you can just feel the anger bubbling beneath the surface.

Serial killers are such a strange thing for America to be obsessed with, but America is a strange place. I remember when I worked the night shift at a call center, I wasn't allowed to keep a book at my desk and I had access to only one non-company website: Wikipedia. So, when I got bored, I would read Wikipedia entries on serial killers. When I was on the entry for Ed Gein, one of the people who would inspire the character of Buffalo Bill, someone came up behind me to ask me a question and I screamed so loud everyone turned and looked at me. "Sorry, definitely not reading about a guy who made belts out of dead people, guys."

Author's Note: Jonathan Demme passed away recently. He will be missed tremendously. His contribution to film was unbelievable.

Runtime: 116 minutes.

The Sixth Sense
(1999)

There are some real "you had to be there" movies. If I'm talking to someone who was too young to remember when *The Sixth Sense* was

new, I'm just like, "Seriously, you just had to be there." When I saw *The Sixth Sense* in the theater with my mom, when the big reveal comes at the end of the film, everyone in attendance just about shit themselves. It was incredible. It was the kind of movie you came home from and when someone asks you how it was, you emphatically reply, "OH MY GOD IT WAS SO GOOD!"

Bruce Willis plays Dr. Malcolm Crowe, a child psychologist. He's married to a beautiful woman named Anna (Olivia Williams, the object of Max's affection in *Rushmore*) that he loves very much, but everything changes one night when an old patient of his, now grown up and unfortunately an emotionally-disturbed adult, breaks into his house. He shoots Malcolm and then himself.

Things begin to go much darker for Malcolm after that. He barely speaks to his wife. Gone is his old demeanor from those opening scenes. He's now sullen and depressed. He has a new patient, a young boy by the name of Cole (Haley Joel Osment), a quiet kid who has many of the regular problems most kids do, but there's something darker that he's not willing to admit, not until he gets to know Malcolm better.

Cole's mother is played by Toni Collette in one of those roles that could have been a real thankless role, a kind of padding to the overall plot, but she's given a great character that she can work with. Toni Collette is a fantastic actress when she's given the right material, and she really nails it here. She's a single mom who's made a lot of sacrifices for Cole to make sure he's getting the best education possible. There's a great shot with her watching the kitchen table as Cole's handprint on the surface begins to evaporate.

The secret that Cole is hiding from everyone, from his mom and from Malcolm, is that he sees dead people. Yeah, yeah, we've all seen the trailer and we've all seen the parodies. But the moment when Cole actually confesses that to Malcolm is incredibly chilling. It's a scene that deserves to be studied in film analysis and theory classes, because it's amazing. The performances and the writing and the direction needed to be perfect to sell this scene—if just one thing had been off, it would have been laughable, the entire film would have fallen apart

because of it. Instead, it's the best scene in a movie filled with brilliant scenes.

My beef with most movies about ghosts is that they all have the same problem, which is that you begin with a mystery, and the film begins so well shrouded in that mystery, and the more the movie explains what's happening and goes further into the story, the fear dissipates as the mystery is solved. It's a structure that seems impossible to sustain much tension, unless you keep the nature of the specters as vague as possible. *The Sixth Sense* does, actually, violate my general rule for horror movies by completely explaining the nature of the horror, explaining every single little thing, but for some reason it doesn't make it any less scary. Maybe, also, because the movie keeps the surprises coming, and saves its best surprise for the very end.

All these years later (Jesus, it's been that long?!), *The Sixth Sense* holds up because, even though the twist at the end of the film remains one of the most incredible, breathtaking, awesome twist-endings of any movie in any era, it didn't rely on that twist to pack a wallop. The rest of the movie is just as incredible, breathtaking and awesome, and the twist is a much-deserved payoff at the end. In some movies, a twist equally shattering will be revealed, but the rest of the movie wasn't deserving of it, so you're left with a flimsy excuse of a plot in order to get to an unrewarding payoff. Seeing a bad movie with an unearned twist is like the cinematic equivalent of following all those billboards on a road trip that advertise "What is THE THING?" and when you finally get there and see what it is, you're like, "Goddammit..." *The Sixth Sense* is like the best episode of *The Twilight Zone* to never air. It was such a good movie, M. Night Shyamalan is still riding the success of it. He's made plenty of other good movies in his career, but this is the one he's going to be remembered for for the rest of his life.

I saw a lot of movies in the theater with my mom in 1999 and it's a kind of weird maybe three-month long period I'm nostalgic for in a weird way. A couple times a week we'd have to drive up 45-minutes through a windy-ass country road to where my brother was going to school at Mt. San Jacinto Community College. Driving back home, then back there again and back home once more just wasn't feasible, so we'd stay in town and watch a movie to kill time. I'd go with her so she

wouldn't die of boredom, and we'd catch a movie together at the dollar theater. When I say it was a 45-minute drive through a windy-ass country road, I'm not exaggerating. It was a terrible drive and when we'd hit up the movies, I'd still feel a little carsick and I'd recover in time just to hit the road again. We saw some real mediocre stuff, but we saw some real gems, too, and *The Sixth Sense* was one of my favorites. Seeing it was pure magic, and I'll never forget it.

Runtime: 106 minutes.

The Snapper
(1993)

When I was a kid, my mom managed a video store, and one of the coolest perks of her working there was that studios used to send us "screener" tapes. The idea was, based on the movie we were sent, she was to make a judgment call on how many copies to order. Obviously, we didn't get tapes for things like *Independence Day* which was going to be off the shelves no matter its quality. Instead, we'd get a lot of independent movies a lot of people weren't familiar with, but had the potential to spread through word of mouth. If the movie was good, she'd order multiple copies. If it wasn't so good, she'd just order the one—maybe two if it was bad, but she knew people were going to like it. Sometimes making the call was impossible based on just one person's opinion, so we'd usually watch a couple movies and she'd ask my dad and all us kids what we thought of it. For low-budget kid's stuff like Full Moon's *Prehysteria*, my mom pretty much solely relied on what I thought to determine how many copies to order.

Some of these tapes we got ended up being really, really good. Most of them were forgettable, but every once in awhile we'd up with *The Crow* or *Muriel's Wedding* or, in this case, *The Snapper*, one of the strangest movies to have as a household favorite, but at the Russell homestead, we all loved it. Plus, I was always a big "Star Trek" fan when I was young, so seeing Colm Meaney, the guy who played Chief Miles O'Brien in both *The Next Generation* and *Deep Space Nine*, was

always a treat for me, which might be one of the reasons I loved it so much.

The Snapper is directed by Stephen Frears and stars Tina Kellegher as Sharon, a young woman who finds herself unexpectedly pregnant after a drunken night and refuses to tell her family who the father is. She knows who he is, alright, but she's damn ashamed of it, and instead tells everyone it was a Spanish sailor who was responsible. Colm Meaney plays her father, Dessie, is a complicated man who, at once, is outraged with his daughter and embarrassed by what she's putting the family through, while desperately trying to be supportive and caring as she comes closer and closer to her due date. He doesn't always do or say the right thing, but he tries his best and he's a good person at heart.

The "snapper" of the title is Irish slang for a fetus, or an unborn child, referring to Sharon's having gotten knocked up. Her unexpected pregnancy takes her family through a lot of drama, with gossip spreading around town. Friends who were supposed to be there for her no matter what end up betraying her.

The drama that occurs at home is especially dramatic since she still lives with her mom, dad, three brothers and two sisters, all living in a cramped home in Ireland. There's no escape for her when things end up getting tough to handle.

There's just something about the movie that, at the time, was something novel to me at such a young kid when I'd first seen it: Here, you had a movie that was, essentially, a family drama—the kind they have made-for-TV movies about where everyone's crying and wringing handkerchiefs and the entire family deteriorates. That never really happens in *The Snapper*. Yes, shouts are yelled, tears are shed, and there are times when things reach a boiling point, but the family is never in any real jeopardy of being torn apart. Instead of disowning the poor girl, or her running away, they stick together, and *not* sticking together was never really an option. They deal with the problem together. In another movie, the mother would watch the father throw his daughter out into the streets, but that never happens here. Instead, the movie always keeps a good sense of humor about the situation the family is in. It's not necessarily a comedy, per se, but a

movie that understands how important it is to find the humor in a scenario when things begin to look their worst.

In a way, *The Snapper* was always more moving to me than some of movies that really prided themselves as being "uplifting", with the way the full orchestra swells in those movies to the emotional beats of the film's ending. *The Snapper* just felt more real to me, like people I might know, like a friend's family or something, and seeing the Curleys pull through was more rewarding to me because it just rang true. Seeing everyone come together at the end for the birth of Sharon's child is a victory that was never in any real danger of not happening. It's just a happy moment to see them all together, laughing and joyous, celebrating.

Runtime: 95 minutes.

Sorcerer
(1977)

Sorcerer is one of those rare remakes that improves upon the original. In this case, I still absolutely love the film *Sorcerer* is based on, *The Wages of Fear*, but *Sorcerer*, to me, is the better version of the same story. It improves upon the introduction of the characters and has a better ending. *The Wages of Fear* is absolutely worth watching, though, as it has more to say politically about the United States' involvement in foreign countries, and is an expertly-crafted film. But, as far as remakes go, *Sorcerer* remains one of the best ever made.

The film begins with the long introduction of our main characters, the antiheroes from all around the world gathered in a place they can't escape from. Roy Scheider is Jackie Scanlon, an American involved in a robbery against a rival gang. Bruno Cremer plays Victor Manzon, a man involved with fraud against the Paris stock exchange. Francisco Rabal plays a man named Ribal, a professional hitman from Mexico. The actor named Amidou plays Kassem, an Arab terrorist. The four of them, from four different parts of the world, must seek refuge in a South American village named Porvenir, a sort of purgatory for

criminals; it works as a refuge against various law enforcement officials looking for them (and personal enemies outside of the law), but also serves as an inescapable place with nowhere near enough money coming in for anyone to emigrate elsewhere. They're stuck, living in extreme poverty.

"Fortune", or something similar but more sinister, shines on the four men when a lucrative opportunity calls that they can't refuse. The town's economy relies on the U.S. oil industry and when one of the refineries explodes, action must be taken to stop the fire from burning up the well's resources. The only way to put out the fire is by the use of dynamite, and the only dynamite that they have access to was improperly stored, bleeding out chunks of nitroglycerine. The dynamite is incredibly unstable and if jostled too roughly, it will explode.

The four men set aside their differences and apparent distrust of each other and accept the job of driving scrapped-together trucks loaded with the unstable explosives for the 200-mile journey to the burning oil refinery. The job represents their way out of Porvenir, to live life as men, as humans, once again.

The journey is rife with peril. Downed trees that must be eliminated with the unstable dynamite blocking entire passages. At one point, they must drive the trucks over a rope bridge that sways back and forth. Their trek through the jungle toward their eventual freedom is almost like a descent into hell. For Jackie, it becomes literal madness as he begins to lose his mind near the end of it, hallucinating and sweating with insanity.

The basic plot of *Sorcerer* is the same as *The Wages of Fear*, with how the actual journey itself playing out differently, both films containing plenty of surprises unique to their own stories, and I would recommend watching them both, because they're both excellent.

I'm convinced that if *Sorcerer* didn't open up on the same weekend as *Star Wars*, it would be a fondly-remembered classic today instead of a lost gem. It was a failure at the box office and remains largely unseen by a lot of people, which is a shame, because it's one of the best films of the 1970s. It was made right at around the time when director

William Friedkin seemed incapable of making a bad movie. *Sorcerer* followed right after *The Exorcist* which followed right after *The French Connection*. *Sorcerer*, in some ways, represents the end of Friedkin's winning streak in filmmaking. After the financial failure of it, he went on to make some very good movies, and some truly terrible movies. *Sorcerer* was sort of like his last hurrah, and if it had been the properly-received success that he had gambled on, who knows what would have happened with his career?

It seems that audiences were also confused about the title. "Sorcerer" here refers to evil forces of fate behind the four men's journey into hell. I see what Friedkin was going for, but let's face it, it's a terrible title. That, combined with opening against the unstoppable box office force that was *Star Wars* secured its own kind of inescapable fate of box office neglect. Perhaps given the omnipresent existential dread throughout, *Sorcerer*'s inevitable financial failure and fall into obscurity is totally appropriate.

When I watch *Sorcerer* today, I'm awe-struck by the kind of stunts they were able to pull off in the days before CGI. It's an incredible movie—it's one of the best action films ever made, surrounded by one of the best philosophical thrillers of all time. It's a movie that begs for repeat viewings. And the score by Tangerine Dream (the third film in this book that they've scored), is brilliant. I even own the movie's soundtrack on vinyl.

Runtime: 121 minutes.

Speed
(1995)

I've always liked Keanu Reeves. I don't know what it is, but there's something inherently likable about the guy. In a weird way, he reminds me of someone who might be a friend of mine or something, and whenever I see them turn up in a movie that does well, I'm legitimately happy for him. Like, "Good on, you, Keanu!" when he winds up in something as instantly classic as, say, *The Matrix*,

something that just takes the world by storm. It also does my heart good to hear multiple reports that Keanu Reeves is every bit the nice guy in real life he seems to be.

Keanu Reeves reminds me of Nicolas Cage in that they both get a lot of flak for being "bad actors." I mean, I've seen some pretty stilted performances from Keanu (or he's been just disastrously miscast, such as the case in *Bram Stoker's Dracula*), but when he's in a suitable performance in the right vehicle, he's damn good. He turns in a great, nuanced performance in *River's Edge* and, somehow, he's one of the best actors in *The Gift*, and that's a movie starring Cate fucking Blanchett, for god's sake. So, yeah, it's safe to say that when Keanu's good, he's really good, and he's at his best in the 1994 action flick, *Speed*.

Speed is like a panic attack turned into a movie. The director, Jan de Bont, was a cinematographer for some of the best action films ever made prior to this. He lensed *Die Hard*. So, prior to his directorial debut, he was already a veteran of the genre, and he needed his first movie to be something worthy of his talents. *Speed* pretty much hits the ground running and never lets up. The ways it's structured is that the movie is essentially a feature-length action scene with some quiet moments scattered throughout so that we can catch our breaths.

Beginning with a sequence involving a rigged elevator, the movie taps into some of our most basic fears. A madman named Howard Payne, played by Dennis Hopper, because of *course* he's played by Dennis Hopper, has placed an explosive device to the top of an elevator and has a full capacity of hostages stuck inside. If he doesn't get what he wants, he'll blow the bomb, sever the cables, and allow it to fall a hundred stories, killing everyone inside. Two LAPD SWAT team members, Jack and Harry (Reeves and Jeff Daniels), thwart his plan and corner him, but before they can capture him, he appears to kill himself in an explosion. This scene prays on a primal fear, with a claustrophobic interior of a trapped elevator car and the acrophobic potential of a massive fall.

Flash forward to about a month later, where Payne shows that he's decidedly *not* dead by going back to his usual explosive antics and blows up a city bus, just to show Jack that he's not kidding around with

what he tells him next: There is another bus with a similar bomb attached to it. If the bus goes over 50 miles per hour, it arms the bomb. If the bus drops below that speed, it will explode. Jack of course locates the bus with the bomb rigged to it and spends the rest of the movie on board, trying to keep the damn thing over 50 mph in Los Angeles. During rush hour.

Sandra Bullock plays Annie, one of the passengers aboard the bus, and she helps keep the vehicle at the desired cruising speed to avoid imminent explosion. Sandra Bullock and Keanu Reeves are great together in this movie, and it's a shame they haven't been in more movies together.

Annie gets into a lot of the same situations that the love interest woman always falls into in these kinds of movies, but she's never a resigned victim. She's a sarcastic badass who just wants her car back so she doesn't have to ride the bus anymore.

The script is courtesy of Graham Yost (with dialogue retouches by Joss Whedon), who went on to write some great television, like *Justified* and a couple episodes of the HBO miniseries *Band of Brothers*. The script is very, very tight and keeps everything constantly in motion. It's a work of art when an action movie works perfectly, to keep it at that breakneck pace for such a sustained amount of time without overwhelming the viewer—it never becomes an endurance test to see how much mayhem you can be subjected to, it's just moves from one thrilling set piece to the next. The set pieces make great use of the movie's situation, and suddenly a traffic jam isn't just a minor inconvenience, it's a life-threatening situation.

Speed is one of the finest action films ever made. Its commitment to sustained tension isn't an easy task to pull off. The end result of the film could have been unwatchable, but it took a lot of great work to make *Speed* as successful as it was. After the critical success of *Reservoir Dogs* and *True Romance* the directing job was offered to Quentin Tarantino, but he wisely passed because it wasn't really suited to his style as a filmmaker. In the end, this film belongs to Jan de Bont.

Runtime: 115 minutes.

Star Trek II: The Wrath of Khan
(1982)

It's hard to describe how much I love the universe of *Star Trek*. For this entry, I wanted to only focus on one of the *Star Trek* movies because when it comes to that particular can of worms, I could probably just write a whole book on that. I didn't want to get bogged down on comparing one movie to the next or focus on the popularly-believed idea that every odd-numbered *Trek* movie is shit, or get lost in the different series' focus on different aspects of their shared universe. I felt that *Star Trek II: The Wrath of Khan* was a perfect movie to choose to sort of highlight everything that I love about *Star Trek* in general.

The Wrath of Khan is far and away the best of the *Star Trek* movies. It's also one of the finest science-fiction films ever made, and one of the best sequels ever made. I probably like *Star Trek: The Motion Picture* more than most people seemed to, but it was a wise choice to have the sequel go back to the basics of the original series, even downsizing to an appropriately-sized budget for its adventure (going from $46 million to $11 million for *Wrath of Khan*). *The Wrath of Khan* also increased the action and adventure and had less to say, philosophically, about the mysteries of the universe. The intellectual focus is, instead, on something much more human: Getting older.

James T. Kirk (William Shatner), now promoted to an Admiral instead of the Captain he was for the Federation, finds his new rank to be troublesome for himself. He's just not admiral material. He was always destined to be a captain, and his new position divorces himself from the actual mission of Starfleet, which is to explore strange new worlds, seek out new life, to boldly go where no (one) has gone before. His unhappiness also stems from growing old. *Star Trek II: The Wrath of Khan* may have less to say about the mysteries of the universe than its predecessor, but it has plenty to say about the human condition.

Trouble comes in the form of Khan Noonien Singh (Ricardo Montalbán), the villainous, genetically-engineered superhuman who had appeared in the series episode "Space Seed." At the end of the episode, Kirk and the crew of the U.S.S. Enterprise banished Khan and his followers to a desolate planet as a sort of prison, but unbeknownst

to Kirk or anyone else at Starfleet, an exploding planet changed the ecosystem of the world Khan inhabited, turning it into a desert nightmare. Khan has been dreaming of revenge against Kirk for decades.

Khan gets to realize his dream of revenge when a crew of Starfleet planetary investigators (including Chekov played by Walter Koenig, also of the original series) turns up on the planet to check its viability for the Genesis Project, an invention that creates habitable worlds out of dead ones. It works by first annihilating the planet, then rebuilding it with coded DNA that builds it up from scratch. Khan uses a nasty little bug that burrows into the ears of its victims to control the minds of his Starfleet visitors to give him command of their ship. The U.S.S. Reliant isn't much of a combat ship, ordinarily, but with an intimate knowledge of how the U.S.S. Enterprise works, Khan plans on using a sneak attack, catching Kirk with his pants down, and exacting vengeance on him and his crew for what they did to him.

Khan's plan works perfectly, slicing up the Enterprise while it has its shields down, crippling it. Kirk doesn't go down without a fight and heads into a nebula system where he escapes Khan's final blows to the ship that would kill everyone aboard. With the Enterprise mortally wounded, Kirk and Khan engage in a game of cat and mouse against each other. At its best moments, *The Wrath of Khan* plays out like a terrific WWII submarine film, with the real tension coming from what we *don't* see. The absence of visibility works in its favor, making the volley of phaser blasts and torpedo shots incredibly thrilling.

The death of Spock at the end of the film is a pivotal moment I like to point to when comparing *Star Trek* of this era, and particularly this film, to the rebooted editions. We all knew Spock was going to come back. It's *Star Trek*. You can't just kill Spock! It wouldn't work. But killing Spock off (Leonard Nimoy's idea, and he only wanted to resurrect the character under the condition he could direct the next film) made a statement about who Spock was, and about his friendship he had forged over the years with Kirk. There was no risk of him staying dead, but we felt sadness in the moment anyway, because of the heartache suffered by the crew. In *Star Trek into Darkness*, the quasi-remake of *The Wrath of Khan*, something similar happens with

another character, and it's a cheap shortcut to dramatic storytelling. The results aren't anywhere near the same and it uses death exploitatively. There's no drama, it's an unnecessary complication to an absurd plot.

Star Trek II is my favorite of all the films, *The Next Generation* films included. Out of the movies made, I prefer the crew of *The Original Series*, but when it comes to the actual shows, I'm a *Next Generation* man. After that, I'm a *DS9* man. Then I'm a *TOS* man. Then *Voyager*. Then *Enterprise*.

Runtime: 113 minutes.

Star Wars: The Original Trilogy
(1977-1983)

Deep down, I'm a Trekkie. Always have been, always will be. It's where my allegiance lies. In the great debate about which you prefer, I chose my side, but that doesn't mean I don't love me some *Star Wars*. The two franchises are just totally different in what they focus on, and the world of film is big enough for the both of them. And hell, one wouldn't have happened without the other, in a weird, cyclical way. Without *Star Trek*, there wouldn't be a *Star Wars*—for everything *Star Trek* did in its original run on television, it created a look and a language we all know about science fiction, and its unending popularity made movies like *Star Wars* possible. And without *Star Wars* and its immense box office success, Paramount never would have greenlit *Star Trek: The Motion Picture*, or if it had, it wouldn't have pumped all that money into it (for what it's worth, no *Star Trek* movie will ever look as good as *Star Trek: The Motion Picture* does). The two benefitted from the existence of the other and if there ever was a competition between the franchises, it was mutually beneficial.

Star Wars is less concerned with scientific ideas and more concerned with fantasy and spirituality. The Force is, to me, a metaphor for total enlightenment, a higher plane of existence. The Rebel Alliance and its ongoing war against the fascist Empire is a perfect parable for good

versus evil. It's easy to sympathize with the scrappy underdogs and their quest for galactic freedom.

The first film, which I call *Star Wars* and adamantly refuse to ever call "A New Hope" could have been perfectly fine as a standalone film. The story that it tells leaves enough loose ends open that a sequel would have been possible, but satisfactorily ends its story well enough that had it been a flop, it could have been a self-contained narrative without any issues. Well, *Star Wars* was about the furthest thing from a flop that a film can be and, instead, redefined what the Hollywood system views as a successful movie. It changed everything we know about filmmaking in general. The special effects were revolutionary; there are many special editions that have been made that include "improved" special effects, but if you watch the untouched originals in the trilogy, the special effects are still impressive today, especially because they had to all be achieved without the use of computer-generated imagery. They did things the old fashioned way, but invented new techniques on how to capture those effects. Because of *Star Wars*, an entire special effects industry was birthed, with George Lucas right at the top of it, with his Industrial Light and Magic.

In many interviews, George Lucas had said he feels more comfortable as a producer, and opted out of writing and directing the sequels to *Star Wars*. I still think *Star Wars* is my favorite of the original three, just because it has such a personal feel to it, and says a lot about George Lucas's passions as a storyteller, but if someone tells me that their favorite is *The Empire Strikes Back*, I'm not about to argue. *Empire Strikes Back* is a damn good movie. It takes the continuing saga of *Star Wars* and takes it on a darker trajectory. *Star Wars* introduces us to unlikely heroes like Luke Skywalker, Han Solo and Princess Leia, and then *Empire* puts them through hell. *Return of the Jedi* is the closure of the trilogy, resolving the leftover turmoil from the middle portion of the story, and ending the epic with an explosive, thrilling finale. I understand a lot of the complaints lobbed at *Jedi*, but I just respectfully disagree—I think that *Return of the Jedi* is a fantastic movie, Ewoks included.

Luke (Mark Hamill) is the perfect surrogate for the audience. When he's introduced to us in the beginning, he's a naïve small planet boy (is

that the correct term for a smalltown boy in a sci-fi/fantasy setting?), but at the end of the final film, he's an enlightened mind wizard, who passed the ultimate test in not giving in to his darker impulses by killing evil personified: Darth Vader.

Darth Vader (voiced by James Earl Jones) represents the ultimate redemption story. While he is behind the coldest, cruelest form of fascism in the galaxy, there's a good person in there somewhere. It would be easy to leave him as an empty shell that murders and spreads misery, but *Star Wars* isn't interested in easy ways out and instead reminds us that even the most evil men are still human.

Princess Leia (Carrie Fisher) should be a template as to how to portray "damsels in distress" like the first film did. She was captured and in need of rescue, but was never a helpless girl waiting for men to do the dirty work for her. She may be a princess, but she's also the voice of a rebellion, so she needs to know how to handle herself in battle.

If Luke Skywalker is the perfect surrogate for the audience, Han Solo (Harrison Ford) is the person we all kind of *wish* we were. We all sort of wish we had those perfect quips, like he does when Princess Leia says she loves him and he fires back with, "I know." Han Solo plays by his own rules, understands that the universe is harsh and fires first against bounty hunters when he needs to, to save his own life.

The supporting cast, like Chewbacca, R2-D2, C-3PO, Yoda, Lando Calrissian and Obi-Wan Kenobi are pivotal to helping the universe of *Star Wars* feel massive. They help the films actually feel real, like they live and breathe. And the films are loaded with little nearly-subliminal moments that provide us with character insight, such as when the giant beast called the Rancor is slain by Luke Skywalker and a man, presumably the monster's owner, drops to his knees and begins to weep. In *Star Wars*, someone even loves something as terrifying at the Rancor.

Star Wars Runtime: 121 minutes.

Empire Strikes Back Runtime: 124 minutes.

Return of the Jedi Runtime: 131 minutes.

Suspiria
(1977)

Much more so than many other "surreal" or "nightmarish" horrors, *Suspiria* truly captures the feeling of being trapped in a bad dream and being unable to awaken from it. There's a self-contained logic that is never fully explained and real life is never allowed to intrude on the macabre story that unfolds.

I wish I was clever enough to have thought of this myself, but someone once described *Suspiria* as playing like a horror movie made by someone who had never actually *seen* a horror movie, just heard descriptions of them and decided to go hog-wild with these eccentric deaths that not only don't make sense in any tradition way, but don't need to make sense. Somehow the horror of the movie is amplified by being completely entrenched in absurdity.

There's a tendency in horror movies to over-explain the horror. If a horror movie has a haunted house, the movie feels that it's necessary to explain who it's haunted by and why and what the spirits wants. If a horror movie has a demonic entity following a family, the movie feels that it's necessary to explain that one of the family members is a chosen one in the ongoing battle between Good and Evil. A sequel in a slasher series might explain that said slasher is really, after so many movies, trying to really kill their long-lost sister. And so on, and so on.

In *Suspiria*, what we do know is that a very prestigious ballet school in Europe is secretly run by a coven of witches. We don't know why. Why should we care? We can draw our own conclusions. Perhaps the witches require money and tuition for such a school can't be cheap, so each new student brings a sizable income. Maybe they just need innocent victims for their sacrifices. A witch, especially as defined by this movie, isn't really human, so we would never understand their motivations and any sort of logical motivation relatable to us mortals would cheapen the dark suspense beneath the action. What we *are* shown is scary enough: A coven of witches run a school and the student body is subjected to their mysterious, evil whims.

The story that *Suspiria* has to tell is as basic as they come. A young American girl, a fish out of water, is accepted to the school that has an evil secret, and terrifying things happen to her. Very few surprises are hidden as the movie twists its way to its finish—it's little more than a basic framework giving the director creative license to find creative ways to kill young girls.

But, as a great film critic once said, a movie's quality isn't so much in what's it telling, it's in how it's told. The direction, by Dario Argento in his prime, is gorgeous. Much of the film's beauty is in its photography, lensed by cinematographer Luciano Tovoli, utilizing imbibition Technicolor prints (the process used by classic Hollywood films like *The Wizard of Oz* and *Gone with the Wind*). The music by Goblin is excellent. The setting of the school is a wonderful source of labyrinthine corridors where anything can jump out around any corner like some sort of funhouse with dire consequences.

Much of the film's charm lies in its innocence. These college-age students are actually stand-ins for what should be prepubescent girls, and they contain the same amount of maturity. The producers behind the film felt that Dario Argento could never get away with such graphically violent acts against children. So, he kept the characterizations intact from his script and set doorknobs higher up on doors on the set so that they would effectively look like children while having much more commercially viable victims at a suitable age being slaughtered. This works to the film's advantage, however, in that the world of *Suspiria* is unlike any other world we've ever seen in film. Adults act like children and the guardians of those women-children act like the Gestapo. Everything is exaggerated. Colors, characterizations, violence... everything.

The gore, while graphic, is always beautifully staged in a sort of operatic form, reminiscent of the Grand Guignol. Each death scene is its own set-piece. Each murder becomes some sort of artful display. No one simply dies in *Suspiria*, they must have their beating heart beneath their rib cage exposed and displayed before being stabbed; a woman mustn't simply be trapped in a bottomless pit of barbed wire after stepping through a door to nowhere, she must have her throat opened

like a zipper; if you have a seeing eye dog, God help you. The blood always looks like thick paint on a canvas dedicated to all things horrific.

Suspiria is my go-to definition of a pure horror movie. I remember when I was a young teenager seeking out all-things-fucked-up, I watched *The Evil Dead* and it left me terrified for days. I read Leonard Maltin's review in his handy little review book and he noted its similarity to *Suspiria*, and I had to see if a movie that inspired my nightmare fuel would be anywhere near as terrifying.

I watched *Suspiria* in my family friend's trailer with him and my sister on a warm summer night stoned out of my gourd... just higher than all hell, and when the maggots began raining down from the ceiling in the film, I was so unnerved and so thrilled by what I was watching, I kind of fell in love with the movie right then and there. Sometimes a movie is about what is has to tell and sometimes it's about how it's told, but sometimes a movie is about how you experienced it. I will never forget watching *Suspiria* with coyotes howling and yipping into the moonlight as I immersed myself in the macabre for the evening.

Runtime: 98 minutes.

The Terminator/Terminator 2: Judgment Day
(1984/1991)

Any movie, regardless of how stupid it sounds, can be a great movie as long as it's in the right hands. To me, the original *Terminator* movie is a prime example of this. A schlocky-sounding B-movie like *The Terminator* ended up becoming a massive cultural touchstone. James Cameron had had plenty of experience on Roger Corman productions as an art director, and later as a director (who got fired) on *Piranha 2*. I imagine that's where he learned a thing or two about economic filmmaking, as well as a first-hand lesson on what *not* to do on some movies. To get an idea of the kind of movie *The Terminator* could have been, just look at any number of knockoffs throughout the course of the 1980s that followed. It makes all the difference to see how a story is told.

In the future, machines will rise up against their masters and enslave humanity. All-out war will ensue. Humanity will live their days in fear, starving to death, engaging in battle with the machines, and constantly hiding from the metallic harbingers of death. But one man will lead humanity to victory after victory. The man's name is John Connor, and he's the leader of the rebellion against Skynet, the network of artificial intelligence that controls the machines. After calculating a potential loss for themselves in the future, Skynet takes the fight to the past by sending a cybernetic organism known as a Terminator through a time machine in order to find and kill the mother of John Connor, to keep the leader of the rebellion from ever being born, thus ensuring Skynet's control and victory over the future.

Arnold Schwarzenegger plays the Terminator, a cyborg sent to the past to find and kill the mother of the future of humanity. He's cold. He's ruthless. He doesn't have to say or emote much, just be an intimidating physical presence and Arnold Schwarzenegger is perfectly cast. Michael Biehn plays Kyle Reese, sent back in time by John Connor himself to protect his mother and to make sure that the rebellion has a fighting chance of survival in the future.

The Terminator, model T-800, doesn't know what she looks like, so he goes down the list in the phone book and finds everyone with her name and kills them. Reese has a picture of her, so he locates her and watches her from afar to make sure that she's safe. When the Terminator finally does locate her, he springs into action and saves her life, and the two escape together.

Sarah Connor (Linda Hamilton) is John's mom. She spends her days as a waitress at a diner, and her nights out trying to find dates. When she's told by Reese that she's the mother of a hero, she can't believe it. It all sounds so absurd. One day, she's leading the most boring life imaginable, and the next she's told that she might be responsible for birthing one of the most important men in history.

The Terminator is an incredibly well-made, low-budget action flick. It cost about $6 million to make, but looks like it cost much, much more than that because of some ingenious special effects, like a seamless mixture of models and full-scale props. The only effects that have *really* shown their age are the ones with the stop-motion Terminator

endoskeleton. Aside from that, the stunts, the action, everything looks pretty good for being well over thirty years old.

What I love most about *The Terminator* is in making the Terminator a palpable threat. In every movie ever made, when the bad guy has his victim in his sights, he takes forever to load his weapon, draws it up at a deliberate pace and is surprised when he gets interrupted. In *The Terminator*, there's a scene where something similar happens, but the T-800 is reloading his weapon at an *incredible* speed and gets shot just mere seconds before he has the chance to kill Sarah. It adds a realism to the movie and a sense of urgency, like if the characters don't act fast enough, the movie will absolutely not hesitate to kill off the main character.

Terminator 2: Judgment Day somehow pulls off the impossible by following up one of the greatest action films of its time with one of the greatest action films of *all* time. When I was a little kid, I remember I wanted to be the liquid metal T-1000, the new bad guy made for the sequel. I probably missed the point of the movie a bit, but holy shit was the T-1000 a cool addition.

The plot unfolds much like the first film, with a few twists here and there. Two time-travelers have been sent to the past, this time the target being young John Connor (Edward Furlong) himself, who is only ten-years-old. The ultimate switcheroo comes when it is revealed that Arnold Schwarzenegger, reprising his role as a model T-800 Terminator is, in fact, a good guy in this outing. The person we believe to be a Kyle Reese-like character is actually a much more advanced version of the Terminator, being able to shapeshift into other people and inanimate objects, as well as turn its arms into spikes, blades and swords.

James Cameron is a master of the action scene, especially in the *Terminator* films. *T2* avoids becoming a dull exercise in one-upmanship, with each scene bigger and noisier than the last, but here it somehow ups the ante and increases how exciting it gets until the very end. Even my girlfriend, who doesn't really care much for action movies, at one point had to marvel at the excess of *T2* when she said, "Did they seriously just fly a helicopter for real under a bridge?" That's perhaps *T2*'s best asset, is that it was created recently enough to take full advantage of emerging computer-generated graphics to create the

too-cool T-1000, but also long enough ago that CGI wasn't capable of duplicating effects that were left better practically, like using real helicopters for stunts and actual puppets for certain close-ups of the T-1000 after sustaining damage.

I love that both films also create such a unique look for themselves. The first one is a low-budget actioner that looks like a low-rent version of *Blade Runner*, like a gritty noir tale set in some vague future version of the 1980s. Its look is also replete with denim, mohawks and cigarette smoke. *T2*, on the other hand, is this sleek-looking movie that really shows off its unprecedentedly-high budget at the time, costing a then-unheard-of $100 million, and boy does it look it. In cinematography alone, it's absolutely gorgeous, and still looks better than most movies that come out today.

I watch both movies once a year and always look forward to it. They're some of the best action movies out there, and perfect companion pieces to each other.

The Terminator Runtime: 107 minutes.

Terminator 2: Judgement Day Runtime: 137 minutes.

The Thin Blue Line
(1988)

On November 28, 1976, Officer Robert Wood of the Dallas Police Department pulled over a car for driving without headlights and when he approached the vehicle, he was shot five times and killed.

An innocent man was found guilty of the murder and was sentenced to death. *The Thin Blue Line* reconstructs the events of the murder and made such a compelling case that Randall Adams was released from prison shortly after the documentary premiered. That's the power of film. Movies have the ability to make us laugh, cry and scream, but they also have the power to correct injustices.

At the time the documentary was being made, director Errol Morris was actually set to make a completely different documentary, about the psychiatrist Dr. James Grigson, aka Doctor Death, a man who made

a career working for prosecuting attorneys for convictions that ultimately resulted in the death penalty. Among the people Errol Morris interviewed were Randall Adams, who claimed his innocence. Morris believed him, and switched the focus of the documentary to be specifically about his case.

The Thin Blue Line sets about by telling the story of Randall Adams. He says that everything in his life at that particular time was working eerily in his favor. He moved, got a job almost instantly, and his future began to look bright. On his way home one night, his car ran out of gas and he was picked up by a 16-year-old named David Harris. He and David smoked some pot, drank some beers, and watched a movie at the drive-in.

Adams' string of good luck seemed to end when, that evening, Officer Robert Wood was shot and killed.

According to Randall Adams, he was at home at that time, and he can remember what he watched on television when he got in. He watched the end of the "The Carol Burnett Show" and about twenty minutes of the news before going to bed.

According to David Harris, he and Randall Adams were together at the time. They got pulled over by Officer Wood at around midnight and when he approached the window, Randall Adams began firing, killing the officer.

Meanwhile, it is revealed that the car Harris was driving was a stolen car and that in the aftermath of the murder, he was bragging to people about how he was the one who did the shooting. The prosecution seems to ignore this information and instead sets their sights on Adams. In interviews with people involved in the trial, the police just weren't committed to ruining a young man's life. Or, could it be that they were more inclined to pursue conviction that could lead to the death penalty? Harris was too young to be sentenced to death, but Adams was the perfect age.

The film contains reenactments of the murder in order to highlight contradictory evidence and statements. The scene of the murder is shown again and again in painstaking (but thankfully not graphic) detail. The film builds the case against Randall Adams, tears it down,

and builds it back up again to show how imperfect the prosecution's assessment of events was.

David Harris, who in the film is serving time in prison on death row for an unrelated murder asks the director, "Heard of proverbial scapegoat?" When Errol Morris asks him what he means, Harris all but confesses to the murder of the police officer. He says that he was a scared young kid, and that he pointed the finger at Adams because he was in the wrong place at the wrong time, and because he asked Adams for a place to stay and was refused. He says, "I've always thought if you could say why there's a reason Randall Adams is in jail, it might be because the fact that he didn't have no place for somebody to stay that helped him that night... landed him where's he's at..." Morris's camera wasn't working that day, which actually elevates the scene, as everything is captured on a tape recorder in a series of Dutch angles. Not being able to see their faces makes the confession all the more chilling.

The Thin Blue Line is one of the all-time great documentaries, one of the absolute must-sees, but it's also one of the best works ever made, of any format or genre, about American crime. It's in a league with Truman Capote's *In Cold Blood* in terms of the examination of a crime and the obsession with details. Both works are, at surface-level, about a tragic murder, but use the crime as a starting point to examine our culture and society.

Philip Glass's hypnotic score is essential to the film. It sets the mood for everything we're about to see. Even as a lover of documentaries, sometimes you have to be in the mood for one. I feel like even if you're not in the "mood" it's going to suck you in. It's going to create the right mood for you right then and there. It's pure magic.

Runtime: 101 minutes.

The Thing
(1982)

The Thing was the *other* alien movie that Universal Studios put out in 1982. While *E.T.* went on to become the highest-grossing film of all

time (at that time), *The Thing* kind of struggled to stay afloat and while it didn't lose money, it was considered a flop given its budget. I still can't believe that there was a time when a studio gave John Carpenter's alien movie a higher budget than the one they gave to Steven Spielberg.

The Thing was one of those movies that, at the time of its release, also got really snotty reviews, too. Every critic called it a disgusting barf bag of a movie, and kept comparing it to the Howard Hawks original *The Thing from Another World*, saying how great the original was—which, it's good, but Jesus fucking Christ, guys, let's not pretend the movie about a giant vegetable played by James Arness is freaking *Ben-Hur*. *The Thing* was even nominated for a Razzie Award (don't get me started on the Razzies and how much I hate them and how consistently wrong they are in their ongoing, bizarre war against child actors). Today, it's rightly acknowledged as a classic and, in my mind, is probably the best remake ever made.

At an isolated science outpost in Antarctica, a group of Americans watch as a pair of Norwegians chase an Alaskan malamute with a helicopter, hell-bent on killing the dog. They toss bombs at it and fire at it with a rifle. One of the Norwegians accidentally kills himself with an explosive and the other is shot and killed by the American station commander.

R.J. MacReady (Kurt Russell) flies a small expedition out to the Norwegian camp to see what might have gone wrong. He is convinced that the two men they saw had gone mad from isolation or cabin fever, and are afraid something worse might have happened back at their home base. When they get there, they find the place destroyed. Everyone is dead. A man had opened his wrists and the blood pouring out of the wounds had frozen before it touched the ground. Outside, they find a still-smoking, burned corpse of a mutated, human-like creature. They take it with them and head back home.

The dog they rescued from death is put back in a kennel with their other dogs and once it's alone, it begins to transform into something else, some sort of monster that absorbs the other dogs. I hate it in horror movies when animals get hurt or die, but the kennel scene is so good that I'm able to put aside my usual annoyances, because it is

brilliant, brilliant, *brilliant* in execution, the way everything unfolds. And the special effects, in a movie this old, are still some of the best I've ever seen.

After the commotion, and witnessing the creature devouring their dogs, MacReady eliminates the monster with a flamethrower.

The camp's doctor (Wilford Brimley, of all people) performs an autopsy on the creature and studies the records and videotapes from the Norwegians and discovers that it comes from another world. This alien crash-landed in Antarctica god only knows how long ago, able to lay dormant in a state of suspended animation until it was discovered by the Norwegian scientists. It functions by dissolving its victim and then learns how to replicate that person perfectly.

The Thing expertly ramps up the paranoia and the tension. Around every corner, it could be lying in wait. Everyone could be the thing… no one quite knows who to trust. The only thing MacReady can be sure of is that at least *some* of the people at the camp are still human, or else they would have gotten to him already and if they band together, they can fight it.

The basic formula of *The Thing* is one of those easy horror plots to copy and make it your own—sort of like *Alien* or *Jaws*—something you see copied, imitated and paid homage to again and again throughout the years. I remember when I first saw *The X-Files* episode "Ice" it scared the *shit* out of me. After it was over, my dad said, "Oh that was just a rip-off of *The Thing*." I said I'd never seen it and he said I was in for a treat, so he rented it for me the next day and, man, he was right… I was in for a treat, but it scared me even worse than *The X-Files* did.

The Thing combines existential dread with gross-out body horror and all-out gore… every aspect it devotes to the horror and terror of the story, it does perfectly. It's such an iconic, monumental entry in the genre, a movie I adore endlessly. There are some moments of the film that are just so perfect, they're like perfect works of art hiding in the overall narrative—a narrative that does those perfect moments justice. *The Thing* is a movie to watch with the lights off, cell phones put away and all of your attention on the screen.

Runtime: 108 minutes.

Tombstone
(1993)

Tombstone is the best possible movie that could have emerged from such a troubled production. A much more ambitious, sweeping epic western was initially planned, but when Kevin Jarre, the original director of *Tombstone*, was fired, the project had to be scaled back quite a bit. Whole storylines were dropped. Entire characters were written out or combined into other characters. A lot of what happened wasn't Jarre's fault... Robert Mitchum was scheduled to play a character that ended up not making the final cut because the actor got sick (Mitchum was still involved, though, as the film's narrator). The studio wasn't necessarily comfortable with him any longer and cut him loose.

Kurt Russell, the star of the film, wrangled up a new director, George P. Cosmatos, under the suggestion of Sylvester Stallone (Russell and Stallone worked together on *Tango & Cash*) because Cosmatos was a good workman of a director who would allow an actor to call the shots in shaping the movie, basically standing in as a ghost director for a studio that didn't want to take a chance on an unproven actor who'd never directed a film before.

Making the most of a difficult situation, Kurt Russell would ask the principle cast what some scenes were that they couldn't part with, like what was one scene that they were married to as an actor, and from that, he'd begin cutting where he could in order to stay in at budget.

Who knows what kind of movie *Tombstone* would have ended up being if Kevin Jarre hadn't been fired? According to Kurt Russell, he swears that the original film under Jarre's vision would have been incredible. It very well may have been a technically better film, but all I know is that the movie that ended up being birthed as a result of the troubled production, is one of my favorite movies of all time.

Tombstone tells the true story of the Earp family relocating to Tombstone, Arizona in 1879 to make it rich in the booming silver mining industry. Wyatt (Kurt Russell) is already a legendary lawman at

around this point, because of his career and reputation from Dodge City, Kansas. He reunites with his two brothers Virgil (Sam Elliott) and Morgan (Bill Paxton), and his longtime friend "Doc" Holliday (Val Kilmer)... a sort of unlikely friendship, with Doc playing by his own rules when it comes to the law, and Wyatt being such a straight-and-narrow kind of guy. When Virgil asks Wyatt why they're even friends, all Wyatt has to say on that is, "He makes me laugh." They're just friends, and that's what matters.

Things work immediately in favor of the Earps in the way of good fortune and lucrative business deals, but their happiness doesn't last long when they start butting heads against a local gang of outlaws that go by the name of the Cowboys, led by the violent psychopath Curly Bill Brocius (Powers Boothe, who has the coolest name in Hollywood, next to maybe Rip Torn) and his equally sadistic second-in-command Johnny Ringo (Michael Biehn). The Cowboys are murderers and thieves, and the lawlessness of Tombstone allows them to function with total immunity. Virgil and Morgan decide that something has to be done and sign up as U.S. Marshals and offer their services to maintaining some semblance of order within town limits. Wyatt wants no part of it. He moved to Tombstone to get *away* from law enforcement and violence, not to pursue it all over again in another part of the country.

Eventually, all three Earp brothers plus Doc are involved in a bloody confrontation at the O.K. Corrall, leaving several members of the Cowboys dead. Never once in the history of organized crime has a gang let bygones be bygones. The Cowboys react about as you'd expect... with bloody retribution against the Earps.

While Wyatt's peace of mind corrodes, so does his home life, as his wife Mattie slips deeper and deeper into drug addiction. He begins a seemingly-doomed extramarital affair (of sorts; it's mostly an emotional bond) with Josephine Marcus (Dana Delany) an actress that he falls head-over-heels for almost immediately. The most common complaint I hear about *Tombstone* is in the "cheesy" romance between Wyatt and Josephine, but I'm an unapologetic defender of it. I love it. I think the two actors are great together, and I love the epilogue, dancing in the snow, while Robert Mitchum's narration informs us

that, "Up or down, thin or flush, in 47 years they never left each other's side."

Tombstone really benefits from its attention to detail and period-correct costuming. I'm sure shooting in the Arizona summer, rife with scorpions and heat, was a nightmare in those wool costumes, but the movie works as well as it does because of those details. It looks real. It *feels* real. There's a lived-in quality to the sets we see. And though some historical details were combined or fictional characters were created as a composite of multiple real-life people to condense certain events, it really does pay close attention to the true story. Even a ridiculous-sounding scene like Wyatt Earp charging through a shallow body of water as bullets whiz by him happened in reality. And speculative scenes like a confrontation between Doc and Ringo were based on rumors from the time.

As good as Kurt Russell is in the lead role, the picture really belongs to Val Kilmer, who puts in his very best performance as Doc Holliday. Val Kilmer is a damn good actor, and even if he's in something not worthy of his talents, he usually (*Island of Dr. Moreau* aside) comes across well, and rises above the material. In *Tombstone*, he just steals the scene whenever he's on screen.

Tombstone was a family favorite in my house when I was growing up, and lines of dialogue just became part of my everyday vernacular. Quotes from the movie evolved into commonplace colloquialisms. Like, if someone announced that they're leaving to do something, it'd be met with a sarcastic, "Well…. Bye," a la Curly Bill taunting the bereaved Earp family. Or, to signify being slightly intoxicated, to mimic the way Doc says "Why, Ike!" just a little too loud.

Tombstone is a more emotional movie than most westerns, with musings on life and death and the Great Beyond, so perhaps it's appropriate that it ends with the narrator's line, "Tom Mix wept."

Runtime: 130 minutes.

Tremors
(1990)

Growing up in a small town in the country, I identified with the rural town of Perfection, Nevada, the fictional center of action in the film *Tremors*. My hometown had a population of about 7,000, a sizeable difference from the population of 14 boasted by Perfection, but there were still similarities. The climates were just about identical. When I would watch the movie when I was a kid, I'd pretend that the movie took place where I lived, and when I'd go outside I'd jump from rock to rock to keep from being eaten by Tremors—I know the movie dubbed the monsters "Graboids" but I always liked the name "Tremors" better. It's like, I know the shark in *Jaws* is named Bruce, but I want to call it Jaws, anyway. It's like calling John McClane "Die Hard." It just feels right.

Kevin Bacon and Fred Ward play Val and Earl, handymen stuck in a rut. They spend their days doing odd jobs around town, whether they're putting up fences and barbed wire for cattle, or pumping out shit from a septic tank. Their social lives seem to be just about nonexistent, to the point when a new person arrives in town, it's a call for celebration—particularly when it's supposed to be some young, cute college girl. Much to Val's disappointment, Rhonda LeBeck (Finn Carter), the graduate student studying seismology out in the desert surrounding Perfection, isn't a well-endowed blond, betraying his general tastes.

One day, after enough is enough, Val and Earl decide they're getting out of Perfection. They feel if they wait around any longer, they'll be trapped there forever. They even turn down a job that offers free beer. Life, it seems, has other plans for them, and keeps them from leaving.

First, they find the town drunk perched up high on a telephone pole dead. His cause of death was dehydration, meaning he was too afraid to come down and stayed up on a telephone pole for two or three days and eventually succumbed to dying of thirst. Second, they find old man Fred's flock of sheep torn to shreds... along with Fred's severed head in the middle of a depression in the ground. And then, finally,

their only way out of town, the one highway that passes through town is blocked off with rubble so that no vehicle can pass. They have effectively been isolated.

The next morning, right before the sunrise, Val and Earl head out on horseback to get to the nearest town for help. The cause of all the death in town appears to be from these big snake-like creatures. On their journey out of town, they are attacked by the snake creatures and their horses are pulled down. Val aims his rifle at one of them and fires, and the ground begins to swell and crack. "There must be a million of 'em!" Fred warns. When the ground breaks open, it reveals that there's only one creature, and those snakes are merely its many tongues. The monster is sort of like a giant worm, and uses its tentacles to bite and hold its victims while it swallows them whole.

Val and Earl haul ass on foot away from the creature and attempt to jump across a concrete aqueduct, accidentally killing it when it rams the concrete wall at full speed. With the help of Rhonda, the graduate student, they make it back to town to warn everyone else that, according to Rhonda's charts, there are more of those things out there and they're all headed toward town.

When Burt and Heather Gummer (Michael Gross and Reba McEntire) the two gun-loving isolationists, prove that you can kill the creatures with good old fashioned firepower, the creatures adapt and learn to hide. One of the best things about *Tremors* is that, yes, it's a cheesy monster movie by design, but it's also a very smart movie. Some characters are guilty of dying in that beloved horror movie trope where they fall victim to their own stupidity, but for the most part, the monsters have smart ways of setting traps or by learning how to work around the human's vantage points. At one point, the townsfolk outsmart the monsters by climbing up on top of their roofs, and the monsters retaliate by destroying the foundation of the buildings to bring them down.

Tremors is a PG-13 rated horror movie, and in some parts where someone uses one of those substitution words for "fuck" like "hump" you can see their mouths don't move right. It's sort of like watching a TV-version of a rated-R movie that's, for whatever reason, fine with other swears like "shit" and lets one of the F-bombs slip. Universal

must have been trying to maximize their revenue since it was so close to being PG-13, anyway. And in a weird way, I think it works better this way. *Tremors* is better suited to being a horror movie families with kids old enough can all watch together, because while it can be incredibly scary in parts, it's mostly a very fun outing. It's a great movie through and through, and one of my very favorite monster movies. When it's funny, it's laugh-out-loud funny. When it's scary, such as the scene where the doctor's wife is buried alive in a car, it's almost unbearably scary. It's a genuine roller coaster ride of a movie.

Runtime: 96 minutes.

True Romance
(1993)

True Romance is like the perfect date movie. If the person you're with doesn't like it, don't ever, *ever* call them back. If they love it as much as you do, it was meant to be. Plus, the movie has it all. It's incredibly romantic, in that schizophrenic, violent way only movies from the 90s could be, and it has great action sequences we can all enjoy. And, god, that cast! What an incredible cast! Most ensembles seem to scoop up as many A-list names as they can and it detracts from the story significantly; *True Romance* casts appropriately for the role, lucking out on many actors before they ended up becoming famous. In the supporting realm you've got a microsecond of Samuel L. Jackson, a minute of Gary Oldman chewing scenery, Val Kilmer as the ghost of Elvis (and you never see his face), Brad Pitt right at the cusp of superfame, James Gandolfini as a gangster years before *The Sopranos*, Tom Sizemore and Chris Penn as foul-mouthed cops, Bronson Pinchot doing his thing, and somehow in all of this there's enough time for an incredible, dialogue-heavy scene between Christopher Walken and Dennis Hopper.

Christian Slater and Patricia Arquette play Clarence and Alabama, fugitives on the run from Detroit to Los Angeles to make it rich. They're sort of like the happier, less psychotic version of Mickey and Mallory from *Natural Born Killers* (it's no coincidence that Quentin

Tarantino penned both films). Alabama was a prostitute, hired by Clarence's boss to show him a good time for his birthday, but she fell for him for real. She decides to quit the life and Clarence goes to her pimp to pick up her stuff for her. A fight breaks out and Clarence kills her pimp. When he brings a suitcase home, they realize he accidentally grabbed the wrong one. It's not filled with clothes at all but, rather, pure and uncut cocaine. A fortune's worth of the stuff.

Clarence doesn't know a whole lot about dealing drugs or even crime, but he does know that a lot of Hollywood big shots do cocaine, so that might the perfect place to unload such a large quantity of it. His plan is to use his friend, an aspiring actor, as an in to a Hollywood producer and then sell the cocaine at a massively discounted price, one that is impossible to refuse by a potential buyer, but still enough of a profit that he and Alabama can live in comfort while they start a new life together.

Unfortunately for Clarence and Alabama, the cocaine Clarence lifted from Alabama's pimp belonged to the mafia, and they want their product back. They know who he is and they know where he's going, and they're in hot pursuit.

The way everything comes together at the end, in the ultimate showdown, is obvious and predictable, but I don't think the movie was ever trying to buck our expectations when it came to that. If anything, knowing where the film is going while we get to know these characters makes the inevitability of violence all the more painful. Sometimes when I rewatch it, I kind of hope everything goes okay this time and that no one gets hurt. I guess that wouldn't make much of an interesting movie, though.

True Romance is like the perfect counterpart to *Natural Born Killers*. Everything about the two movies mirrors the other, with *NBK* being the darker reflected image. Both movies were written by but not directed by Quentin Tarantino. They're both about lovers on the road who find themselves neck-deep in blood and gore. And they're both essential movies to the culture and identity of the early 90s. Whereas *Natural Born Killers* is sort of the preachy one with a message about society and violence, *True Romance* is just a fun romp across the country. *Natural Born Killers* deviated heavily from the original script,

but *True Romance* stayed mostly faithful to it—the ending was changed and the director, Tony Scott, decided to ditch the nonlinear framing and telling it in a much more traditional way, but by and large it's pretty much the same script.

When I was a teenager trying to learn how to write scripts, I read a lot of screenplays. I read the one for *True Romance* and I was surprised to find there exists a cut of the movie online somewhere that retains the downer of an original ending as well as the original novelistic format, cutting back and forth between timelines. If you were a fan of the screenplay like I was, there's a fan-made cut just for you. What a niche audience that must be.

I'm obviously a big fan of Quentin Tarantino, but I think *True Romance* benefits from having someone else direct it. The change of the ending, for one, is more appropriate to the story. Tarantino begged Tony Scott not to give in to some Hollywood bullshit to make the ending more digestible for audiences, but according to Scott, he had just grown too attached to the characters himself and didn't want anything bad to happen to them after all they'd been through. Fair enough, right? I think that sort of naivety is part of what makes *True Romance* as fun and charming as it is. It wouldn't work without its optimism.

Runtime: 120 minutes.

What We Do in the Shadows
(2014)

I knew *What We Do in the Shadows* was probably going to be good because Jemaine Clement was involved, and co-writer/co-director Taika Waititi had also been involved with *Flight of the Conchords*, but for some reason I just wasn't excited about it. Every rave thing I heard, I just sort of shrugged off. Another vampire movie. Another mockumentary. Who cares? For some reason, when I'm just not

interested in seeing something, I can be incredibly stubborn. I will dig my heels into the ground. *Especially* when I'm wrong.

I was at the library with my girlfriend and she spotted *What We Do in the Shadows* and it was her idea to rent it. It was free, it was there, and I figured it would probably at the very least be pleasant to watch, so I said, "Sure. Let's get it." I remember watching it a couple days later just to get it over with, so I could say I did it, that I watched it, but I wasn't prepared for what happened when I did finally watch it. I loved it. I mean I really, really loved it. It was like a movie made specifically for me. It was like Taika Waititi and Jemaine Clement knew my love of classic vampire lore and what kind of jokes made me laugh and just modeled a movie around that. It was a great experience watching it for the first time. I loved it so much that I ended up watching it three times that weekend. My girlfriend ended up buying it for me on Blu-ray. To me, it joins the ranks of such movies as *Wet Hot American Summer*, another movie I can similarly watch for the 100th time and still laugh like it's all brand new to me.

What We Do in the Shadows begins with a title card informing us that every year, there is a masquerade ball for the undead and that the film we are about to see is about a group of vampires who plan on attending that ball. The crew of the documentary had been blessed with holy water and given crucifixes to ensure their safety.

In a flat in New Zealand, four vampires room together. Viago (Taika Waititi) is the "dandy" of the group, the one who is more uptight about things like dishes, which sometimes go unwashed for as long as five years. Vladislav (Jemaine Clement) is of an older generation, at 862-years-old. Back in the day, when he was in a darker place, he got his kicks by torturing people. He was turned into a vampire when he was 16, which explains why he always looks like he is 16 (of course, life was tough back then for a 16-year-old, so he looks closer to 40). Deacon (Jonathan Brugh) is the young badboy of the group, only 183-years-old and often misses the major point in conversations, like when the subject of the dirty dishes is brought up he's told he's a cool guy, but he really needs to pull his weight around the house. "Oh, I am glad to hear that I am cool," he says, pleased. Petyr (Ben Fransham) is the oldest vampire of the group at a whopping 8,000-years-old. He no

longer resembles a human being, looking more like Count Orlok from *Nosferatu*, existing as some ancient creature that predates Christ for six millennia. Petyr is treated the way an 85-year-old human would be treated... he gets to miss flat meetings because, let's face it, climbing stairs at that age is no easy task.

My favorite scenes are the ones with Viago, Vlad and Deacon trying to act like normal people, despite being centuries-old vampires who still think wearing frilly, silk shirts is really cool to do. They like the same things most people like, like going to clubs or dancing, but they can't come inside unless invited, so that usually doesn't work out very well for them. When it comes to victims for their needed blood-feedings, they're not overly picky, although they do prefer a virgin if one can be wrangled up. The way Vlad puts it is like imagine how much better a sandwich would be if you just knew that no one had fucked it.

Things get complicated for them when Petyr turns a younger guy into a vampire. No one likes him. He's an ass. He keeps blabbing around town that he's a vampire, which attracts some unwanted attention from actual vampire hunters. Although he does introduce them to Stu, the kind of person everyone immediately takes a liking to. Stu introduces them to technology so that they can finally see what they look like since they can't rely on a mirror's reflection for their own appearances.

I have no doubt that in the years to come *What We Do in the Shadows* will be regarded as a classic. It's one of the funniest movies I've ever seen. This the kind of movie that, like *Young Frankenstein*, will be rediscovered with every new generation that follows.

Runtime: 86 minutes.

Who Framed Roger Rabbit (1988)

My favorite movies when I was a kid were the kids' movies that didn't insult the intelligence of its intended audience, and instead gave them challenging ideas, and took things as far as they could. I loved movies like *Return to Oz*, movies that weren't afraid to go into darker territory

and trust that kids could be scared out of their goddamned minds and love every second of it.

Who Framed Roger Rabbit is one of the most fucked-up movies geared toward children that's ever been made, and I love it for that. The screenplay is a sort of homage to *Chinatown*, focusing on citywide political corruption in Los Angeles, on public transit instead of water rights. It also has a racial subtext, a commentary on how people of color were treated by the Hollywood machine, using cartoons as stand-ins for minorities. It's also a film noir, with murder, blackmail and "patty-cake", a pretty thinly-veiled metaphor for extramarital sex. Somehow, this didn't raise any eyebrows, because the movie features cameos from just about every major cartoon character you can think of. Mickey Mouse and Bugs Bunny appear in a scene together. Daffy Duck and Donald Duck wage war on each other. Goofy and Dumbo and Yosemite Sam all show up for cameos.

Eddie Valiant (Bob Hoskins) is a classic noir private investigator, a guy who drinks too much, who wallows in depression and views the world with an eye of cynicism. He's never been the same since his brother, his partner, died... some 'toon (the possibly-derogatory slang term for cartoons that exist in the physical world) dropped a piano on his head. Ever since, he refuses to work with 'toons. Until, that is, a job comes his way that he can't pass up.

Roger Rabbit (Charles Fleischer) hasn't been fulfilling his duties in the movies lately. His mind seems to be somewhere else, and his boss, R. K. Maroon, thinks he knows why: Jessica Rabbit (Kathleen Turner), it seems, is playing patty-cake with another man on the side. And R. K. Maroon wants Eddie to find out who. Maroon believes that when Roger finds out and leaves his cheating wife, his mind will be clearer, that he'll turn in better performances. It doesn't quite work out like that. Roger freaks out, and runs off in a fury when he sees the pictures Eddie took of the affair. The very next day, the man she was with, an inventor by the name of Acme, is found dead—a safe dropped on his head, a common murdering technique among the 'toons, it seems.

At the murder scene of Acme, Eddie meets Judge Doom (Christopher Lloyd), who promises to bring Roger Rabbit to justice. 'Toons, you see, are durable. You can drop a piano on 'em, an anvil, shoot 'em, burn

'em, blow 'em up and they'll shake it off. They can shake off just about anything. Anything but dip, that is. Dip is the invention of Judge Doom and it will permanently kill a toon, which he demonstrates to Eddie by sacrificing a cartoon shoe into the dip—a scene that will be burned into my mind's eye for the rest of my life.

Eddie heads back to his office and finds Roger hiding there, waiting for him. Before Eddie saw his brother get murdered, he had a reputation as someone that the 'toons could trust. Roger swears that he was framed and that he had nothing to do with Acme's death. Later, it seems Roger is telling the truth when Jessica shows up to tell Eddie that she had been forced to pose for those pictures he took of her and Acme. Something is very, very wrong and everything keeps coming back to the expansion of the Los Angeles freeway system and the impending destruction of Toon Town.

I loved *Who Framed Roger Rabbit* as a kid because it was bright, colorful, funny and featured just about every cartoon character I loved, all in one movie. And who didn't have a crush on Jessica Rabbit when they were four or five years old? Michelle Pfeiffer as Catwoman was the first woman I remember having a crush on, but Jessica Rabbit was my first-ever crush. I'm not even embarrassed that my first crush was on a cartoon character.

I love *Who Framed Roger Rabbit* as an adult because of the tremendous amount of technical skill that went into bringing the cartoons to life. They don't look like special effects, they look like they actually do inhabit the same world as the physical actors. What makes the film work as good as it does is that the script and the performances are all as good as the special effects that help bring the world that the 'toons live in to life.

Runtime: 103 minutes.

Who's Afraid of Virginia Woolf?
(1966)

Who's Afraid of Virginia Woolf? is a movie to watch between crisscrossed fingers clamped tight over your eyes to shield you from the awful awkwardness on display, peeking out only momentarily during the most intense scenes to hear George (Richard Burton) and Martha (Elizabeth Taylor) scream something deep and cutting at each other.

The thing about *Virginia Woolf* is that we've all been there. We've all been stuck in a situation we desperately wanted to leave, but for whatever reason we couldn't. It's like watching people in a movie about a haunted house and you want to yell at them, "Why don't you just leave?!" But you know why they don't just leave. They can't. Too much alcohol has been drunk, too many ugly things have been said, and everyone's in it now. Everyone's in it for a long, stygian descent of an evening.

As the film begins, George and Martha are already drunk. They stagger through the house, defeated in their lives and angry with each other. Martha reveals to George that she has invited a young couple they met at the party over for a few more drinks. When the young couple arrive—Nick and his wife Honey (played by George Segal and Sandy Dennis)—it only gets worse. Since Nick is a professor at a university and Martha is the daughter of the dean, he and his wife appear to be trapped, to endure the torment of their hosts.

At first, George and Martha's openly-antagonistic relationship plays like some sick game that they're playing on their party guests. It seems like they're getting off on watching them squirm. But as the evening progresses and the booze flows and insults are hurled at each other, Nick and Honey go from innocent bystanders to active participants in the acts of cruelty.

When the evening finally comes to an end, we've been witness to so much it feels like smoke from a battlefield is clearing when those final credits roll. There are histories exhumed that involve both real and

fictional deaths of children… threats… adultery… impotence… blackouts. Whenever I rewatch the movie, I feel like never having a drink again in my life.

Who's Afraid of Virginia Woolf? is probably the darkest movie I love with an unabashed glee. Darker movies exist, and I'm sure darker movies that are technically better, too, exist. But something about *Who's Afraid of Virginia Woolf?* speaks to me. It's, at turns, deeply depressing, equally upsetting, but somehow also laugh-out-loud hilarious in equal measure. People talk about the art of "cringe comedy" in shows like *Seinfeld* or *Curb Your Enthusiasm* or *Louie*, but none of those shows have got anything on *Who's Afraid of Virginia Woolf?*, which has such brilliant and funny lines as, "I hope that was an empty bottle, George! You can't afford to waste good liquor, not on *your* salary!"; "I swear, if you existed, I'd divorce you." and "Martha is 108… years old. She weighs somewhat more than that."

The screenplay by Ernest Lehman remains mostly faithful to the original play by Edward Albee. The direction by Mike Nichols (in his first film, though he was a veteran of the stage by that point) is some of the best of his entire career.

I'm surprised *Who's Afraid of Virginia Woolf?* hasn't been remade again and again and again. It seems ripe for it. If I were to remake it (I'm not saying I *should*, but if I *did*), I would want to cast a real-life couple again, but perhaps not one with the up-and-down Hollywood Royalty drama of Burton and Taylor. I think I'd go with a healthy couple everyone loves seeing together, and get them to scream insults at each other for the better part of two hours. Kurt Russell and Goldie Hawn, maybe?

Movies and plays like *Who's Afraid of Virginia Woolf?* exist as a kind of catharsis. You feel beaten down when it's over. You feel exhausted. You feel like you've gone 10 rounds of emotional fighting with someone you're supposed to care about. You, frankly, feel like crap when it's all said and done and George and Martha watch the sun come up. As for me, personally, I often have to wonder, "What was the *point* of all that?" at the end. The point, I suppose—if there is one—is that when you recover from the madness, you can hopefully say,

"Well, my life might have its problems, but at least I'm not George or Martha." They exist as an example of what never to become.

Runtime: 131 minutes.

The Wild Bunch

(1969)

The first line spoken by Pike Bishop (William Holden) in *The Wild Bunch* is, "If they move, kill 'em!"

The Wild Bunch is a western that even people who hate westerns would love. It's a dark, nihilistic journey through the soul, slathered in violence and dust and dirt and grit. With censorship in films via the Hays Code coming to an end, movies were suddenly afforded much more license to explore darker themes through language, nudity and violence. The year before, the film *Bonnie & Clyde* made history by showing people getting shot with visible blood and exploding wounds—*The Wild Bunch* would take this even further with an almost gleeful portrayal of brutal bloodshed.

The film begins with a band of outlaws making their way to a bank that they intend to rob. Pike is the leader. Ernest Borgnine plays Dutch, the second-in-command. Also along for the ride are two brothers named Lyle and Tector (Warren Oates and Ben Johnson), and Angel (Jaime Sánchez). The bank robbery is to be Pike's big last score before retirement. In a terrifying premonition of things to come, children torture a scorpion by dropping it into a pile of ants. When the children grow tired of their game, they set fire to both the scorpion and the ants.

A shootout breaks out between Pike and his gang and a man named Deke (Robert Ryan), Pike's former partner, and a pair of bounty hunters. Dozens of innocent people are caught in the crossfire and killed. The film emphasizes the chaos through rapid-cutting techniques and slow-motion, techniques still widely used today. Watching that opening shootout in *The Wild Bunch*, if you didn't know what year it had been filmed, you'd swear it was a modern, revisionist western to come out within the past couple years.

The Wild Bunch represents the end of an era for Pike and his gang. It's not the 1800s anymore. It's 1913 and the world is growing up without them. Automobiles and machine guns are replacing horses and lever-action rifles. The world is becoming a place they no longer recognize.

The loot from the bank robbery ends up being a decoy, bags filled with nothing but steel washers instead of the coins, silver and gold, that they should have gotten. Stranded in the desert, broke, betrayed and dismayed, they decide to head south for Mexico and try their luck out there, and to evade the law that is after them.

Sam Peckinpah is not my favorite director, but he's made plenty of movies that I enjoy and as far as I'm concerned every movie he made after *The Wild Bunch* could have been terrible and he still would have had a lifetime pass. *The Wild Bunch* is one of the most innovative films to have come out during its time. The sound effects went against that typical western oeuvre where every "bang!" sounds the same, instead playing with different effects of bullets striking surfaces or whistling through the air. As much as I love the TV show *The Rifleman*, which was developed by Peckinpah, *The Wild Bunch* is a world apart from the good-natured adventures of Lucas McCain.

William Holden has no shortage of great roles—*Sunset Boulevard, Bridge on the River Kwai, Network, Stalag 17*—but this is the first movie where I don't feel like he's playing some version of William Holden. He exudes none of the simultaneously smarmy and charming energy he usually does. Instead, he looks like he's stared death in the face one too many times and is just tired. Physically, emotionally and existentially.

When it comes to a film like *The Wild Bunch*, the hardest thing to do is to end the damn movie. With such a perfect introduction and a thrilling series of set-pieces like an army train robbery that occurs later, if you slap together some inconsequential ending, you run the risk of letting these great scenes and characters go to waste and wind up with the worst kind of movie: One that only *flirted* with greatness, but never lived up to its full potential. What happens, instead, is an ambiguous moment that can either be regarded as redemption, or as one last hurrah knowing that your time has passed. The era we know as the "Wild West" is long gone at this point and Pike is a relic of that.

The Wild Bunch abstained from many of the trends and clichés of the genre by having the characters at the center of the film be such despicable criminals, and it would be damned if it was going to revert back to any familiar imagery by having them silhouetted on horseback, riding off into the sunset. No, what happens instead is much better than that. It's a powerful ending that leaves you breathless as those final credits begin to roll and sticks with you for days and weeks after you've watched it.

Runtime: 145 minutes.

About the Author

Billy Russell was born in San Diego, CA in 1986 and grew up in the small town of Anza, CA. He currently resides in Phoenix, AZ with his girlfriend Yolie and his cat Frida. *VideoBilly's 101 Must-See Movies: A Bathroom Book* is his first book, but hopefully not his last.

If you want to send Billy love and adoration, or if you want to send him a message telling him that you hate his stupid, ugly face, you can either visit his website and leave a comment or send him a quick email.

Website – http://videobilly.com

Email – billyleerussell@gmail.com

www.ingramcontent.com/pod-product-compliance
Lightning Source LLC
Chambersburg PA
CBHW020900180526
45163CB00007B/2569